Functions
of Painting

The Documents of
20th-Century Art

ROBERT MOTHERWELL,
GENERAL EDITOR

BERNARD KARPEL,
DOCUMENTARY EDITOR

Functions of Painting
by Fernand Léger

TRANSLATED
BY ALEXANDRA ANDERSON

EDITED AND INTRODUCED
BY EDWARD F. FRY

WITH A PREFACE
BY GEORGE L. K. MORRIS

NEW YORK THE VIKING PRESS

Fonctions de la Peinture

© 1965 by Éditions Gonthier

Translation, Preface, and Introduction Copyright © 1973 by
The Viking Press, Inc.

All rights reserved

First published in 1973 in a hardbound and a paperbound
edition by The Viking Press, Inc., 625 Madison Avenue,
New York, N.Y. 10022

Published simultaneously in Canada by
The Macmillan Company of Canada Limited

SBN 670-33221-6 (hardbound)

670-01945-3 (paperbound)

Library of Congress catalog card number: 71-184540

Printed in U.S.A.

Publishers' Note

This collection of essays is based on *Fonctions de la Peinture*, published in France in 1965. The editors have made a number of significant changes in preparing this English-language edition. The essays have been arranged chronologically rather than in the original thematic sequence in order to illuminate the course of Léger's thinking. As a result, numerous repetitions of thought and phrasing have become obvious. No attempt has been made to edit these out since they are a gauge of the ideas Léger considered important enough to warrant particular and repeated emphasis. In some cases, the same phrases and examples appear in different contexts; in others, the repetition may have occurred simply because Léger intended the essay for a different audience. (Note, for example, that certain sections of "Modern Architecture and Color," published in 1947 in the United States, recur in an essay published in *Art d'Aujourd'hui* in Paris in 1949.) Some of the essays printed here were never published during Léger's lifetime, and one may deduce that he borrowed certain ideas from them for use in current work.

Three of the essays have not been translated from the texts in *Fonctions de la Peinture*. These were all published in the United States in the 1930s and 1940s but did not appear in France until some time later. The French versions, in *Fonctions*, differ in some degree from the English texts, but the latter are used here since they had a decided impact when they were published and, moreover, are no longer easily

available. The publishers are grateful to Harold Rosenberg and George L. K. Morris for permission to include their original translations.

Other respects in which this edition varies are in the illustrations, which now include several photographs of the artist himself, and in the addition of a selected bibliography by Bernard Karpel. In place of the French preface by Roger Garaudy, there is a new one written especially for this edition by George L. K. Morris, along with a critical introduction by Edward F. Fry, who discusses Léger's writings in the context of his artistic development.

Preface

Painters of many persuasions have long delivered their theories of art in print. Only a handful, however, have examined additional aspects of their contemporary worlds. Perhaps it is no accident that the two who have done so most tellingly—Eugène Delacroix and Fernand Léger—both happened to be French.

Léger had ideas about everything, and his eye was everywhere. Early in the twentieth century he detected a new civilization, with an accent of its own. A culture primarily urban, its heart—for good or ill—was the machine. Cézanne had maintained that a work of art should hold its own with nature; he would appraise a painting against a background of foliage. Léger, of a later generation, insisted it was with manufactured objects that a painting must now compete.

Léger bristled with ideas for improving the modern megalopolis. Although urban officials turned deaf ears, it is interesting to note that some of his proposals have been realized fortuitously nonetheless. In 1931 he suggested—in jest, let us hope—that New York might be demolished (he picks Marshal Pétain, under whom he defended Verdun, for the job) and that it be rebuilt with structures made entirely of glass. If he could witness New York's current self-demolition and the glass walls that reflect our avenues, he might consider himself a prophet. (No one, however, has followed his next step—to paint, in various colors, the ceilings and floors within.) A few years later, the organizers of the 1937 Paris Exposition invited Léger to submit a project that might astonish the world. His suggestion was

that 300,000 unemployed workers sandblast every building in the city and proclaim PARIS TOUTE BLANCHE. Forty years later, on Malraux's initiative, the city has been (almost) scrubbed clean; we have PARIS COMPLETELY WHITE, and it is indeed sensational.

My first glimpses of Léger have remained vivid through the years. In 1929, avant-garde paintings were rarely encountered in New York —or in Paris either, for that matter. The few examples I had seen made little sense to me; nevertheless, I was determined to see what, if anything, made them tick. After I reached Paris, I heard about one class with two instructors—Léger (Wednesdays) and Ozenfant (Saturdays). So the following week I walked around to the Académie Moderne and enrolled. To my surprise, the registrar was an amiable American; she informed me that the studio had once been Bartholdi's and that the Statue of Liberty had been designed there.

The room, which was on the street level, was large and rather dark. A nude was posing on a platform with a screen behind her; on one side was a stool and, next to her left foot, a vase of artificial flowers. There were about twenty students of various ages and nationalities, most of whom were depicting the model quite realistically. I selected an easel and—fortified with my Art Students' League technique from John Sloan's and Kenneth Hayes Miller's classes—proceeded to do likewise. Beside me was a white-haired English lady, crouched over water colors; she was not doing the model at all, just the vase of flowers.

I awaited Wednesday afternoon with impatience. It was almost closing time when the door finally opened. I had visualized a tough character, sharp and sarcastic; no one could have been more different. I first caught sight of a blue turtle-neck sweater that contrasted with dark-red hair. Léger was massively built but in no way gross. He looked surprisingly gentle and troubled, with deep lines in his face. His manner was shy and remote as he moved from one easel to another, mumbled a few words, and passed on. It was finally my turn. He looked fixedly at me for a minute, then at the painting, then at me again, all of which I found rather unnerving. Finally he said: *"Continuez."* He then moved to the flowers in water color next to me and mumbled *"Ça va."*

Next week was a repeat performance—except that I got *"Ça va"* and the English lady *"Continuez."* Later on I heard him talking to a pupil just in front of me. He never raised his voice, so I drew closer. Léger was saying that the hands were too indefinite; he took out pencil and paper and proceeded to sketch a very large thumb; it was the most wonderful rendering of a thumb I had ever seen, absolutely neat and accurate down to the last crease on the knuckle. He went on: "You see, make it *tight*, make it *dry*. Then, when you understand completely what you're doing, you can loosen your technique and it will hold." He added, addressing us all, "The world is full of artists who can make a good start, but how many can carry a painting through to completion!"

The following Wednesday a young girl brought in a canvas that she had painted during a weekend in the country. It depicted a medieval gateway, with a wheelbarrow in the lower right and, I think, some chickens. I thought it was quite good, and Léger thought so too. "But look," he said, "the wheelbarrow should be up here"—pointing to a vacant spot in the sky—"then you'd start to get a composition." He continued with an equally unexpected disposition of the chickens.

I got the message and returned to the painting on my easel. I moved the vase of flowers high up on the wall; the stool went in one direction, the nude in another, with the screen broken into fragments. Next week Léger went straight to my canvas: "Look! There's someone who has seen the light!" It was the first time I had heard his voice above a mumble, and from then on a barrier between us seemed to have been lifted.

As we got better acquainted, I would try to entice some critical opinions from him. I had recently made several new acquaintances— Mondrian, Arp, Pevsner—and was interested in his estimate of their work. He replied that his own approach was so different that he felt unable to appraise them; they were abstract whereas he was interested in the *object*. I asked about Picasso's recent paintings; he found them too "romantic" in his judgment. His highest enthusiasm was reserved for the Douanier Rousseau: *"Voilà un homme formidable!"* It was Rousseau's dryness that Léger admired. I could also see in his own work a comparable relation to folk art. He had little praise for the High Renaissance, but he admired the Italian primitives, whom he

thought magnificent craftsmen. At art exhibitions he could be briefly communicative. I recall him once in front of a Matisse (laughing): *"Voilà une Matisse bien frisée!"* And (with mock solemnity) before a Dufy: *"A l'ombre de Matisse en fleur!"*

In discussing his own work he was equally laconic. When I suggested that he alone was carrying on the great French classical tradition, he merely shrugged and looked embarrassed. I had begun to realize that Léger's best work projected a monumentality unknown since Seurat. At the same time his art could be very human. Less subjective and more sculptural than that of the actual cubists, it could accommodate humor and satire while maintaining its poised aloofness.

On one occasion he invited me to lunch at his home, along with A. E. Gallatin.* We drove out to the square brick house and were greeted by Mme. Léger, who was charming. She bore an unexpected resemblance to her husband, as well as to the girls in his paintings— except that she was considerably prettier than either, and blonde. She led us to her rose garden in the rear, where Léger was exercising his goat on a leash. He and the goat seemed genuinely fond of each other; he tethered it to a post while Mme. Léger took photographs.

On the street front, two flights of steps led up on either side to a small terrace, where the luncheon table was set. It was very pleasant, except that the house was located on a boulevard where the Métro became an elevated instead of a subway; there was a considerable roar from each passing train, and sparks would almost land in the soup. Léger said he loved this sensation of being immersed in the mechanical world and pushed back his chair in contentment. Suddenly there was an awful vacancy where Léger had been, and I shall never forget that split second when the large soles of his shoes appeared above the red tablecloth. Mme. Léger screamed, *"Qu'est-ce que tu fais, Papa!"* Gallatin and I were frozen with horror; Léger had fallen backward down the flight of steps. We all flew to the rescue, but he had already reappeared sucking his wrist. He sat again at the table and said he

* The late A. E. Gallatin, American painter, was director of the Museum of Living Art, then at New York University, which featured works by Léger and the cubists.

often did that for the amusement of his guests—fortitude worthy of a hero of Verdun!

Several years later Léger visited New York on the occasion of his exhibition at the Museum of Modern Art. He was in high spirits and said he'd like to go to the theater. The hit of the season was *The Cat and the Fiddle* (music by Jerome Kern), so I procured tickets and assembled a few friends. I had never seen him enjoy himself so thoroughly; he was enraptured by the females on stage: "See how this one is the true siren and contrasts with the ingénue, who has had no experience with life." He laughed uproariously at the jokes, although he understood no English; I offered to translate. "Don't bother," he said. "I look only at the *object.*"

The last time we met I was walking on a street in Montparnasse. I heard a noise like a sea lion; it was Léger calling from the opposite curb. We walked together for a few blocks, and he asked me about Gallatin; he said Gallatin seemed so old. After a pause he asked: "How old *is* Gallatin?" I told him. "Mon Dieu," he exclaimed, "just the same age as I am!" Léger added that he wanted to be like the great Italian painters, who kept working—and improving—on into their nineties. He looked so sturdy I was sure he could have his wish. A few months later, in Switzerland, I saw the incredible headline on a newsstand: LE PEINTRE FERNAND LÉGER EST MORT.

GEORGE L. K. MORRIS

New York, 1971

Contents

Illustrations

Introduction

Many of the artists who were the principal creators of twentieth-century styles and movements have left written statements of their ideas: Boccioni, Kandinsky, Malevich, and Le Corbusier were among the more prolific; and even Mondrian and Klee wrote extensively on their art and aesthetic theories. It is one of the paradoxes, however, of the School of Paris that few of its most important figures have written to any significant degree about their art. Picasso has acknowledged only a handful of personal statements, despite the innumerable sayings attributed to him. Among the other artists of the cubist generation only Gleizes and Delaunay produced a substantial body of critical or theoretical writings, and they did so only after their most important work as artists had been accomplished.

Léger not only wrote at length about his own art and the ideas that were important to him but continued to do so during the more than fifty years of his prolific career. His writings, therefore, stand as a major exception to the code of the School of Paris—which seems to have been to paint (or sculpt) one's ideas and not to write about them until after the fact. Léger was, furthermore, almost unique among the leading artists of his generation in his expressed awareness of and concern for the social context of art and for the socioeconomic realities of the world in which he worked. He was perhaps the most *public* artist of his time, not only in his insistence on the social function of his own art and that of his fellow artists, but also in his instinctive

sense of the need to communicate to the world at large by whatever means lay at hand—painting, teaching, films, or the written and spoken word.

The energy that Léger so admired in the modern world, especially in the common people with whom he felt a lifelong bond and identity, is reflected in his unique literary style. Almost impossible to translate directly, it has the rough, condensed, physical quality of the argot spoken by a farmer, or by a worker in blue overalls at the bar of a French café. Never stilted or lost in abstract verbalisms, his language is a verbal equivalent to the plastic vigor of his paintings.

There is a dividing line in Léger's art and thought between the hermetic formalism of his cubist period and the increasingly public concerns of his entire later life. The line can be drawn in his art as early as *The City* (*La Ville*) of 1919, although it was without doubt his experiences in the 1914–18 war that changed his direction both as artist and as artist-in-society. He later explained, in an essay of 1946,[1] that World War I had given him the chance to know his fellow men again and to renew himself through them. Léger's sense of loyalty to the people, to the common man, became the strongest guiding principle of his life. Although he could never be considered sentimental or merely populist, this loyalty moved Léger the artist to say repeatedly that "the people are a poet," meaning that for him the mass of men is as imaginative and as creative as any single artist. It is revealing that Léger's stated preferences in literature were Balzac, Dostoevsky, Walt Whitman, and his own friend Blaise Cendrars;[2] in all these writers he found a corroboration of his instinctive reverence for the genius of ordinary mankind.

In view of Léger's own beginnings as the son of a cattleman in Normandy, the strength of his belief in ordinary men should not be surprising. That he should retain it throughout a long life of worldly success and honor, and with sincerity rather than with lip service, is no less than extraordinary. However, when one views Léger's work and thought in its entirety, it becomes clear that his involvement with cubism and the School of Paris was a brilliant yet limited episode in his life. His artistic achievements during the cubist period still stand as landmarks of early twentieth-century art, and his formal innovations

of those years were to remain constants in his approach to painting. The intellectual and stylistic formalism of his cubist achievements nevertheless receded into a secondary position, subordinate to the public concerns of his mature years as well as to his solidarity with and belief in the working class from which he came.

Léger was never able to find a satisfactory resolution of the conflict between his mastery of cubist high art and his desire that art be put at the service of all men, not just of collectors, connoisseurs, and the culturally privileged, who, he recognized, were thus privileged primarily for social and economic reasons. Much of his thinking in these essays, beginning as early as the 1920s, is devoted to resolving this dilemma. At some point, probably in the middle 1930s, Léger realized that liberal solutions within a bourgeois capitalist society—increased educational opportunities for the working class, more free time, greater accessibility of art to the masses—would not bring about the goal of freeing the individual to develop his creative abilities to the fullest degree. During the late 1930s, at the time of the socialist Popular Front in France, Léger in one of his finest essays[3] made a moving plea to honor those individuals who had been beaten in their struggle against the wrongs and hypocrisies of society. He also acknowledged that collective forces were rising in the society and urged that the individual align himself with them. The crux of Léger's dilemma then appears, for he asserted that the greatest merit any social system can possess is to grant freedom to the creative individual. The dilemma reaches its final point when, in the same essay, Léger, *speaking as an artist*, encouraged the people to liberate themselves socially and to seek cultural enlightenment, adding that "you will find us [the artists] at the end of the road to organize this hard-won leisure." This admission that the artist should act as guide and organizer for the people, even after their freedom is gained, seems to place Léger within the old liberal position; but at the end of the essay Léger turned once more toward his goal: "We [artists] are the present. The future belongs to you [the people]." Seven years later, in 1945, Léger joined the French Communist Party; it was a further logical step in his quest.

Many of the greatest figures in modern French culture had already joined the Party or soon did so. Picasso joined in 1944, and he and

Léger, who were the two most celebrated artists in the Party, soon came into conflict with the official Communist style—socialist realism.[4] This Stalinist solution to the problem of art for the masses in a planned society was obviously no more convincing to Picasso and Léger than was the opposite extreme of cultural elitism and of art used as a means of delectation by the ruling class. That Léger continued to struggle with this dilemma is evident in his later paintings, notably *The Builders* (*Les Constructeurs*) of 1950 and such monumental, virtually mural paintings as *The Great Parade* (*La Grande Parade*) of 1954. The precedent for these works was *The City*, where for the first time the themes of modernity, the machine, the street, and the worker are presented together in a large-scale work. *The Builders* is in many ways a reprise of the earlier painting, although Léger's style had long since moved beyond the cubist vocabulary of flat color planes. In his later paintings Léger accorded much greater importance to subject matter than he had permitted himself as a cubist. During the 1940s and 1950s he consciously chose proletarian subjects—sailors, workers, and such popular amusements as the circus, picnics, bicycle outings, parades—as a means of bridging the gap between his own aesthetic imperatives and his wish to make art accessible to the people *without* resorting to socialist realism. In his painting alone, Léger was unable to go beyond this point toward solving the dilemma of art and the people; though hardly a complete success, his effort was nevertheless more extreme and concerted than that of virtually all of his contemporaries, with the possible exception of Picasso.

Like his art, Léger's writings may be understood as a progressive development of themes, each of which, once stated, joins the body of those previously acquired. By 1914, when Léger's first two essays had been published[5] (both presented originally as lectures), he had long since assimilated the pictorial innovations within the cubism of Picasso and Braque as well as the iconographic and coloristic explorations of his close friend Robert Delaunay, and had devised a personal version of cubist style suited to his own gifts and temperament. Léger's cubism shared with that of Picasso and Braque the common grounds of ultimate indebtedness to Cézanne, avoidance of traditional illusionism and chiaroscuro modeling, the use of flat color planes and planar

overlay, the priority of conception over perception, and in general the depiction of motifs that are potentially observable from a single point in time and space. To these shared cubist elements Léger added his own concerns with visual dynamics. As he explains in his 1913 essay, "The Origins of Painting," the most dynamic and powerful tool available to painting is that of contrast, be it of colors, of flatness and volume, or of straight lines and curves. It was a method that Léger developed brilliantly in his series of paintings entitled *Contrasts of Forms* of 1913–14 and that in modified form he continued to use throughout his life.

Of the other themes that appeared in Léger's writings as early as 1913 and that were to remain with him, the two most important are his love of machines and his infatuation with speed and dynamism—attitudes generally associated with Italian futurism. Léger probably was influenced by futurist ideas during the years 1912 to 1914, but these and similar themes also appear in the pre-1914 paintings of Delaunay and La Fresnaye, with their celebrations of the Eiffel Tower, the airplane, and other characteristic products of modern industrial life. Drawing on his principle of contrast, Léger in his 1914 essay,[6] "Contemporary Achievements in Painting," praised the new experience of nature as seen from a speeding car or train, or the visual impact of an advertising billboard in the midst of a peaceful landscape. Such attitudes on the part of the Italian futurists and their French contemporaries have been aptly characterized as an idolization of modernity on the part of many artists and poets who came to maturity immediately before the disillusionment of World War I.[7]

From this pre-1914 period in his thinking emerge two further ideas of importance both to Léger's own work and to much of the subsequent development of twentieth-century art. In his essays of 1913 and 1914 Léger stressed the formal, visual qualities in painting and their priority over subject matter, declaring the primacy of the painting as *object* rather than as *subject*. This idea, which has its roots in late-nineteenth-century aesthetics, has become the central credo of modernism and a ruling principle not only of abstract art but also of much of the architecture of the twentieth century. Léger is probably the first, however, to formulate the corollary of this principle: *"Each art is isolating itself and limiting itself to its own domain"*[8] (1913). Thus

architecture would restrict itself to concerns that are purely and uniquely architectural, painting would occupy itself only with the concerns of painting, and so on.

This second principle was elevated to the status of critical dogma in post–World War II American art, particularly through the influence of the critic Clement Greenberg on the painting of the 1960s. It is fascinating to see how Léger himself gradually changed his thinking about formalism and the purity of media. As early as 1925, when in both painting and cinema he was creating his most abstract works, Léger could say that specialization in either literature or the plastic arts could produce nothing.[9] In 1935 he still maintained that there was no hierarchy among images in painting and that the human face and body had no greater plastic value than trees, plants, or rocks as elements in a formal composition.[10] By 1945, however, he had concluded that abstract art had reached the end of its development, except for its use either as mural decoration or as pure color in architecture;[11] and in 1952 he went one step further to declare it normal and logical for easel painting to return to "great subjects"[12]—a radical change for Léger, but it was a step he had already taken in many of his post-1945 works.

The year after World War I ended Léger painted *The City*, in which he recapitulated all his old cubist ideas of contrast and formal autonomy. Here also he opened his art to the world outside the studio: the street, the common people, the dynamism of modern urban and mechanized life, and architecture—the themes of his work and thought during the next thirty years. Léger's farewell to the pure world of cubist style came a few years later with his film *Ballet Mécanique* of 1923–24, and with a series of architectonic, and in several instances abstract, compositions of 1924–27. A group of the latter works was exhibited as an integral element in Le Corbusier's Esprit Nouveau Pavilion at the 1925 Paris Exposition of Decorative Arts. It is significant that with these, his last formalist, cubist works, Léger should have turned to media that were quintessentially modern in character and rationale and that continue to be the most public of the plastic arts in the twentieth century.

As early as 1923 Léger declared that as an artist he stood with the

people and not with the bourgeoisie, and he urged other artists to adopt the same position, noting that middle-class tastefulness is fatal to creativity and that most artists emerge from lower-class roots.[13] In 1925 he announced that the artist must go out into the streets for the activity and reality of modern times; there in the street he would see and hear the creativity of the common man, in the shopkeepers' arrangements of their display windows or in the verbal inventiveness of slang.[14] It was at this time also that Léger wrote movingly and eloquently on the traditional dances of the common people in their *bals* (dance halls),[15] as he later eulogized such popular spectacles as the circus[16] and great athletic festivals.[17]

By the 1920s he had learned the hard economic realities of industrial capitalism. His awakening probably came through his experience in cinema, with its problems of financing and the star system; and he soon saw that in time of peace commercial activity could be as much a war as was any military operation.[18] He saw also that, as a result of the existing economic system, monetary values had been assigned to all actions and all objects; everything had become rationalized; and there was no longer anything one could afford to waste or throw away.[19]

It is nevertheless curious and somewhat surprising to encounter at this time (1925), not only Léger's enthusiasm for the dynamism of such a society and its economic equivalent to war, but also his enthusiasm for war itself: "I find the state of war much more normal and more desirable than the state of peace. . . . If I stand facing life, with all its possibilities, I like what is generally called the state of war, which is nothing more than *life at an accelerated rhythm.*"[20] It is in such statements that Léger comes closest to pre-World War I futurist attitudes, as well as revealing his own lingering and almost boyishly energetic naïveté.

With his departure from formalist concerns in the mid-1920s Léger adopted a freer mode of composition in his painting and drew upon a much larger repertory of imagery than that of the cubist studio world. It was a turn already taken by Picasso and other cubists earlier in the decade, and it paralleled the rise of surrealism; but even with the strange assemblages of imagery in his paintings of the 1930s Léger never entered the surrealist world except on the grounds of shared

political beliefs. The strongest motivation for his escape from what Juan Gris had called the "Golden Cage" of cubist thinking was probably his increasing involvement with architecture, beginning in 1925 with his collaboration with Le Corbusier. The Le Corbusier relationship was of undoubted importance to Léger by the end of the decade. In 1928 he lectured on Le Corbusier in Berlin; in 1929 he taught with Le Corbusier's colleague Amédée Ozenfant at the Académie Moderne; and in 1933, he traveled with Le Corbusier to Greece. The results of this friendship are apparent in Léger's writings by the early 1930s, beginning with "The Wall, the Architect, the Painter," a paper delivered in 1933. The inherently social function of architecture seems to have been both a reproof and an opportunity for Léger, the painter in search of an escape from the social limitations of his art.

The solution he arrived at during the 1930s was to put his talents and experience as a painter to serving humanity through collaboration with architects. He soon realized that the fruitful areas for such collaboration were (1) the creation of murals and compositions on either interior or exterior wall surfaces, to be integrated with the overall architectural scheme; and (2) the use of his painter's knowledge of color in relation to architectural space, as well as to the appearance of entire cities. By the mid-1930s Léger was calling for a rebirth of mural art and for the possibility of reordering the subjective perception of architectural interiors by means of pure color.[21] By 1946 he had found confirmation of his ideas in the example of a factory in Rotterdam where the proper use of color had improved the workers' morale (an idea which, with its overtones of Taylorism and cost-efficiency planning, seems alien to Léger's socialist instincts); but Léger at the same time also suggested that various colors be used in hospitals as aids to the stimulation or repose of the patients.[22] In the same essay Léger for the first time explicitly identified easel painting as a form of speculative merchandise, and in 1952 he linked the birth of easel painting in the Renaissance to the simultaneous rise of individualism and capitalism.[23]

As a painter during the 1930s and 1940s, Léger did carry out as far as possible his ideal of a public, mural art, the culmination of which was his mural decoration for the United Nations in New York in 1952. Concurrently he reached a compromise solution for easel painting:

with his works of the 1940s and 1950s, where as noted above he used imagery depicting the lives and pleasures of the common people, he frequently chose to work on a very large and even monumental scale—the final version of *The Great Parade* measures nine by thirteen feet. In these large, late canvases Léger seems not only to have perfected a monumental style but also possibly to have deliberately painted "easel" pictures so large that they would of necessity be destined for public display and would be difficult to treat as portable objects of commerce.

It was as a result of Léger's desire to put his artistic talents, particularly his sense of scale, color, and spectacle, to work in a public setting that he conceived one of the most extraordinary projects in the history of twentieth-century art. In an essay of 1949 he recalls a meeting with Leon Trotsky in Montparnasse during World War I. Léger had suggested that an entire city could be polychromed.[24] Trotsky had been enthusiastic and had envisioned a polychromed Moscow. Léger then reveals that in 1937 he had proposed the following: the 300,000 unemployed in Paris were to be given the job of cleaning all its buildings; by day Paris would thus be pure white. At night, however, the entire city would be bathed in colored light, the whitened buildings serving as screens for projectors, some of which would be stationary while others would be mounted on airplanes flying overhead. The idea was rejected of course, although ironically the buildings of Paris were indeed cleaned almost thirty years later. The greater irony, however, was that something very similar to Léger's idea was utilized in the 1930s, not as imagined by the humane spirit of a great French artist but at the Nazi rallies in Nuremberg, under the direction of Albert Speer.

Léger's stature as a major figure in cubist and postcubist painting will assure his essays a durable importance in the literature of modern art; the sheer volume and diversity of his writings are indications of his energetic fascination and concern with the central cultural issues of the century. Without solving them, he nevertheless located their source: the failure of liberal capitalism to extend cultural as well as political and economic enfranchisement to all members of society. As a product not of the bourgeoisie but of the working class who rose to elite status through his art, Léger could easily have turned his eyes away from the

people, as so many twentieth-century artists have done. Although not taking Rodchenko's ultimate step of proudly renouncing art in order to work for the people, Léger achieved something very similar: he continued the development of his purely artistic abilities while at the same time searching for ways of putting them to human use that would betray neither his own gifts nor his loyalty to his fellow men. It is the hardest of all tasks facing an artist, be he Jacques-Louis David, Tolstoy, Picasso, Tatlin, or Camus, and it is to Léger's honor that his was an exemplary effort among twentieth-century painters.

EDWARD F. FRY

New York, 1972

Notes

1. "Art and the People," 1946, p. 143.
2. "The Machine Aesthetic: Geometric Order and Truth," 1925, p. 62.
3. "Color in the World," 1938, p. 119.
4. Donald Drew Egbert, *Social Radicalism and the Arts—Western Europe* (New York: Knopf, 1970), pp. 346–53.
5. "The Origins of Painting and Its Representational Value," 1913, p. 3; "Contemporary Achievements in Painting," 1914, p. 11.
6. P. 11.
7. See Pär Bergman, *"Modernolatria" et "Simultaneità"* (Uppsala: Svenska Bokforläget/Bonniers, 1962).
8. "The Origins . . . ," 1913, p. 3. Italics Léger's.
9. "The Machine Aesthetic: Geometric Order and Truth," p. 62.
10. "The New Realism," 1935, p. 109.
11. "The Human Body Considered as an Object," 1945, p. 132.
12. "Mural Painting," 1952, p. 178.
13. "Notes on Contemporary Plastic Life," 1923, p. 24.
14. "The Machine Aesthetic: Geometric Order and Truth," p. 62.
15. "Popular Dance Halls," 1925, p. 74.
16. "The Circus," 1950, p. 170.

17. *"The Spartakiades,"* published posthumously in 1960, written probably in 1955, p. 189.
18. "The Spectacle: Light, Color, Moving Image, Object-Spectacle," 1924, p. 35.
19. "The Machine Aesthetic: Geometric Order and Truth," p. 62.
20. *Ibid.* Italics Léger's.
21. "Modern Architecture and Color," 1946, p. 143.
22. *Ibid.*
23. "Mural Painting," p. 178.
24. "A New Space in Architecture," 1949, p. 157. Cf. Léger's essay "Color in the World," 1938, p. 119. There is an important earlier historical precedent, however, in the work of Naum Gabo, who in 1929 designed an unexecuted project for a "fête lumière" in Berlin; see *Gabo*, with introductions by Herbert Read and Leslie Martin (London: Lund Humphries; Cambridge, Mass.: Harvard University Press, 1957), pl. 46.

Chronology

1881	February 4: born in Argentan (Orne)
1897–1899	Apprentice with an architect in Caen
1900–1902	Draftsman with an architect in Paris
1902–1903	Military service in Versailles
1903	Admitted to the École des Arts Décoratifs. Refused by the École des Beaux-Arts, but nevertheless attends the courses given there by Gérôme and Ferrier
1904	Employed in an architect's office, then as a retoucher for a photographer
1905	*My Mother's Garden* (*Le Jardin de ma mère*) painted under the influence of the impressionists
1906–1907	Spends the winter in Corsica. Paints landscapes influenced by the fauves
1907	Sees Cézanne retrospective at the Salon d'Automne
1908–1909	Moves into La Ruche, 2 Passage de Danzig, where he makes friends with Delaunay, Chagall, Soutine, Archipenko, Laurens, Lipchitz, Max Jacob, Reverdy, Apollinaire, Maurice Raynal, and Blaise Cendrars
1909	*Woman Sewing* (*La Couseuse*). Meets Henri Rousseau
1910	*Nudes in the Forest* (*Les Nus dans la forêt*). Exhibits at D. H. Kahnweiler's with Braque and Picasso. *Smoke on the Rooftops* (*Les Fumées sur les toits*)
1912	Exhibits *Woman in Blue* (*La Femme en bleu*) at the Tenth Salon d'Automne. *Smoke* (*La Fumée*)

1913 First contract with Kahnweiler. Lecture: *The Origins of Painting and Its Representational Value* at the Académie Wassiliev

1914 *Village in the Forest (Village dans la forêt)* and *Geometric Elements (Éléments géometriques)*. Lecture: *Contemporary Achievements in Painting* at the Académie Wassiliev. *Composition with Parrots (Composition aux perroquets)*. Mobilized August 2 as a sapper in the Engineer Corps (Argonne Campaign, 1914–1916)

1916 At Verdun. Gassed in September

1917 *The Card Game (La Partie de cartes)*

1918 *Mechanical Elements (Éléments mécaniques)*

1919 *The City (La Ville)*. Marries Jeanne Lohy, December 2

1920 Meets Le Corbusier. *The Luncheon, Large Version (Le Grand Déjeuner)*

1921 Collaborates with Blaise Cendrars on Abel Gance's film *The Wheel*

1922 Curtain, sets, and costumes for *The Creation of the World* for Rolf de Maré's Swedish Ballet

1923 *The Tugboat (Le Grand Remorqueur)*

1923–1924 Makes the first plotless film: *Ballet Mécanique*

1924 Visits Italy, notably the mosaics in Ravenna. Lecture at the Sorbonne: *The Spectacle*. Opens a school with Amédée Ozenfant

1925 Abstract mural paintings for Le Corbusier and Mallet-Stevens at the Exposition of Decorative Arts

1928 Travels to Berlin for the exhibition of his work at the Flechtheim Gallery

1930 *Mona Lisa with Keys (La Joconde aux clés)*

1931 First trip to the United States

1932 *The Bather (La Baigneuse)*

1933 In Zurich for his exhibition at the Kunsthaus; gives a lecture: *The Wall, the Architect, the Painter*. Travels to Greece with Le Corbusier for the Fourth CIAM Congress (discussions with architects)

1934 Lecture at the Sorbonne: *From the Acropolis to the Eiffel Tower*

1935 Second trip to the United States: exhibitions at the Museum of Modern Art in New York and the Chicago Art Institute

1936 Participates in the debates on "The Dispute over Realism" at the Maison de la Culture, with Aragon and Le Corbusier

1937 *The Outburst of Forces* (*Le Transport des forces*), mural for the Palace of Discovery

1938–1939 Third trip to the United States; decorates Nelson Rockefeller's apartment in New York

1939 Sets for Jean Richard Bloch's *The Birth of a City*

1940 Fourth trip to the United States. Teaches at Yale University with Henri Focillon, André Maurois, Darius Milhaud. Begins series of *The Divers* (*Les Plongeurs*)

1945 Returns to France in December. Joins the French Communist Party

1946 Thomas Bouchard's film *Léger in America* (commentary by Fernand Léger). Asked by Father Couturier to do a mosaic for the façade of the church at Assy (Haute-Savoie); finished in 1949

1947 Plays a role in Hans Richter's film *Dreams That Money Can Buy*

1948–1949 *Leisure: Homage to David* (*Les Loisirs: Hommage à David*)

1949 Text and illustrations for *The Circus* (*Le Cirque; Tériade*). Sets and costumes for Darius Milhaud's *Bolivar* at the Paris Opera. First ceramics at Biot (Alpes-Maritimes). Exhibition at the Musée National d'Art Moderne, Paris

1950 Death of Jeanne Léger. *The Builders* (*Les Constructeurs*). Mosaics for the memorial at Bastogne in Belgium

1951 Stained-glass windows for the church at Audincourt (Doubs). Paints many landscapes in Chevreuse

1952 Marries Nadia Khodossevitch, his student since 1924 and assistant in his studio. Mural for the large auditorium of the United Nations Building in New York. Moves to Gif-sur-Yvette

1954 Stained-glass windows for the church at Courfaivre in Switzerland and for the University of Caracas, Venezuela. *The Great Parade (La Grande Parade)*

1955 Travels to Czechoslovakia for the Congress of Sokols in Prague. Exhibition at the Lyons Museum. Exhibition at the Third São Paulo Biennale; wins the Grand Prize. Dies August 17, at Gif-sur-Yvette

1957 February 24: laying of the cornerstone for the Musée Fernand Léger in Biot, founded by Mme. Léger with the collaboration of Georges Bauquier

1960 May 13: opening of the Musée Fernand Léger

1967 October 10: Musée Fernand Léger and its collections donated to the French state. The museum becomes a national museum

1972 January: major retrospective opens at the Grand Palais, Paris

Functions
of Painting

The Origins of Painting and Its Representational Value

Without claiming to explain the aim or the means of an art that is already at a fairly advanced stage of development, I am going to attempt, as far as it is possible, to answer one of the questions most often asked about modern pictures. I put this question in its simplest form: "What does that represent?" I will concentrate on this simple question and, with a brief explanation, will try to prove its utter inanity.

If, in the field of painting, imitation of an object had value in itself, any picture by anyone at all that had any imitative character would have pictorial value. As I do not think it is necessary to insist upon this point or to discuss such an example, I now assert something that has been said before but that needs to be said again here: the *realistic* value of a work of art is completely independent of any imitative character.

This truth should be accepted as dogma and made axiomatic in the general understanding of painting.

I am using the word "realistic" intentionally in its most literal sense, *for the quality of a pictorial work is in direct proportion to its quantity of realism.*

In painting, what constitutes what we call realism?

Definitions are always dangerous, for in order to capture a complete concept in a few words, it is necessary to make a concession, which often sacrifices clarity or is too simplistic.

In spite of everything I will risk a definition and say that, in my

view, pictorial realism is the simultaneous ordering of three great plastic components: Lines, Forms, and Colors.

No work can lay claim to pure classicism, that is, to a lasting quality independent of the period of its creation, if one of those components is completely sacrificed to the detriment of the other two.

I am well aware of the dogmatism of such a definition, but I believe that it is necessary in order to differentiate clearly between the pictures that have classical traits and those that do not.

Every epoch has seen facile productions whose success is as immediate as it is ephemeral, some completely sacrificing depth for the charm of a colored surface, others satisfied with an external calligraphy and form. The latter has even been christened "Painting of Character."

I repeat: every epoch has produced such works, which, despite all the talent they involve, remain simply period pieces. They become dated; they may astonish or intrigue present generations, but since they do not have the components needed to attain to pure realism, they must finally disappear. For most of the painters who preceded the impressionists, the three indispensable components that I mentioned earlier were closely linked to the imitation of a subject that contained an absolute value in itself. Apart from portraits, all compositions—one as decorative as the next—were restricted to the description of great human events illustrating either religious or mythological ideas or contemporary historical facts.

The impressionists were the first to reject the *absolute value of the subject and to consider its value to be merely relative*.

That is the tie that links and explains the entire modern evolution. The impressionists are the great originators of the present movement; they are its primitives in the sense that, wishing to free themselves from the imitative aspect, they considered painting for its color only, neglecting all form and all line almost entirely.

The admirable work resulting from this conception necessitates comprehension of a new kind of color. Their quest for real atmosphere even then treated the subject as relative: trees, houses merge and are closely interconnected, enveloped in a colored dynamism that their methods did not yet allow them to develop.

The imitation of the subject that their work still involves is thus, even then, no more than a pretext for variety, a theme and nothing

more. For the impressionists a green apple on a red rug is no longer the relationship between two objects, but the relationship between two tones, a green and a red.

When this truth became formulated in living works, the present movement was inevitable. I particularly stress this epoch of French painting, for I think it is at this precise moment that the two great pictorial concepts, *visual realism* and *realism of conception*, meet—the first completing its ascent, which includes all traditional painting down to the impressionists, and the second, realism of conception, beginning with them.

The first, as I have said, demands an object, a subject, devices of perspective that are now considered negative and antirealistic.

The second, dispensing with all this cumbersome baggage, has already been achieved in many contemporary pictures.

One painter among the impressionists, Cézanne, understood everything that was incomplete in traditional painting. He felt the necessity for a new form and draftsmanship closely linked to the new color. All his life and all his work were spent in this search.

I will borrow some observations from Émile Bernard's extremely well-documented book about the Master of Aix, and also some thoughts drawn from Cézanne's own conception. "His optics," says Bernard, "were much more in his brain than in his eyes." He overinterpreted what he saw; in short, what he made came completely from his own genius and if he had had creative imagination, he would have been able to spare himself from going to "the motif," as he called it, or from placing still-life arrangements in front of himself. In Cézanne's letters I notice ideas like these: "Objects must turn, recede, and live. I wish to make something lasting from impressionism, like the art in museums"; and further on, he writes something that supports what I said earlier, "For an impressionist, to paint after nature is not to paint the object, but to express sensations." He wept with despair before Signorelli's drawings and exclaimed: "I have been unable to realize, I remain the primitive on the road I have discovered."

In his moments of doubt and depression, Cézanne from time to time reverted to a belief in the necessity of ancient forms. He haunted the museums, he studied the methods of expression of the painters who had preceded him; he made copies, hoping in this way to find what his

restless sensibility sought. His work, beautiful and admirable as it is, frequently bears the mark of this restlessness. He saw the danger of that culture. He understood that it is perilous to look back and that the traditional value of a work of art is personal and subjective. Moreover, he wrote in one of his letters (I quote): "After having looked at the old masters, one must make haste to leave them and to verify in one's self the instincts, the sensations that dwell in us."

This observation by the great painter deserves careful study.

Every painter, when confronting works based on traditional conceptions, must guard his personality. He must look at them, study them, but in a wholly objective way.

He must dominate and analyze them but not be consumed by them; it is the amateur in art who abandons his own personality for one imposed by the work.

The artist must always be in harmony with his own time and in this way counterbalance the entirely natural need for varied impressions.

In the history of modern painting Cézanne will occupy the place that Manet held some years before him. Both were transitional painters.

Manet, through his investigations and his own sensibility, gradually abandoned the methods of his predecessors to arrive at impressionism, and he is unquestionably its great creator.

The more one examines the work of these two painters, the more one is struck by the historical analogy between them.

Manet was inspired by the Spanish, by Velásquez, by Goya, by the most luminous works, to arrive at new forms.

Cézanne finds a color and, unlike Manet, struggles in the pursuit of a structure and form that Manet has *destroyed* and that he feels is absolutely necessary to express the great reality.

All the great movements in painting, whatever their direction, have always proceeded by revolution, by reaction, and not by evolution.

Manet destroyed in order to arrive at his own creative principle. Let us go back further. The painters of the eighteenth century, too sensuous and too mannered, were succeeded by David, Ingres, and their followers, who reacted by excessive use of the opposite formulas.

As this movement ended in an equivalent excess, it made Delacroix necessary. Breaking violently with the preceding notion, he returned to

sensuality in color and to powerful dynamism in forms and drafts-manship.

These examples will be enough to illustrate clearly that the modern concept is not a reaction against the impressionists' ideas but is, on the contrary, a further development and expansion of their aims through the use of methods they neglected.

Divisionism in color, however tentative it was, nevertheless exists in the impressionists' work, and it is being followed not by a static con-trast but by a parallel exploration of divisionism in form and line.

And so the impressionists' work is not the end of a movement, but rather the beginning of another, which is being continued by the mod-ern painters.

The relationships among volumes, lines, and colors will prove to be the springboard for all the work of recent years and for all the influ-ence exerted on artistic circles both in France and abroad.

From now on, everything can converge toward an intense realism obtained by purely dynamic means.

Pictorial contrasts used in their purest sense (complementary colors, lines, and forms) are henceforth the structural basis of modern pic-tures.

As was true of painters before the impressionists, northern artists will still tend to seek their dynamic means through the development of color while southern painters will probably give great importance to forms and lines.

This understanding of contemporary painting, born in France, is founded on a universally valid concept that permits the development of all sensibilities; the Italian futurist movement is one proof of this. Logically the picture is going to become larger, and output must be limited.

Every dynamic tendency must inevitably move toward an enlarge-ment of the means in order to be able to achieve its full expression.

Many people are patiently awaiting the end of what they call *a phase* in the history of art; they are waiting for *something else*, and they think that modern painting is passing through a stage, a necessary one perhaps, but that it will return to what is commonly called "painting for everyone."

This is a very great mistake. When an art like this is in possession of

all its means, which enable it to achieve absolutely complete works, it is bound to be dominant for a very long time.

I am convinced that we are approaching a conception of art as comprehensive as those of the greatest epochs of the past: the same tendency to large scale, the same collective effort. This last remark warrants lengthy consideration. It is important.

Most French literary and artistic movements have generally manifested themselves in the same way. It is proof of their great vitality and the power of dissemination. One may cast doubt on an isolated creative work, but the vital proof of its validity is established when it is translated collectively into very distinct means of personal expression.

The sentimental notion in plastic art is certainly the one closest to the heart of the great majority. The old masters, besides achieving purely plastic qualities, were obliged to satisfy this need with their pictures and to fulfill a complex social task. They had to assist architecture in its popular expressiveness and provide literary values suitable to instruct, educate, and amuse the people. To this end they illustrated churches, public buildings, and palaces with decorative frescoes and pictures representing the great deeds of humanity. Descriptive quality was a necessity of the age.

For painters, living like everyone else in an age neither more nor less intellectual than preceding ones, merely different, in order to impose a similar way of seeing and to destroy everything that perspective and sentimentalism had helped to erect, it was necessary to have something else besides their audacity and their individual conception.

If the age had not lent itself to this—I repeat, if their art had not had an affinity with its own time and had not been an evolution deriving from past epochs—it would not have been able to survive.

Present-day life, more fragmented and faster moving than life in previous eras, has had to accept as its means of expression an art of dynamic divisionism; and the sentimental side, the expression of the subject (in the sense of popular expression), has reached a critical moment that must be clearly defined.

In order to find a comparable period, I will go back to the fifteenth century, the time of the culmination and decline of the Gothic style. During this entire period, architecture was the great means of popular

expression; the basic structure of cathedrals had been embellished with every lifelike ornament that the French imagination could discover and invent.

But the invention of printing was bound to revolutionize and change totally these means of expression.

I quote the famous passage from Victor Hugo's *Hunchback of Notre-Dame*, from the chapter "This Will Kill That":

"In the fifteenth century, human thought discovered a way of perpetuating itself not only more durable and more lasting than architecture but also simpler and easier: Orpheus's letters of stone were replaced by Gutenberg's letters of lead.

"The book is going to kill the building."

Without attempting to compare the present evolution, with its scientific inventions, to the revolution brought about at the end of the Middle Ages by Gutenberg's invention, in the realm of humanity's means of expression, I maintain that modern mechanical achievements such as color photography, the motion-picture camera, the profusion of more or less popular novels, and the popularization of the theaters have effectively replaced and henceforth rendered superfluous the development of visual, sentimental, representational, and popular subject matter in pictorial art.

I earnestly ask myself how all those more or less historical or dramatic pictures shown in the French Salon can compete with the screen of any cinema. Visual realism has never before been so intensely captured.

Several years ago one could still argue that at least moving pictures lacked color, but color photography has been invented. "Subject" paintings no longer have even this advantage; their popular side, their only reason for existence, has disappeared, and the few workers who used to be seen in museums, planted in front of a cavalry charge by M. Detaille or a historical scene by M. J.-P. Laurens, are no longer there; they are at the cinema.

The average bourgeois also—the small merchant who fifty years ago enabled these minor local and provincial masters to make a living—now has completely dispensed with their services.

Photography requires fewer sittings than portrait painting, captures a likeness more faithfully, and costs less. The portrait painter is dying

out, and the genre and histarial painters will die out too—not by a natural death but killed off by their period.

This will have killed that.

Since the means of expression have multiplied, plastic art must logically limit itself to its own purpose: *realism of conception.* (This was born with Manet, developed by the impressionists and Cézanne, and is achieving wide acceptance among contemporary painters.)

Architecture itself, stripped of all its representational trimmings, is approaching a modern and utilitarian conception after several centuries of false traditionalism.

Architectural art is confining itself to its own means—the relationship between lines and the balance of large masses; the decorative element itself is becoming plastic and architectural.

Each art is isolating itself and limiting itself to its own domain.

Specialization is a modern characteristic, and pictorial art, like all other manifestations of human genius, must submit to its law; it is logical, for by limiting each discipline to its own purpose, it enables achievements to be intensified.

In this way pictorial art gains in realism. The modern conception is not simply a passing abstraction, valid only for a few initiates; it is the total expression of a new generation whose needs it shares and whose aspirations it answers.

Montjoie!, Paris, 1913

Contemporary Achievements in Painting

Contemporary achievements in painting are the result of the modern mentality and are closely bound up with the visual aspect of external things that are creative and necessary for the painter.

Before tackling the purely technical questions, I am going to try to explain why contemporary painting is representative, in the modern sense of the word, of the new visual state imposed by the evolution of the new means of production.

A work of art must be significant in its own time, like any other intellectual manifestation. Because painting is visual, it is necessarily the reflection of external rather than psychological conditions. Every pictorial work must possess this momentary and eternal value that enables it to endure beyond the epoch of its creation.

If pictorial expression has changed, it is because modern life has necessitated it. The existence of modern creative people is much more intense and more complex than that of people in earlier centuries. The thing that is imagined is less fixed, the object exposes itself less than it did formerly. When one crosses a landscape by automobile or express train, it becomes fragmented; it loses in descriptive value but gains in synthetic value. The view through the door of the railroad car or the automobile windshield, in combination with the speed, has altered the habitual look of things. A modern man registers a hundred times more sensory impressions than an eighteenth-century artist; so much so that our language, for example, is full of diminutives and abbreviations.

The compression of the modern picture, its variety, its breaking up of forms, are the result of all this. It is certain that the evolution of the means of locomotion and their speed have a great deal to do with the new way of seeing. Many superficial people raise the cry "anarchy" in front of these pictures because they cannot follow the whole evolution of contemporary life that painting records. They believe that painting has abruptly broken the chain of continuity, when, on the contrary, it has never been so truly realistic, so firmly attached to its own period as it is today. A kind of painting that is realistic in the highest sense is beginning to appear, and it is here to stay.

A new criterion has appeared in response to a new state of things. Innumerable examples of rupture and change crop up unexpectedly in our visual awareness. I will choose the most striking examples. The advertising billboard, dictated by modern commercial needs, that brutally cuts across a landscape is one of the things that has most infuriated so-called men of . . . good taste. It has even given rise to a stupefying and ridiculous organization that pompously calls itself "The Society for the Protection of the Landscape." Can anyone imagine anything more comic than this high court of worthy men charged with solemnly decreeing that such and such a thing is appropriate in the landscape and another thing is not? By this reckoning, it would be preferable to do away with telegraph poles and houses immediately and leave only trees, sweet harmonies of trees! . . . The so-called men of good taste, the cultivated people, have never been able to stomach contrast. There is nothing worse than habit, and you will find the same people who protest with conviction in front of the billboard writhing with laughter at the Salon des Indépendants in front of modern pictures, which they are incapable of swallowing, like the rest of the public.

And yet, this yellow or red poster, shouting in a timid landscape, is the best of possible reasons for the new painting; it topples the whole sentimental literary concept and announces the advent of plastic contrast.

Naturally, in order to find in this break with time-honored habits a basis for a new pictorial harmony and a plastic means of dealing with life and movement, there must be an artistic sensibility far in advance of the normal vision of the crowd.

In the same way, modern means of locomotion have completely upset relationships that have been taken for granted since time immemorial. Formerly a landscape had a value in itself, and a white and quiet road could cross it without changing the surroundings at all.

Now the railroads and the automobiles, with their plumes of smoke or dust, seize all the dynamic force for themselves, and the landscape becomes secondary and decorative.

Posters on the walls, flashing advertising signs—both are the same order of ideas. They have led to a formula as ridiculous as the Society mentioned above has ever cited: "Post No Bills."

A lack of comprehension of everything new and alive is what has brought out these wall policemen. Also, those interminable walls of governmental and other buildings are the saddest and most sinister surfaces I know of. The poster is a piece of modern furniture that painters immediately knew how to use. It is bourgeois taste again that one finds in these rules, the taste for monotony that they drag around with them everywhere. The peasant resists these mollifications; he has retained a taste for violent contrasts in his costume, and a poster in his field does not upset him.

In spite of this resistance, the old-fashioned costume of the towns has had to evolve with everything else. The black suit, which contrasts with the bright feminine outfits at fashionable gatherings, is a clear manifestation of an evolution in taste. Black and white resound and clash, and the visual effect of present-day fashionable parties is the exact opposite of the effect that similar social gatherings in the eighteenth century, for example, would have produced. The dress of that period was all in the same tones, the whole aspect was more decorative, less strongly contrasted, and more uniform.

Evolution notwithstanding, the average bourgeois has retained his ideas of tone on tone, the decorative concept. The red parlor, the yellow bedroom, will, especially in the provinces, continue to be the last word in good form for a long time. Contrast has always frightened peaceful and satisfied people; they eliminate it from their lives as much as possible, and as they are disagreeably startled by the dissonances of some billboard or other, so their lives are organized to avoid all such uncouth contact. This milieu is the last one an artist should frequent;

truth is shrouded and feared; all that remains is manners, from which an artist can seek in vain to learn something.

In earlier periods, the utilization of contrasts could never be fully exploited for several reasons. First, the necessity for strict subservience to a subject that had to have a sentimental value.

Never, until the impressionists, had painting been able to shake off the spell of literature. Consequently, the utilization of plastic contrasts had to be diluted by the need to tell a story, which painters have now recognized as completely unnecessary.

From the day the impressionists liberated painting, the modern picture set out at once to structure itself on contrasts; instead of submitting to a subject, the painter makes an insertion and uses a subject in the service of purely plastic means. All the artists who have shocked public opinion in the last few years have always sacrificed the subject to the pictorial effect. Even Delacroix (and that puts us even further back in history) was extremely controversial because, in spite of his burden of literary romanticism, he succeeded in bringing off paintings like *The Entry of the Crusaders into Jerusalem*, where the subject is clearly dominated by plastic expression; he was never accepted by qualified people and officials.

This liberation enables the contemporary painter to use these means in dealing with the new visual state that I have just described. He must prepare himself in order to confer a maximum of plastic effect on means that have not yet been so used. He must not become an imitator of the new visual objectivity, but be a sensibility completely subject to the new state of things.

He will not be original just because he will have broken up an object or placed a red or yellow square in the middle of his canvas; he will be original by virtue of the fact that he has caught the creative spirit of these external manifestations.

As soon as one admits that only realism in conception is capable of realizing, in the most plastic sense of the word, these new effects of contrast, one must abandon visual realism and concentrate all the plastic means toward a specific goal.

Composition takes precedence over all else; to obtain their maximum expressiveness, lines, forms, and colors must be employed with the utmost possible logic. It is the logical spirit that will achieve the

greatest result, and by the logical spirit in art, I mean the power to order one's sensibility and to concentrate one's means in order to yield the maximum effect in the result.

It is true that if I look at objects in their surroundings, in the real atmosphere, I do not perceive any line bounding the zones of color, of course; but this belongs to the realm of visual realism and not to the wholly modern one of realism in conception. To try deliberately to eliminate specific means of expression such as outlines and forms except for their significance in terms of color is childish and retrograde. The modern picture can have lasting value and escape death not by excluding some means of expression because of a prejudice for one alone but, on the contrary, by concentrating all the possible means of plastic expression on a specific goal. Modern painters have understood that; before them, a drawing had one special value, and a painting had another. From now on, everything is brought together, in order to attain essential variety along with maximum realism. A painter who calls himself modern, and who rightly considers perspective and sentimental value to be negative methods, must be able to replace them in his pictures with something other than, for instance, an unending harmony of pure tones.

This is an utterly inadequate justification for a picture of even average size and even less for pictures several square meters in area, like those seen at the last Salon des Indépendants—this is the enlargement of scale by the neoimpressionist formula.

This concept, which consists of using direct contrast between two tones in order to avoid a dead surface, is unproductive in the construction of a large-scale picture. Construction by means of pure color has long been considered to have reached a perfect neutrality and evenness. It is what I call "additional" painting as opposed to "multiplicative painting," which I will try to define further on.

The impressionists, being sensible men, felt that their somewhat meager means did not permit composition on the grand scale; they kept within established bounds. A big picture requires variety and consequently the addition of methods other than those of the neoimpressionists.

Contrasts of tones can be summed up by the ratio 1 and 2, 1 and 2, infinitely repeated. The ideal use of the formula would be to apply it

throughout, and this would lead us to a canvas divided into a number of equal planes in which tones of equal and complementary value are set against one another. One picture composed in this way can astonish us for a while, but ten of them inevitably produce monotony.

In order to achieve construction through color, it is essential that from the point of view of value (for in the end that is all that counts) the two tones should balance, i.e., neutralize each other; if the green plane, for instance, is more important than the red plane, there is no longer any construction. You can see where that leads. The neoimpressionists tried it a long time ago, and it is old-fashioned to go back to it.

By employing all the pictorial means of expression, composition through multiplicative contrast not only allows a greater range of realistic experience, but also ensures variety; in fact, instead of opposing two means of expression in an immediate cumulative relationship, you compose a picture so that groups of similar forms are opposed by other contrary groupings. If you distribute your color in the same way, that is, by adding similar tones, coloring each of these groupings of forms in contrast with the tones of an equivalent addition, you obtain collective sources of tones, lines, and colors acting against other contrary and dissonant sources. Contrast = dissonance, and hence a maximum expressive effect. I will take as an example a commonplace subject: the visual effect of curled and round puffs of smoke rising between houses. You want to convey their plastic value. Here you have the best example on which to apply research into multiplicative intensities. Concentrate your curves with the greatest possible variety without breaking up their mass; frame them by means of the hard, dry relationship of the surfaces of the houses, dead surfaces that will acquire movement by being colored in contrast to the central mass and being opposed by live forms; you will obtain a maximum effect.

This theory is not an abstraction but is formulated according to observations of natural effects that are verified every day. I purposely did not take a so-called modern subject because I do not know what is an ancient or modern subject; all I know is what is a new interpretation. But locomotives, automobiles, if you insist, advertising billboards, are all good for the application of a form of movements; all this

research comes, as I have said, from the modern environment. But you can advantageously substitute the most banal, worn-out subject, like a nude in a studio and a thousand others, for locomotives and other modern engines that are difficult to pose in one's studio. All that is method; the only interesting thing is how it is used.

In many of Cézanne's pictures one can see, barely hinted at, this restless sensitivity to plastic contrasts. Unfortunately, and this corroborates what I just said, his thoroughly impressionist milieu and his period, which was less condensed and less fragmented than ours, could not lead him as far as the multiplicative concept; he felt it but he did not understand it. All his paintings were done in the presence of a subject, and in his landscapes, with the houses awkwardly flattened out among the trees, he had sensed that the truth lay there. He could not formulate it and create the concept of it. To abandon this discovery, which is an assurance of development and a first step into the creative, and go back to neoimpressionism, which is a last stage and an ending, is, I say, an error that must be denounced. Neoimpressionism has said all it has to say; its curve was extremely short—in fact it was a very small circle, in which nothing of value remains.

Seurat was one of the great victims of this mediocre formula in many of his pictures, and he wasted a great deal of time and talent by confining himself to that small touch of pure color which actually has no color at all, for the question of power in the effect of coloration must also be clarified. When you use tonal contrast as a source of dynamic mobility in order to eliminate local tone, your color theoretically loses some of its power; a yellow and a violet contrasted in equal volume are constructive, of course, but only at the expense of the power of color, which has an intrinsic value that is no longer respected; the optical mix is gray. Only local tone has its maximum coloration. Only the system of multiplicative contrasts permits one to use it; consequently the neoimpressionist formula arrives at the paradoxical but certain end of employing pure tones to arrive at a gray entity.

Cézanne, I repeat, was the only one of the impressionists to lay his finger on the deeper meaning of plastic life, because of his sensitivity to the contrasts of forms.

I will stop these technical explanations here, but I do not want to

end this explanation without answering some objections that have been made on the subject of the Salon des Indépendants.

It would be a banality to try to justify this Salon here, but I insist on answering the objections made by people who certainly have forgotten the purpose of the Salon.

The Salon des Indépendants which, as in every year, has occupied a preponderant place in worldwide exhibitions of painting, is first of all a salon of painters for painters. As a result, the people who come there looking for perfectly realized works will find nothing for themselves. They are completely mistaken about the aim of the exhibitors. Others have criticized the fact that painters of yesterday's avant-garde abandon the Salon today and no longer exhibit their pictures there. People believe that there are more or less self-serving motives involved, which is absolutely false. Anyone who thinks this has forgotten that the Salon is first and foremost a salon for artists' exhibits. It is the greatest in the whole world (and I am not exaggerating when I use such terms).

Its perpetual renewal is exactly what gives it its *raison d'être*—unlike the other salons where one sees the same painters' work again and again.

Here, there must always be room for the seekers and their restlessness, and credit for this must be given to the artists definitively in possession of their expressive methods who yield their place to younger artists who need to see their work hung in relation [to their contemporaries]. If all the painters who led the battle at the Indépendants continued to occupy the rooms (which would certainly be attractive), it would be to the detriment of younger artists and would prevent the new manifestations from appearing.

The Salon des Indépendants is a salon of amateurs. When painters have mastered their means of expression, when they have become professionals, they no longer have anything to do there. This Salon could become like all the others: a salon for sales, meant for buyers.

Its perpetual element of newness is what provokes universal interest; it is the one thing which may be allowed to act as a kind of eternal "sliding gear" whose itinerant existence gives it new life every year, instead of diminishing it. Whatever direction the Salon may take, it will always have its public of the curious and of painters. Everyone

important in modern art has shown there, all those artists who search and work, hoping to be exhibited there. Paris should be proud to be the place chosen for this great pictorial exhibition. These shabby rooms in cloth and wood have seen more talent hatched than all the official museums together. It is the Salon of Inventors and along with the follies that will never bear fruit are works of several painters who will be the pride of their period. It is the single place bourgeois good taste has not been able to penetrate; it is the big ugly salon, and it is very fine. There are no rugs to trample, and one catches head colds along with the pictures, but never have so much emotion, life, suffering, and pure joy been piled together in such an unpretentious place.

In order to know what it is, one must have exhibited there during one's youth; trembling, at the age of twenty, one must have taken one's first sketches there. The hanging of pictures, the lighting, the opening, that brutal illumination that hits you and leaves nothing in shadow; all those unknown things that, at a single blow, rout your sensibility and your timidity. One remembers it all one's life. You bring there everything you hold most precious. The bourgeoisie who come to laugh at these palpitations would never suspect that there is a full-fledged drama being played out with all its joys and its stories. If they were aware of it, they would enter with respect as if into a church, for at heart they are decent men.

Soirées de Paris, Paris, 1914

A Critical Essay on
the Plastic Quality of
Abel Gance's Film *The Wheel*

Abel Gance's film involves three states of interest that continually alternate: a dramatic state, an emotional state, and a plastic state. It is this entirely new plastic contribution whose real value and implications for our time I shall struggle to define precisely.

The first two states are developed throughout the whole drama with mounting interest. The third, the one that concerns me, occurs almost exclusively in the first three sections, where the mechanical element plays a major role, and where the machine becomes *the leading character, the leading actor*. It will be to Abel Gance's honor that he has successfully presented an *actor object* to the public. This is a cinematographic event of considerable importance, which I am going to examine carefully.

This new element is presented to us through an infinite variety of methods, from every aspect: close-ups, fixed or moving mechanical fragments, projected at a heightened speed that approaches the state of simultaneity and that crushes and eliminates the human object, reduces its interest, pulverizes it. *This mechanical element* that you reluctantly watch disappear, that you wait for impatiently, is unobtrusive; it appears like flashes of a spotlight throughout a vast, long heartrending tragedy whose realism admits no concessions. The plastic event is no less there because of it, it's nowhere else; it is planned, fitted in with care, appropriate, and seems to me to be laden with implications in itself and for the future.

The advent of this film is additionally interesting in that it is going to determine a place in the plastic order for an art that has until now remained almost completely descriptive, sentimental, and documentary. The fragmentation of the object, the intrinsic plastic value of the object, its pictorial equivalence, have long been the domain of the modern arts. With *The Wheel* Abel Gance has elevated the art of film to the plane of the plastic arts.

Before *The Wheel* the cinematographic art developed almost constantly on a mistaken path: that of resemblance to the theater, the same means, the same actors, the same dramatic methods. It seems to want to turn into theater. This is the most serious error the cinematographic art could commit; it is the facile viewpoint, the art of imitation, the imitator's viewpoint.

The justification for film, its only one, is *the projected image*. This image that, colored, but unmoving, captures children and adults alike —and now it moves. The moving image was created, and the whole world is on its knees before that marvelous image that moves. But observe that this stupendous invention does not consist in imitating the movements of nature; it's a matter of something entirely different; it's a matter of *making images seen*, and the cinema must not look elsewhere for its reason for being. Project your beautiful image, choose it well, define it, put it under the microscope, do everything to make it yield up its maximum, and you will have no need for text, description, perspective, sentimentality, or actors. Whether it be the infinite realism of the close-up, or pure inventive fantasy (simultaneous poetry through the moving image), the new event is there with all its implications.

Until now America has been able to create a picturesque cinematographic fact: film intensity, cowboy plays, Douglas,* Chaplin's comic genius, but there we are still beside the point. It is still the theatrical concept, that is, the actor dominating and the whole production dependent on him. The cinema cannot fight the theater; the dramatic effect of a living person, speaking with emotion, can not be equaled by its direct, silent projection in black and white on a screen. The film is beaten in advance; it will always be bad theater. Now let us consider only the visual point of view. Where is it in all this?

* Léger is probably referring to Douglas Fairbanks here.—Ed.

Here it is: 80 percent of the elements and objects that help us to live are only noticed by us in our everyday lives, while 20 percent are *seen*. From this, I deduce the cinematographic revolution is *to make us see everything that has been merely noticed*. Project those brand-new elements, and you have your tragedies, your comedies, on a plane that is uniquely visual and cinematographic. The dog that goes by in the street is only noticed. Projected on the screen, it is seen, so much so that the whole audience reacts as if it discovered the dog.

The mere fact of projection of the image already defines the object, which becomes spectacle. A judiciously composed image already has value through this fact. Don't abandon this point of view. Here is the pivot, the basis of this new art. Abel Gance has sensed it perfectly. He has achieved it, he is the first to have presented it to the public. You will see moving images presented like a picture, centered on the screen with a judicious range in the balance of still and moving parts (the contrast of effects); a still figure on a machine that is moving, a modulated hand in contrast to a geometric mass, circular forms, abstract forms, the interplay of curves and straight lines (contrasts of lines), dazzling, wonderful, a moving geometry that astonishes you.

Gance goes further, since his marvelous machine is able to produce the fragment of the object. He gives it to you in place of that actor whom you have *noticed* somewhere and who moved you by his delivery and his gestures. He is going to make you *see* and move you in turn with the face of this phantom whom you have no more than *noticed* before. You will see his eye, his hand, his finger, his fingernail. Gance will make you see all this with his prodigious blazing lantern. You will see all those fragments magnified a hundred times, making up an absolute whole, tragic, comic, plastic, more moving, more captivating than the character in the theater next door. The locomotive will appear with all its parts: its wheels, its rods, its signal plates, its geometric pleasures, vertical and horizontal, and the formidable faces of the men who live on it. A nut bent out of shape next to a rose will evoke for you all the tragedy of *The Wheel* (contrasts).

In rare moments scattered among various films, one has been able to have the confused feeling that there must be the truth. With *The Wheel* Gance has completely achieved *cinematographic fact*. Visual fragments collaborate closely with the actor and the drama, reinforce

them, sustain them, instead of dissipating their effect, thanks to its *masterful composition*. Gance is a precursor and a fulfillment at the same time. His drama is going to mark an epoch in the history of cinema. His relationship is first of all a technical one. He absorbs objects and actors; he never submits to means that ought not to be confused with the desired end. In that above all his superiority over the American contribution resides. The latter, picturesque and theatrical in quality, in bondage to some talented stars, will fade as the actors fade. The art of *The Wheel* will remain, armed with its new technique, and it will dominate cinematographic art in the present and in the future.

Comœdia, Paris, 1922

Notes on
Contemporary Plastic Life

In 1918–19, I was severely criticized for having tackled the mechanical element as a plastic possibility.

I am eager to put the thing in focus, and although I may have been the first to employ this modern element for pictorial ends, I do not have the slightest intention of claiming that "that's all there is to it."

The mechanical element is *only a means and not an end*. I consider it simply plastic "raw material," like the elements of a landscape or a still life.

But in accord with the individual's plastic purpose, in accord with an artist's need for the real element, I think that the mechanical element is extremely advisable for anyone who seeks *fullness and intensity in a work of art*.

A picture, as I understand it, which must equal and surpass the industrial "beautiful object" in beauty, must be an "organic occurrence," like the object in question, like every manifestation of human intellectual achievement. Every objective human creation is dependent on absolute geometric laws. Every human plastic creation is in the same relationship.

The relationship of volumes, lines, and colors demands absolute orchestration and order. These values are all unquestionably influential; they have extended into modern objects such as airplanes, automobiles, farm machines, etc. Today we are in competition with the "beautiful object"; it is undeniable. Sometimes its plastic qualities

make it beautiful in itself and consequently unusable; one can only fold one's arms and admire it. There is also today an astonishing art of window display. Certain store windows are highly organized spectacles that are no longer raw material at all and become *unusable*.

If, pushing things to extremes, the majority of manufactured objects and "store spectacles" were beautiful and had plasticity, we artists would no longer have any reason to exist. There is a need for beauty scattered around in the world. It is a question of quantity and demand. It is a matter of satisfying it.

Now I realize that we are still very useful "as producers."

Manufactured objects *rarely* compete on the level of the beautiful.

This is the current situation. But what about the future? It is a rather new and disturbing situation. Personally, I will do my best to get over it through a plastic style that is natural to me while searching for *the state of plastically organized intensity*.

For that, I apply the law of contrasts, which is external as a method of creating an equivalence to life and the only one that has enabled men such as Shakespeare and Molière and others to transcend their epoch and attain lasting significance.

Instead of opposing comic and tragic characters and contrary scenic states, I organize the opposition of contrasting values, lines, and curves.

I oppose curves to straight lines, flat surfaces to molded forms, pure local colors to nuances of gray. These initial plastic forms are either superimposed on objective elements or not, it makes no difference to me. There is only a question of variety.

Here I think I can dominate the situation, for I reach a "multiplicative" state, which it is difficult for any manufactured object to achieve, since its ends are strictly useful.

Notice that in painting of the past there are inclinations toward contrasts, especially in the work of the primitives (the opposition of figures to architecture—Giotto—and later in Poussin). But the subject itself made them deal with this idea. It is the chance effect of a subject and not a plastic will to organization.

Besides, I recognize that modern life is often in a state of contrasts and makes this task easier. The most common example is the harsh,

sharp advertising billboard, with violent colors and lettering, that cuts across a melodious landscape. The soft smoke rising over a harsh mechanistic environment or out of modern architecture also produces a clash of contrasts. All these events are subjects to paint. I am now, I think, closely linked to my own time by my style. But why the outcry as soon as I touched on the mechanical element several years ago? Let us look at how painting began. I think blue sky was discovered and then the white clouds in it, then the trees below; then houses were built, someone painted the houses, and then roads with telegraph poles; all that was painted, and then modern industry created machines, so why at this moment of human evolution would they come and say: "Stop there, you have no right to paint that, to use that"? It is absurd.

Art is subjective, that is understood, but a controlled subjectivity based on "objective" raw material. That is my absolute opinion.

Plastic work is "the ambiguous state" of these two values, *the real* and *the imagined*. The difficulty is to find a balance between these two poles; to cut the difficulty in two and take only one or the other, to make either pure abstractions or imitations of nature, is really too easy and avoids the problem as a whole.

The question of "raw material" in art is extremely serious.

Many artists get lost because of their warped initial instincts, which mislead them in the choice of raw material.

Usable raw material is around us everywhere. It is simply a question of hitting on the right thing.

One does not work with overused elements. The modern street with its colorful elements, its lettering, has very often served me (for me, it is raw material). The Douanier Rousseau frequently used photographs and postcards. The means are everywhere, *it is simply a matter of choice*.

The enormous mistake of the Renaissance painters and of the officials of the École des Beaux-Arts is to run after the "beautiful subject." It is the fundamental error that still continues and the one against which we modern artists react above all. If an object, a subject, is beautiful, it is no longer raw material; it has plastic value and is therefore unusable; one can only look at and admire it. It is not even

"copiable." The experience of it is complete. Put fifty copyists in front of the same model in the same light and then look what they do. *Not one is alike.* Philosophically, it can be deduced from this that nothing exists in itself, that everything is relative. The beautiful subject is now irreparably condemned. It is not raw material.

So we find ourselves, from force of circumstance, in a state of invention and equivalence, and plastic truth is there only. All inventive epochs are beautiful; the others do not exist.

Subtlety lies in making distinctions, for being inventive can come very close to being imitative. Certain primitives, and pictures by Ingres, by David, for example, are very close to being imitative.

There the amateur's difficulty over the destruction of the subject equals the artist's difficulty over the choice of raw material. We touch on the realm of sensibility there. We leave the debatable intellectual spheres behind for an obscure situation where the most justifiable, most acute criticism no longer has influence. *That makes me rejoice.* For it is a safeguard that, in a time as fierce and analytical as ours, criticism may not, with proof and microscope in hand, invade this impenetrable sanctuary. This preserves life and makes it worth having lived.

For if one day a monster really arrives to predict the future to us and dissect a picture as if it were an insect, then that day will really be "the end of the world."

For moral and intellectual health in life, I also think that creators must at all costs avoid soft environments (the average bourgeois, the worn-out aristocracy). There is nothing to gain and everything to lose from feeding on those people; the mechanism of their existence is based on a "minimum of life." Not much effort or diversion, that is all. They adore the state of peace in the wrong sense of the word. Their spectacles and diversions are always "pretty good," never really terrible or really good. One cannot exist in a state of the "pretty good." The lower-class environment, with its aspects of crudeness and harshness, of tragedy and comedy, always hyperactive, is the environment recommended for us. For my part, I live in these places as much as possible and find I am happy there.

Kunstblatt, Berlin, 1923

Notes on
the Mechanical Element

Here are some further notes about my personal work (especially in connection with the mechanical element and the use of contrasts).

I was criticized severely (in 1918) for having tackled the mechanical element as a plastic possibility. I am eager to put things in focus.

Although I may have been the first to employ this modern element for pictorial ends, I have no intention of shouting from the roof tops that "that's all there is to it."

The mechanical element, like everything else, is *only a means, not an end.*

But if one wants to do powerful work that has toughness and plastic intensity, if one wants to do organic work, if one wants to create and obtain the equivalent of the "beautiful object" sometimes produced by modern industry, it is very tempting to make use of its elements as raw material.

A picture organized, orchestrated, like a musical score, has geometric necessities exactly the same as those of every objective human creation (commercial or industrial achievement).

There are the weight of masses, the relationship of lines, the balance of colors. All the things that require an absolute order. All those values influence the contemporary commercialized object—sometimes (rarely) in plastic realizations. When this happens, nothing is left to do but to fold one's arms and admire. But most of the time, these values are diffused, as in a landscape or a still life. Then, the painter's

contribution comes into play and he organizes, he imposes his order on disorder. He creates, he reaches a balance.

The situation at the present moment is tragic enough. The artist is "in competition" with the useful object, which is sometimes beautiful. Or at least fascinating. He must create as well or better. Geometric relationships, volumes, lines, and colored surfaces (airplanes, automobiles, farm machinery, all commercial objects, etc. . . .) can be beautiful; that is *absolutely indisputable*.

If they were always beautiful, there would no longer be any reason for the role of the artist to exist. There are window displays, absolutely perfect modern compositions, impossible to make use of; they are no longer raw material but finished works. It becomes then a question of numbers, for if this production answered human demand, there would be nothing left to do. They answer a need, they retail art.

I repeat, in the face of these objects, the artist's situation is often disturbing.

I myself hope to escape from this by searching for a state of organized intensity.

In order to find it, I apply the law of plastic contrasts, which I think has never been applied until today. I group contrary values together; flat surfaces opposed to modeled surfaces; volumetric figures opposed to the flat façades of houses; molded volumes of plumes of smoke opposed to active surfaces of architecture; pure, flat tones opposed to gray, modulated tones or the reverse.

Between these two kinds of relationships, which are eternal subjects for painting, I look for a relationship of intensity never before achieved.

Earlier artists have always been bothered by what subject to represent. Many have had a vague sense of the value of plastic contrasts. None of them was able to dominate his subject matter enough to apply these values fully, that is, to distort the subject if it were necessary for the plastic result.

From this principle, it follows that I can make a solid representational picture, one that is distorted, or even abstract, and each will result in the same intensity and force.

In this way, I attain *an intensive organized state,* and I am certainly beyond most of the commercial phenomena (industrial products). It is

extremely rare for useful items to participate in such a relationship to the extent that they compete in terms of Beauty with my will to organization through contrast. These achievements depend on observation of modern life. We live *in a geometric world, it is undeniable, and also in a state of frequent contrasts*. The most striking example of this is the advertising billboard—sharp, permanent, immediate, violent—that cuts across the tender and harmonious landscape. A contemporary fashionable party contrasts the men's severe, crisp black clothes with the prettier and more delicately colored dresses of the women. An epoch of contrasts.

An eighteenth-century party was simply tone on tone, all the clothes were similar. An epoch of harmony.

So I am consistent with my own time, and when all is said and done, the result is what counts. As a method, any way is good.

The first painters began perhaps by painting the sky, then the clouds, then the trees, then the houses, then the line of the first road, then the telegraph pole and the car on that road. Why, at this point in human evolution, would people want to cry "Stop there!" to a man who is using the mechanical element? Why? What justifies this action? It is absurd. Art is subjective, of course, but it is a controlled subjectivity built on objective raw material.

The work of art is the *ambiguity* between these two elements. To arrive at a fixed state, an enduring state that is not too far to the right, not too far to the left, but in the middle, is extremely difficult. There must be perfect balance between the artist's instinct and his control. The romantic pushes toward the left—an excess of subjectivity (a warm state). His opposite pushes toward the right—an excess of objectivity (a cold state).

<div style="text-align: right;">Unpublished, 1923</div>

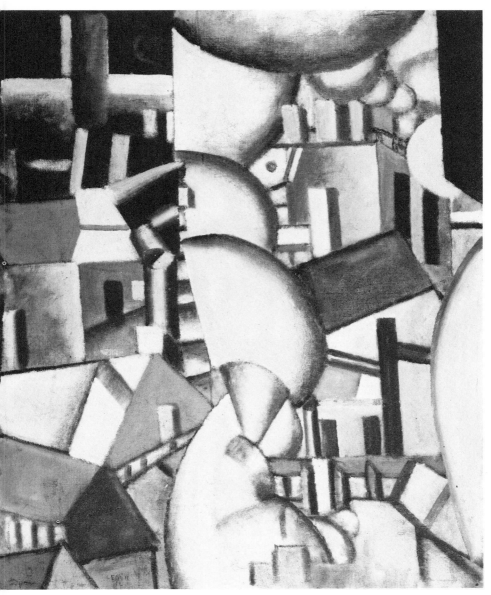

Smoke (*La Fumée*), 1912. Oil on canvas, 36¼″ × 28¾″. Albright-Knox Art Gallery, Buffalo, New York. Room of Contemporary Art Fund.

The City (La Ville), 1919. Oil on canvas, 91″ × 117½″. A. E. Gallatin Collection, Philadelphia Museum of Art. (*Photograph by A. J. Wyatt, Staff Photographer.*)

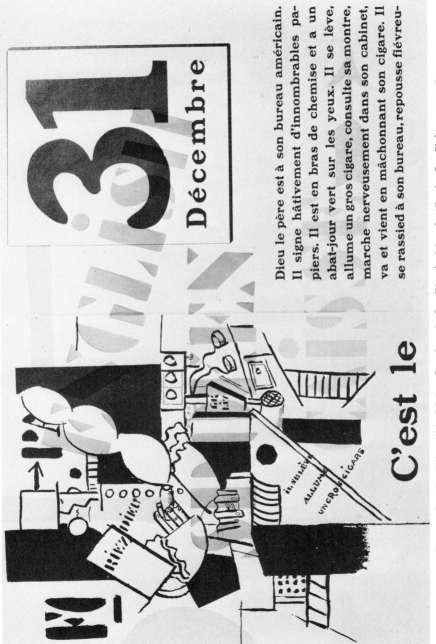

Illustration by Léger for Blaise Cendrars's *La Fin du Monde* (Paris: La Sirène, 1919). (*Photograph courtesy The Museum of Modern Art, New York.*)

Costume sketches by Léger for Rolf de Maré's ballet *La Création du Monde*, 1922.

The Spectacle:
Light, Color, Moving Image,
Object-Spectacle

To have to talk about spectacle is to imagine the world in all its daily visual manifestations (it has become one of the fundamental needs of existence). It dominates all contemporary life.

The eye, the major organ of a thousand responsibilities, controls the individual more than ever. It ceaselessly records from morning to night. It must be quick, accurate, subtle, infallible, and precise.

Speed is the law of the modern world. The eye must "be able to choose" in a fraction of a second or it risks its existence, whether it be driving a car, in the street, or behind a scholar's microscope.

Life rolls by at such a speed that everything becomes mobile.

The rhythm is so dynamic that a "slice of life" seen from a café terrace is a spectacle. The most diverse elements collide and jostle one another there. The interplay of contrasts is so violent that there is always exaggeration in the effect you glimpse.

On the boulevards two men are carrying some immense gilded letters in a handcart; the effect is so unexpected that everyone stops and looks. *There is the origin of the modern spectacle.* The shock of the surprise effect. To organize a spectacle based on these daily phenomena, the artists who want to distract the crowd must undergo a continual renewal. It is a hard profession, the hardest profession.

There must be a constant state of choice and invention. Happily, our modern means are increased tenfold thanks to daily inventions.

Objects, lights, the colors that used to be fixed and restrained have become alive and mobile.

Previously, and around us, the human element dominates the stage; it asserts itself everywhere as entertainment value, from the dazzling dancer who dominates the stage with her talent to the erotic music-hall groups. But the superrevues, with their constant race for something new, have worn out, have coarsened, the already limited means at their disposal.

They have "touched bottom." The spring is dried up.

We are at the end of a crisis.

Let us try to act with newer, brand-new materials.

A spectacle must be fast-moving for the sake of its unity. It cannot go on for more than fifteen or twenty minutes. Let us look at this short time span for "new materials."

We have found what we are competing with; we must renew the man-spectacle mechanically. We can make the materials themselves move, set them in action.

Industry and commerce, swept along in a frantic competitive race, have been the first to grab everything that could serve as an attraction. They admirably sensed that a shop window, a department store must be a spectacle. They had the idea of creating a pervasive, persuasive atmosphere by using only the objects at their disposal. A woman who goes into the store is half won over; she must buy, she will buy because her defenses are destroyed by the "shopkeeper's brilliant trick."

It's a spell, a fascination, knowingly manipulated. The stores want a victim; they often have one. The lighted colored display counter is the one that does the most business.

The Catholic religion has also known how to make use of these methods to steer men according to its instructions. Possessing wonderful churches, it has pushed the art of the spectacle very far; it has subjugated the masses, through masterly and deliberate direction of its interior and exterior cult manifestations.

The church understood long ago that man is drawn instinctively to the brilliant, luminous colored object. It adopted music and song. If it has imposed itself on the world, that is because it has not neglected any of the visual and auditory means of its epoch.

Overwhelmed by the enormous stage set of life, what can the artist who aspires to conquer his public do? He has only one chance left to take: to rise to the plane of beauty by considering everything that

surrounds him as raw material; to select the plastic and theatrical values possible from the whirlpool that swirls under his eyes; to interpret them in terms of spectacle; to attain theatrical unity and dominate it at any price. If he does not rise enough, if he does not reach the higher plane, he is immediately in competition with life itself, which equals and surpasses him. *There must be invention, at any cost.*

Adapting to fashion is inferior and very far from dealing with the problem to be solved. I adapt, you adapt, he adapts—that is the elegant formula, the minimum effort, the established position. Present-day life never adapts; it creates unceasingly, every morning, good or bad, but it invents. If adaptation is defensible from the point of view of theater, it is not defensible as spectacle.

Nowadays there is no place on the vast stage of the world as good as the public stage, but it is restricted to inventors, and is not for arrangers.

Commercial endeavors are so competitive that a procession of models at a good couturier's equals and even surpasses a number of average stage shows in entertainment value.

There has never been an epoch as frantic for spectacle as ours. The rush of the masses toward the screen or the stage is an unending phenomenon. In lower-class districts seats are reserved in advance.

This frenzy, this craving for distraction at any price, must arise from a need for reaction against the harshness and demands of modern life.

It is a harsh, prosaic, precise life: the microscope is trained on everything; the object, the individual is gone into thoroughly, examined from every angle. Time, measurement, are taken seriously; everything is now measured in seconds and millimeters. There is such a race for perfection that inventive genius is pushed to its extreme limits. An epoch that has resulted from an instructive war in which every value was stripped bare, and there was a total revision of moral and material values. Human endurance was tested and pushed to the maximum. After four years of this paroxysm, modern man finds himself on a social plane that is not peace; he finds himself on another plateau where economic war leaves him no room to breathe. It is another state of war as lamentable as the first.

As long as the economic revolution does not give man the hoped-for new equilibrium, as long as he is a victim of the machine instead of being its beneficiary, we will witness that daily phenomenon of people hurrying and scrambling to go to work, to eat, who at night rush to a spectacle in order to try to find distraction from their daily exhaustion. They go there like moths to the light, fascinated, with a kind of intoxication that stands between that of the bistros and that of the drug addicts, also impelled by an obscure feeling, scarcely perceptible but certain—a need for Beauty, to which I will return in a little while.

What is going to be offered to meet this enormous demand?

The music halls, circuses, revues, ballet companies, and gatherings of high or low society are the fields of action (the theater, properly speaking, being outside my subject). However, I will mention Jules Romains's *Six Gentlemen in a Row* as one of the most original theatrical manifestations.

What did one see before our period?

The classical theater was above all theatrical; their means were gesture, declamation, melodrama. As a plastic method, what interests us and moves us is their use of masks; they invented the mask.

The mask dominates classical theater, and the most primitive peoples use it as a means of creating spectacle. They realized, with their weak methods, that on stage the human resemblance was a barrier to the lyric state, the state of astonishment.

They wanted to transform the face.

I am going to do my best to tie in this event because it is one of the important points of this lecture.

[The mask was devised] to make a break between the visual atmosphere of a room and that of the stage, to make the individual disappear in order to utilize human material, to create fiction on the stage. The human material appeared, but it had the same spectacle value as the object and the decor.

Our present methods are manifold, of course, but on one condition, I repeat, that the individual-as-king is really willing to become a means like the rest. The star artist, with or without the necessary talent, is a frequent obstacle to unity. He has all our sympathy, this dancer who, for centuries, "did everything necessary" to elicit the

enthusiasm of the audience, but in spite of all his genius, he doesn't have a thousand different ways to smile, to turn, to fling out his leg, to leap. So after all is said and done, he has had his day. If only all these talented artists would humbly consent to look around, to think of means that would enable them to renew themselves; they will always have their place on stage, they will glitter there, but if only they would look at the human document; daily life full of plastic facts would help them and there would be no need for them to go and "absorb" from the museums.

Why won't they accept the lesson of the acrobats, the simple, humble acrobats? There are more "plastic passages" in ten minutes of an acrobatic spectacle than there are in many scenes of ballet. Now ask the leading dancers to do a cartwheel or to walk on their hands, or even to do a somersault; they all lack quickness. Yet what a wealth of stage effects are to be found there. To be polite, that is the main part of the program. They certainly know that there is grace and charm around us, everywhere, in the street, from the top to the bottom of the houses; they sense that there may be a plane of entertainment there made up of charm and grace, and that has nothing to do with the eternal balletic movements and a pretty smile.

If only they would decide to be choreographers, rather than star performers, if they would agree to become part of a spectacle "with equal billing," if they would accept the role of "moving scenery," if they themselves would direct the advent of the spectacle-object, then a number of entirely new methods would appear that up to now have remained "in the wings." Then you would have the mechanism for unexpected plastic qualities that will be able to come into play and animate the stage.

Let's trace the problem to its origin. We have a dead auditorium, dull and dark. Thirty percent of the audience are people who are inattentive, cold, difficult to reach. In front of them is a stage; between them and the stage there is a neutral, dangerous space, difficult to cross—the footlights; it is an obstacle that nevertheless must be crossed, in order to create the atmosphere indispensable to all entertainment, in order to go and ensnare the gentleman who came to get away from it all.

In order to reach that point, there must be a maximum of stage

effects; the axiom that "the state of the stage must be *inversely propor-tional to the state of the auditorium*" must be proved.

Let's push the system to the extreme. Let's order that what is on the stage must be a complete invention.

The auditorium = immobility, darkness, silence.

The stage = light, movement, life.

I say a stage of total invention.

You will never again see on my stage the nose of that gentleman who offended you on the bus or the profile of the blonde lady who makes you jealous.

The individual has disappeared. He becomes a moving part of scenery, or . . . he goes behind the scenes to manage the new theater of the beautiful object.

Please notice that several music-hall artists have felt the spectacle-object's importance. They surround themselves with it; acrobats and jugglers pay attention to it and improve it, but always behind the performer, in the background.

Their set, as limited as it may be, counts for half the spectacle-effect.

The "Big Top" of the New Circus is an absolutely marvelous world. When I am lost in this astonishing metallic planet with its dazzling spotlights and the tiny acrobat who risks his life every night, I am distracted. In spite of his dangerous game, prescribed by the cruelty of a certain public that has dined well and sends him puffs from their cigars, I forget him. I am looking at the spectacle that is all around him. I no longer see the flushed faces. I am caught up by the strange architecture of colored tent poles, metallic rods, and ropes that cross each other and sway under the effect of the lights.

Keep looking at this event. Draw from it consequences from the viewpoint of attraction.

Very gently make the "little fellow" disappear. I swear to you that the stage will not be empty, for we are going to make *the objects act*.

Let's take a stage with the minimum of depth. Keep to the vertical plane as much as possible; watch in hand, time the length of action (the mechanics of a gesture, a spotlight, or a sound). A plastic movement that is effective for ten seconds becomes poor if it lasts for

twelve. The background scenery is movable. The action begins: six actors, "moving scenery," cross the stage turning cartwheels (a lighted stage); they come back, now phosphorescent (on a dark stage). The top of the set is animated by films projected on it—décor for the moving backdrop, it disappears—the apparition of the beautiful, luminous metallic object, it shifts and disappears. Controlled activity of a whole stage where pleasing, extraordinary surprises and unexpected things are continually at play, woven together, and multiplied at the pleasure of the director. If a face appears, it may be stiff, fixed, frozen, rigid, as if it were metal. The human face can play its part, but its "expressiveness" is absolutely null in the spectacle-stage. Heavily made up or masked, transformed, with set gestures, it can contribute variety, but nothing more. Human material may be used in groups moving in a parallel or contrasting rhythm, on the condition that the general effect is in no way sacrificed to it.

These methods in action ought to cross the footlights to create the atmosphere, take over the theater, and conquer the audience, for if it is logical, if it has a sense of what it wants, it must be satisfied.

Nothing on the stage resembles the rest of the theater. A complete transposition, a new fairyland, is created, a whole new and unexpected world evolves before them.

They are the blind who have suddenly been healed by a magic wand; enchanted, they see a spectacle that they have never seen before.

If it wants to, the modern stage can go this far; we have the means to do it. The public will follow, it has followed; proof is there. The public is better than we think it is, but between the public and the director there is often an important obstructive character—the producer or the impresario—who, often, misunderstands his public and warps everything. They are not all like that, fortunately. Jacques Hébertot is a fabulous director, and I want to pay homage here to Rolf de Maré, the director of the Swedish Ballet, who was the first person in France to have the courage to agree to a spectacle where everything is done with machinery and the play of light, where no human silhouette is on the stage; and to Jean Borlin and his troupe, who are condemned to the role of moving scenery.

In agreeing to perform the Negro ballet *Creation of the World*

(*Création du Monde*) he dared to impose on the public for the first time a truly modern stage, at least in terms of technical means. His effort was rewarded with success. The public immediately went along with him completely, while most of the official critics lost themselves in irrelevant remarks. As French propaganda his work was influential. His creations, eight or ten of which were done by artists of the French avant-garde, have gone around the world. He came back from America, where, in spite of the huge difficulties such a trip entails, he will have been the first to have risked and presented over there an entirely French program. There have to be foreigners such as Rolf de Maré and Serge de Diaghilev to recognize the vital French quality in order to present it to the world.

I have heard that there is a propaganda department in Paris. What has it done? Has it ever made contact with these courageous men who risk enormous amounts of capital without for once being "businessmen"? I don't think so. What did this propaganda department do? What was its staff doing during and after the war? Is there a document somewhere that reveals their heroism?

But in spite of this, everything progresses; in spite of this lamentable negligence, life goes on, and change rushes forward. Cinema came, with its limitless plastic possibilities—an incredible invention, fraught with plastic consequences that unfortunately are often blocked because of a completely wrong point of departure.

Filming a novel is a fundamental mistake, one that results from the fact that most of the directors have a literary background and education.

In spite of their unquestionable talent, they are caught between a scenario that must remain a means and the moving image that must be the end. They often confuse the two things. They sacrifice that wonderful thing, "the image that moves," in order to present a story that is much better in a book. It is still that deadly "adaptation" that is so easy and stops all innovation. Nevertheless, their means are infinite, unlimited; they have this amazing power to personify, to give a complete life to a fragment. The close-up is their alphabet, they can give plastic identity to a detail. It is such a field of innovations that it is unbelievable they can neglect it for a sentimental scenario. Where the fantasies of lyrical imagery can come into play, they show

us famous novels adapted for the screen. They, too, adapt "with might and main"; they are already the victims of the least possible effort.

The average calculation goes like this:

To make a film, you must have money.

To get it, let's take Joan of Arc or Napoleon, characters who have a certain historical notoriety, let's get a famous actor, who is really famous in Paris, as our star, and we're off. It will be "amortized"; we will make a good business deal, and it won't be any trouble. The movie is already made. The monetary viewpoint dominates everything. As a result of this, the cinema is awful, and it is even dangerous for the Princes of the Screen, for they ought to consider that, by debasing the cinematic art to this level, they have no defense against competition. On that plane, anyone with an average intelligence can become a screen ace.

They will be thrown overboard, drowned by the "spontaneous hatching" of mediocre competitors who invade the marketplace. If they had the courage to raise the artistic level above the average possibilities, they would be authentic and invulnerable kings. But they submit to the backer who is terrified about his money. They are dominated by him and by the monstrous star who demands 5,000 francs a week for her pretty face or dubious fame.

We are currently in a frantic mess of millions spent for ridiculous historical productions.

Still it should be possible to have a cinema without millions and without stars. It is an effort that should be made. But on that day it would be necessary for directors to accept at their side a nice unpretentious fellow with plastic training, who from time to .time quietly says to them: "This image a little to the right, a little to the left, that slow group a little faster, this charming person is really seen too much. Stay with black and white. Enough literature, the public is sick of it. No perspective, why all these subtitles? So are you incapable of making a story without subtitles, with nothing but the image? But cartoonists have done it on the back page of a newspaper. That's what you must manage and a lot of other things that we'll see about later, and then good cinema is on the way."

Let's recognize this:

The French screen has contributed the only truly plastic achievement that has been presented so far.

Abel Gance, assisted by Blaise Cendrars in *The Wheel* (*La Roue*), Jean Epstein in *The Faithful Heart* (*Coeur fidèle*), Marcel L'Herbier in *Gallery of Monsters* (*Galerie de monstres*) and *The Inhuman* (*L'Inhumaine*), Moujoskine in *Keim,* have all obtained, achieved, and successfully presented plastic emotion to the public through the simultaneous projection of "fragments of images" in an accelerated rhythm. They have achieved an equivalent plane through absolutely new technical means; Gance and Cendrars's exploding train, Epstein's street carnival, L'Herbier's circus and laboratories, Moujoskine's jig are the reasons for the success of their films. It is plasticity, it is the image alone that acts on the spectator, and he submits to it, is moved, and conquered. It is a beautiful victory—achieved before an audience that has reacted to and applauded for something other than a sentimental literary intrigue.

The new values are making progress everywhere. The stage and the screen are gradually being liberated.

Spectacle, properly speaking, changes, and we imagine the next advent of new possibilities.

The Eiffel Tower and the Great Wheel, those two enormous "object-spectacles" that dominate Paris, are as much admired as the beautiful Gothic façades.

Everyone regretted the disappearance of the Great Wheel; it was a familiar silhouette. It was better than the Eiffel Tower because of its form. An entire object whose initial form is the circle is always much sought after for its value of attractiveness.

The wheel, lighted and colored, dominates the street carnivals.

The circle is satisfying to the human eye. It is a totality, a whole, there is no break in it.

The ball, the sphere, have enormous possibilities as plastic values.

Put a sphere or a ball—never mind what material it is made of—in your apartment. It is never unpleasant and always will fit in wherever it may be. It is the beautiful object with no other purpose than what it is.

We live surrounded by beautiful objects that are slowly being revealed and perceived by man; they are occupying an increasingly important place around us, in our interior and exterior life.

Cultivate this possibility, release it, direct it, extend its consequences.

So that as early as elementary school, children may be taught to admire beautiful manufactured objects.

The collapse of religions has caused a void that spectacle and sensualism cannot fill.

Our eyes, closed for centuries to the true realistic Beauty, to the objective phenomena that surround us, are beginning to open up. Something is ending; something else is beginning. We are at the crossroads, in transition—a thankless, cruel epoch, where every mistake and reaction can operate. But out of all this confused throng of desires and mistakes a sure possibility appears—the cult of the Beautiful. Here I agree with the theories dear to Ozenfant; the demand for the Beautiful is everywhere daily, urgent and undeniable.

Let us be aware of our daily actions; concern for the Beautiful fills three-quarters of everyday life.

From our need to arrange the room we live in, to the discreet arrangement of a lock of hair under a hat, the desire for harmony penetrates everywhere. Don't think, for example, that taste in clothes concerns young people alone. Go into the shop of a little dressmaker in the provinces. Have the patience to watch all through a fitting that a local businesswoman is having. To get the effect she wants, she will be more meticulous, more exacting than the most elegant Parisian. This stout, fifty-year-old lady, she too wants to achieve a harmony that is appropriate for her age, her environment, and her means. She too organizes her spectacle so that it will make its effect where she thinks necessary; she hesitates between the blue belt and the red one, indicates her choice, and accordingly worries about "the Beautiful." Let us help all those who display nothing more than indifference and routine observance for the old, outdated religions, let us work for them: relief is coming. Don't stop denouncing those officials of the École des Beaux-Arts and the others, useless and ridiculous, who are bent on restoring departed times and who plagiarize from them badly.

Those grotesque societies for the protection of the French landscape who presume to stop life and to prevent Cadum Baby* or Brand-X Pills

* Picture used by a toiletry company that advertised widely on billboards in Paris at this time.—Tr.

from being inserted into a landscape—but what is a landscape? Where does it begin and end? What court is presumptuous enough to define the elements that make it up?

Let's frankly discard this queer antiquated little world and look with fully opened eyes at contemporary life as it rolls along, shifts, and brims over beside us.

Let us try to dam it up, to channel it, organize it plastically.

An enormous job, but possible.

The hypertension of contemporary life, its daily assault on the nerves, is due at least 40 percent to the overdynamic exterior environment in which we are obliged to live.

The visual world of a large modern city, that vast spectacle that I spoke of in the beginning, is badly orchestrated; in fact, not orchestrated at all. The intensity of the street shatters our nerves and drives us crazy.

Let's tackle the problem in all its scope. Let's organize the exterior spectacle. This is nothing more or less than creating "polychromed architecture" from scratch, taking in all the manifestations of current advertising.

If the spectacle offers intensity, a street, a city, a factory ought to offer an obvious plastic serenity.

Let's organize exterior life in its domain: form, color, light.

Let's take a street; ten red houses, six yellow houses. Let's exploit beautiful materials—stone, marble, brick, steel, gold, silver, bronze; let's avoid dynamism completely. A static concept must be the rule; all the commercial and industrial necessities will be developed, instead of being sacrificed—a constant anxiety in society.

Color and light have a social function, an essential function.

The world of work, the only interesting one, exists in an intolerable environment. Let us go into the factories, the banks, the hospitals. If light is required there, what does it illuminate? Nothing. Let's bring in color; it is as necessary as water and fire. Let's apportion it wisely, so that it may be a more pleasant value, a psychological value; its moral influence can be considerable. A beautiful and calm environment.

Life through color.

The polychromed hospital.

The colorist-doctor.

The leprous, glacial hospital is dressed up in multicolor.

We are not in the realm of vague prophecies; we are coming very close to tomorrow's realities.

A society without frenzy, calm, ordered, knowing how to live naturally within the Beautiful without exclamation or romanticism.

That is where we are going, very simply.

It is a religion like any other. I think it is useful and beautiful.

Bulletin de l'Effort Moderne, Paris, 1924

Ballet Mécanique

Ballet Mécanique dates from the period when architects talked about the machine civilization. There was a *new realism* in that period that I myself used in my pictures and in this film. This film is above all proof that machines and fragments of them, that ordinary manufactured objects, have plastic *possibilities*.

There are not only natural elements such as the sky, the trees, and the human body; all around us are things man has created that are our new realism. The day that public taste accepted a house in a landscape was the beginning. A house is not a natural element, so there is no reason to pause and then set about replacing the noble *subject* with the *object* which is the current plastic problem. In this film, in the midst of the quest for new realism, there are elements of repose, distraction, and contrast. The film has been shown several times all over the world. It has unquestionably influenced the development of modern film (in Russia and Germany), the *art of window display,* and the development of photographic collections where geometric and mechanical elements are explored.

The fact of giving *movement* to one or several objects can make them plastic. There is also the fact of recognizing a plastic event that is beautiful in itself without being obliged to look for what it represents. To prove this, I once set a trap for some people. I filmed a woman's polished fingernail and blew it up a hundred times. I showed

it. The surprised audience thought that they recognized a photograph of some planetary surface. I let them go on believing that, and after they had marveled at this planetary effect and were talking about it, I told them: *"It is the thumbnail of the lady next to me."* They went off feeling angry. I had proved to them that the subject or the object is nothing; it's the effect that counts.

The story of avant-garde films is very simple. It is a direct reaction against the films that have scenarios and stars.

They offer *imagination and play* in opposition to the commercial nature of the other kind of films.

That's not all. They are *the painters' and poets' revenge.* In an art such as this one, where *the image must be everything* and where it is sacrificed to a romantic anecdote, the avant-garde films had to defend themselves and prove that *the arts of the imagination,* relegated to being accessories, could, all alone, through their own means, construct films without scenarios by treating *the moving image* as *the leading character.*

Naturally, the creators of these films have never intended to make them available to the public at large for commercial profit. All the same, there is a minority of people in the world who are for us; it is more numerous than one might think, and it prefers quality to quantity.

Whether it is *Ballet Mécanique,* somewhat theoretical, or a burlesque fantasy like *Entr'acte* by Francis Picabia and René Clair, the goal is the same: *to avoid the average,* to be free of the *dead weight* that constitutes the other films' reason for being. To break away from the elements that are not purely cinematographic, to let the imagination roam freely despite the risks, to create adventure on the screen as it is created every day in painting and poetry.

Our constraints are self-imposed; little money, little means.

The grasping financier who presides over the big commercial films is disgraceful. When Von Stroheim spends a fortune to make *Greed,* that marvelous and so little known film, so much the better; but 99 percent of the films that are turned out do not warrant these enormous expenditures. Money is *antiart,* an excess of technical means is *antiart.* Creative Genius is used to living with constraints; it knows all about that, and the greatest works generally spring from poverty.

All artistic decadence arises from overabundance.

To know *how to deal with constraints* in the midst of abundance is a rare talent.

It's difficult to be rich.

The cinema is in danger of dying from it. In its gilded theaters with its silver stars, it doesn't even take the trouble to think up its own stories; it pirates from the theater, it copies plays. Then you can imagine for yourself that the recruitment of the human material necessary for these enterprises isn't difficult. Anybody will do. I take a well-known play. I add a well-known star. I mix, I shake gently, and I bring out one of those little *Boulevard Paramount* masterpieces that I'm sure you'll find first-rate.

Right now everyone is wondering when the Commercial Cinema is going to collapse. The average theatrical production is less contemptible. It is sustained by a kind of tradition and by the vanity of the actor who, in front of the footlights in flesh and blood, "gives it everything he's got." If he is weak one night, the next night he redeems himself. The cinema is a mechanism that affords *no second chances.*

I am going to say a little about *Ballet Mécanique.* Its story is simple. I made it in 1923 and 1924. At that time I was doing paintings in which the active elements were *objects* freed from all atmosphere, put in new relationships to each other.

Painters had already *destroyed the subject,* as the descriptive scenario was going to be destroyed in avant-garde films.

I thought that through film this neglected *object* would be able to assume its value as well. Beginning there, I worked on this film, I took very ordinary objects that I transferred to the screen by giving them a very deliberate, very calculated mobility and rhythm.

Contrasting objects, slow and rapid passages, rest and intensity—the whole film was constructed on *that.* I used the close-up, which is the only cinematographic invention. Fragments of objects were also useful; by isolating a thing you give it a personality. All this work led me to consider the event of objectivity as a very new contemporary value.

The documentaries, the newsreels are filled with these beautiful "objective facts" that need only to be captured and presented properly. We are living through *the advent* of the object that is thrust on us in *all those shops that decorate the streets.*

A herd of sheep walking, filmed from above, shown straight on the screen, is like an unknown sea that disorients the spectator.

That is objectivity.

The thighs of fifty girls, rotating in disciplined formation, shown as a close-up—that is beautiful and *that is objectivity.*

Ballet Mécanique cost me about 5,000 francs, and the editing gave me a lot of trouble. There are long sequences of repeated movements that had to be cut. I had to watch the smallest details very carefully because of the repetition of images.

For example, in "The Woman Climbing the Stairs," I wanted to *amaze* the audience first, then make them uneasy, and then push the adventure to the point of exasperation. In order to "time" it properly, I got together a group of workers and people in the neighborhood, and I studied the effect that was *produced* on them. In eight hours I learned what I wanted to know. *Nearly all of them reacted at about the same time.*

"The Woman on the Swing" is a *post card* in *motion.* To get the material for it, I also had complications. It's very hard to rent straw hats, artificial legs, and shoes. The shopkeepers took me for a madman or a practical joker.

I had put all my materials in a chest. One morning I noticed that someone had filched all my junk. I had to pay for everything and this time buy other materials.

An epoch alive with exploration, risk, which perhaps is ended now. It continues through animation, which has limitless possibilities for giving scope to our imagination and humor. It has the last word.

Unpublished (c. 1924)

The Machine Aesthetic:
The Manufactured Object,
the Artisan, and the Artist

Modern man lives more and more in a preponderantly geometric order.

All mechanical and industrial human creation is subject to geometric forces.

I want to discuss first of all the *prejudices* that blind three-quarters of mankind and totally prevent it from making a free judgment of the beautiful or ugly phenomena that surround them.

I consider plastic beauty in general to be completely independent from sentimental, descriptive, and imitative values. Every object, picture, architectural work, and ornamental arrangement has an intrinsic value that is strictly absolute, independent of what it represents.

Many individuals would be *unintentionally* sensitive to beauty (of a visual object) if the preconceived idea of the *objet d'art* did not act as a blindfold. Bad visual education is the cause of it, along with the modern mania for classifications at any price, for categorizing individuals as if they were tools. Men are *afraid of free will,* which is, after all, the only state of mind possible for registering beauty. Victims of a critical, skeptical, intellectual epoch, people persist in wanting to understand instead of giving in to their sensibilities. "They believe in the *makers of art,*" because these are professionals. Titles, honors dazzle them and obstruct their view. My aim is to try to lay down this notion: that there are no categories or hierarchies of Beauty—this is the worst possible error. The Beautiful is everywhere; perhaps more in

the arrangement of your saucepans in the white walls of your kitchen than in your eighteenth-century living room or in the official museums.

I would, then, bring about a new architectural order: *the architecture of the mechanical.* Architecture, both traditional and modern, also originates from geometric forces.

Greek art made horizontal lines dominant. It influenced the entire French seventeenth century. Romanesque art emphasized vertical lines. The Gothic achieved an often perfect balance between the play of curves and straight lines. The Gothic even achieved this amazing thing: moving architectural surfaces. There are Gothic façades that shift like a dynamic picture. It is the play of complementary lines, which interact, set in oppposition by contrast.

One can assert this: a machine or a machine-made object can be beautiful when the relationship of lines describing its volumes is balanced in an order equivalent to that of earlier architectures. We are not now confronting the phenomenon of a new order, properly speaking; it is simply one architectural manifestation like the others.

Where the question becomes most subtle is where one imagines mechanical creation with all its consequences, that is, its *aim.* If the goal of earlier monumental architecture was to make Beauty predominate over utility, it is undeniable that in the mechanical order the dominant aim is *utility,* strictly utility. Everything is directed toward utility with the utmost possible rigor. *The thrust toward utility does not prevent the advent of a state of beauty.*

I offer as a fascinating example the case of the evolution of automotive form. It is even curious because of the fact that the more the car has fulfilled its functional ends, the more beautiful it has become. That is, in the beginning, when vertical lines dominated its form (which was then contrary to its purpose), the automobile was ugly. People were still looking for the horse, and automobiles were called horseless carriages. When, because of the necessity for speed, the car was lowered and elongated, when, consequently, horizontal lines balanced by curves became dominant, it became a perfect whole, logically organized toward its purpose; and it was beautiful.

This evidence of the relationship between the beauty and utility of the car does not mean that perfect utility automatically leads to per-

fect beauty; I deny it until there is a conclusive demonstration to the contrary. I have seen frequent examples, though I cannot offhand recall them now, of the loss of beauty through the accentuation of function.

Chance alone governs beauty's occurrence in the manufactured object.

Perhaps you regret the loss of fantasy; the state of geometric coldness that has not agreed with you is offset by the play of light on bare metal. Every machine object possesses two qualities of materials: one, often painted and light-absorbent, that remains static (an architectural value), and another (most often bare metal) that reflects light and fills the role of unlimited fantasy (pictorial value). So it is light that determines the degree of variety in the machine object. Another aspect of color leads me to consider a second plastic occurrence connected with the machine: *the occurrence of polychromed mechanical architecture.*

Here, certainly, we find ourselves witnessing the birth of a fairly obscure, but nevertheless definite plastic taste: *a rebirth of the artisan* or, if you prefer, the birth of a new artisan.

The absolutely indispensable manufactured object did not need to be colored for either functional or commercial purposes; it sold anyway, in response to an absolute need. *Before this occurrence, what do we see?* Putting color on the useful object has always more or less existed, from the peasant who decorated his knife handle to the modern industries producing "decorative art." The aim was and still is to create a hierarchy of objects and thus increased commercial and artistic value for the object.

This is the area exploited in the production of objects (decorative arts). It is done with the aim of creating *the deluxe object* (which is a mistake, to my mind) and strengthening the market by creating a hierarchy of objects. This has led us (the professional artists) to such decadence in the "decorative object" that the few people who have sure and healthy taste become discouraged and quite naturally turn to the mass-produced object in plain wood or unpolished metal, which is inherently beautiful or which they can work on or make work to their taste. *The polychromed machine object is a new beginning. It is a kind of rebirth of the original object.*

I know that the machine itself also creates ornaments. However, since it is condemned by its function to work within the geometric order, I put more confidence in it than in the gentleman with long hair and windsor knot in his tie, intoxicated with his own personality and his own imagination.

The charm of color works; this is by no means a negligible point. Commercially, in terms of sales, the manufacturer knows this very well. It is so important that we must examine the question from this aspect: *"the public's reaction to a given object."* How does the public judge an object offered to it? Does it judge beauty or utility first? What is the sequence of its judgment? Personally I think that the initial judgment of the manufactured object, particularly among the masses, frequently concerns its degree of beauty. It is indisputable that the child judges beauty, so much so that he puts the thing he likes in his mouth and wants to eat it in order to show his desire to possess it. The young man says: "The good-looking bicycle," and only afterward does he examine it from the viewpoint of usefulness. One says: "The beautiful automobile" about the car that passes by and disappears (the birth, consequently, of the judgment of beauty, free will above and beyond professional aesthetic prejudices).

The manufacturer has become aware of this value judgment and uses it more and more for his commercial ends. He has gone so far as to put color on strictly utilitarian objects. We are now witness to an unprecedented invasion of the multicolored utilitarian object. Farm machinery itself has developed an attractive character and is decked out like a butterfly or a bird. Color is such a vital necessity that it is recapturing its rights everywhere.

All these colored objects compensate for the loss of color that can be observed in modern dress. The old, very colorful fashions have disappeared; contemporary clothing is gray and black. The machine is dressed up and has become a spectacle and a compensation. This observation leads us to envisage the *inherently beautiful* manufactured object as something of ornamental value in the street. For, after the manufacturer, who has used color as a means of making the object attractive and salable, there is the retailer, the shopkeeper, who in turn arranges his store window.

We arrive at *the art of window display,* which has assumed substan-

tial importance over the last several years. The street has become a permanent spectacle of increasing intensity.

The display-window spectacle has become a major source of anxiety in the retailer's activity. Frantic competition reigns there: *to be looked at more than the neighboring store is the violent desire* that animates our streets. Can you yourself doubt the extreme care that goes into preparing these displays?

My friend Maurice Raynal and I have witnessed this labor of ants. Not even on the boulevards in the brilliance of the streetlights, but at the end of a badly lit arcade. The objects were modest (in the famous hierarchical sense of the word); *they were waistcoats,* in a haberdasher's small display window. This man, this artisan, had seventeen waistcoats to arrange in his window, with as many sets of cufflinks and neckties surrounding them. He spent about eleven minutes on each; we timed him. We left, tired out, after the sixth item. We had been there for *one hour* in front of that man, who would come out to see the effect after having adjusted these things one millimeter. Each time he came out, he was so absorbed that he did not see us. With the dexterity of a fitter, he arranged his spectacle, brow wrinkled, eyes fixed, as if his whole future life depended on it. When I think of the carelessness and lack of discipline in the work of certain artists, well-known painters, whose pictures are sold for so much money, we should deeply admire this *worthy craftsman,* forging his own work with difficulty and conscientiousness, which is more valuable than those expensive canvases; they are going to disappear, but he will have to renew his work in a few days with the same care and the same keenness. Men like this, such artisans, incontestably have a concept of art—one closely tied to commercial purposes, but one that is a plastic achievement of a new order and the equivalent of existing artistic manifestations, whatever they may be.

We find ourselves in the presence of a thoroughly admirable rebirth of a world of creative artisans who make joy for our eyes and transform the street into a permanent and endlessly varied spectacle. I really believe that the entertainment halls would empty and disappear, and people would spend their time outside, if there were no *hierarchical prejudices in art.* On the day when the work of this whole world of laborers is understood and appreciated by people who are

free from prejudices, who will have eyes to see, we will truly witness an extraordinary revolution. The false great men will fall from their pedestals, and values will finally be put in their proper place. *I repeat, there is no* hierarchy of art. A work is worth what it is worth in itself, and it is impossible to establish a criterion. That is a matter of taste and of individual emotive capacity.

In the face of these artisans' achievements, what is the situation of the so-called professional artist?

Before considering the situation in question, I will allow myself a backward glance at a monstrous plastic error that still weighs heavily on people's artistic judgments.

The advent of mechanical beauty, with all its beautiful objects not intending to be art, justifies my making a quick examination of the traditional values of intention that were once considered definitive.

The Italian Renaissance (the *Mona Lisa,* the sixteenth century) is considered by the whole world as an apogee, a summit, an ideal to strive for. The École des Beaux-Arts bases its reason for existence on the slavish imitation of that period. *This is the most colossal error possible.* The sixteenth century is a period of nearly total decadence in all the plastic areas.

It is the error of *imitation,* of the servile copy of the subject, as opposed to the so-called primitive epoch that is great and immortal precisely because it invented its forms and methods. The Renaissance mistook means for ends and believed also in the beautiful subject. It thus combined two major errors: the spirit of imitation and the copy of the *beautiful subject.*

The men of the Renaissance have been considered superior to their predecessors, the primitives. In imitating natural forms instead of seeking their equivalents, they produced immense pictures that complacently described the most striking and theatrical gestures and actions of their epoch. *They were victims of the beautiful subject. If a subject is beautiful,* if a form is beautiful, it is a value absolute in itself, rigorous, intangible.

A beautiful thing cannot be copied; it can be admired, and that is all. At the very most, one can, through one's talent, create an equivalent work.

The Renaissance is responsible for engendering that malady that is

the École des Beaux-Arts, which runs ecstatically after *the beautiful subject*. They wanted something that is even materially impossible; a beautiful subject is uncopiable. It cannot be reproduced in the scientific sense of the word. The everyday experience of thirty students in front of a beautiful object, all in the same light at the same time, but each producing a different copy, is conclusive enough. Scientific methods of imitation such as casting or photography are not the most successful. Every manifestation of beauty, whatever it may be, contains an unknown element that will always be mysterious for the admirer. It is already there for the creator, who, caught between his conscious and his unconscious, is incapable of defining the boundaries of these two realms; the objective and the subjective continually collide with each other, interpenetrating in such a way that the creative event remains always a partial enigma for the artist. *The beautiful machine* is the modern *beautiful subject*; it too is uncopiable.

Two producers then face each other. Are they going to destroy each other?

I believe that the need for beauty is more widespread than it appears to be. From childhood to adult life, the demand for Beauty is considerable; three-quarters of our daily gestures and aspirations are plagued with the desire for it. Here, too, the law of supply and demand functions, but at the present time, it is directed mostly toward *the professional artist,* thanks to the prejudice I mentioned earlier, from which he benefits and which keeps people's eyes still barely open to the very beautiful object manufactured by the artisan, because it is not the work of an "artist."

I have just seen the Paris Fair, a spectacle where invention boils over at every step, where a prodigious effort is made to emphasize the quality of execution.

I am amazed to see that all these men who arranged, for example, those admirable panels of mechanical parts, those astonishing fountains of letters and lights, those powerful and awesome machines, do not understand, do not feel that they are true artists, that they have overturned all the received conditions of modern plasticity. They ignore the plastic quality they create; they are unaware of it.

In such a case, perhaps ignorance is healthy, but it is truly a sad matter—this most disturbing lack of consciousness in artistic creation

—and it will disturb those who evoke the mystery for a long time to come.

Let us suppose all the same, as I just said, that this whole, immense world of engineers, workers, shopkeepers, and display artists became conscious of all the beauty they create and in which they live. The demand for beauty would almost be satisfied by them; the peasant would be satisfied with his beautiful colored mowing machine, and the salesman with his melody of neckties. *Why is it necessary for these people to go into ecstasies on Sunday over the dubious pictures in the Louvre or elsewhere? Among a thousand pictures are there two beautiful ones? Among a hundred machine-made objects, thirty are beautiful,* and they resolve the problem of Art, being beautiful and useful at the same time.

The artisan regains his place, which he should always have kept, for he is the true creator. It is he who daily, modestly, unconsciously creates and invents the pretty trinkets and beautiful machines that enable us to live. His unconsciousness saves him. The vast majority of professional artists are detestable for their individual pride and their self-consciousness; they make everything wither. In these periods of decadence one always observes the hideous hypertrophy of the individual in false artists (the Renaissance).

Take a tour of the Machine Exhibitions, for the machine has its annual exhibitions, just like those fine gentlemen the artists. Go to see the Automobile Show or the Aviation Show, the Paris Fair, which are the most beautiful spectacles in the world. Look at the work very carefully. Every time its execution is the work of an artisan, it is good. Every time it is desecrated by a professional, it is bad.

It should never be necessary for the manufacturers to leave their own terrain and address themselves to professional artists; *that is where all the mischief comes from.* These fine men believe that there is a category of demigods above them who make wonderful things, much more beautiful than theirs, who annually exhibit these immortal masterpieces at the Salon des Artistes Français, at the Salon de la Nationale, or somewhere else. They go to these openings in evening dress and humbly throw themselves into raptures over these imbeciles who should not be mentioned in the same breath with themselves.

If they were able to destroy their stupid prejudice, *they would know*

that the most beautiful annual salons of plastic art are their own. They would have confidence in the admirable men who surround them, *the artisans,* and they would not go out looking for the pretentious incompetents who massacre their work.

What definitive conclusion can be drawn from all that? That the artisan is everything? No. I think there are some men above him, very few, who are capable of elevating him through their plastic concept to a height that towers over the primary level of Beauty. Those men must be capable of viewing the work of the artisan and of nature as raw material, to be ordered, absorbed and fused in their brains, with a perfect balance between the two values: the conscious and the unconscious, the objective and the subjective.

The plastic life is terribly dangerous; its ambiguity is perpetual. No criterion is possible, no tribunal of arbitration exists to settle contentions about the Beautiful.

When the impressionist painter Sisley was shown two of his own pictures that were not quite identical, he could not tell which one was a fake. We must live and create in a perpetual turmoil, in this continuous ambiguity. Those who deal in beautiful things ignore it. In this connection, I will always remember that one year, showing at the Salon d'Automne, I had the advantage of being next to the Aviation Show, which was about to open. Through the partition, I listened to the hammers and the machanics' songs. I jumped over the barrier, and never, in spite of my familiarity with these spectacles, had I been so impressed. Never had such a stark contrast assailed my eyes. I left vast surfaces, dismal and gray, pretentious in their frames, for beautiful, metallic objects, hard, permanent, and useful, in pure local colors; infinite varieties of steel surfaces at play next to vermilions and blues. The power of geometric forms dominated it all.

The mechanics saw me come in; they knew that they had artists as neighbors. They in turn asked permission to go to the other side, and these worthy men, who had never seen an exhibition of painting in their lives, who were clean and fine, brought up amid beautiful raw materials, fell into raptures over works that I would not want to comment on.

I will always see a sixteen-year-old with fiery red hair, a new blue canvas coat, orange pants, and a hand spattered with Prussian blue

blissfully contemplating the nude women in gold frames; without the slightest doubt, he—in his clothes of a modern worker, blazing with color—killed the whole exhibition. Nothing more remained on the walls than vaporous shadows in old frames. The dazzling kid who looked as though he had been fathered by a piece of farm machinery was the symbol of the neighboring exhibition, of the life of tomorrow, when Prejudice will be destroyed.

Bulletin de l'Effort Moderne, Paris, 1924

The Machine Aesthetic:
Geometric Order and Truth

Each artist possesses an offensive weapon that allows him to intimidate tradition. In the search for vividness and intensity, I have made use of the machine as others have used the nude body or the still life. You must never be dominated by the subject. You are in front of the canvas and not above it or behind it. Otherwise, you are out of date. The manufactured object is there, a polychrome absolute, clean and precise, beautiful in itself; and it is the most terrible competition the artist has even been subjected to. A matter of life or death, a tragic situation, but how new! I have never enjoyed copying a machine. I invent images from machines, as others have made landscapes from their imagination. For me, the mechanical element is not a fixed position, an attitude, but a means of succeeding in conveying a feeling of strength and power. The painter is caught between a *realistic* figure and an *invented* figure, which become the objective and the subjective. It is a question of focusing with his head, as it were, in the clouds and his feet on the ground. It is necessary to retain what is useful in the subject and to extract from it the best part possible. I try to create *a beautiful object* with mechanical elements.

To create the beautiful object in painting means breaking with sentimental painting. A worker would not dare to turn in a part that was anything less than cleaned, polished, and burnished. There nothing is wasted; everything is unified. The painter must seek ways to achieve a clean picture with *finish*. The primitives dreamed of these things. *They*

had professional conscientiousness: painting is judged down to a tenth of an inch, while the mechanical is measured to the ten-thousandth of an inch. The artist puts his sensibility at the service of a job. There are workers and engineers. Rousseau is a worker, Cézanne a little engineer.

Pure tone implies absolute candor and sincerity. One does not play tricks with it. At the most, a neutral tone is reborn under the influence of a pure tone if they are adjacent in one of my canvases. Since I seek to give the impression of movement in my canvases, I oppose flat surfaces to volumes that play against them. I have collaborated in doing some architectural designs, and have then contented myself with being decorative, *since the volumes were provided by the architecture and the people moving around.* I sacrificed volume to surface, the painter to the architect, by being merely the illuminator of dead surfaces. In works of this kind, it is not a question of hypnotizing through color but of refining the surfaces, of giving the building, the town *a joyful countenance.* For us French painters, our epoch is escaping us. In Germany, the collaboration between architects and painters is close. Only there does the plastic life exist. It is nothing in Paris, and it will be nothing so long as the possibility of *illuminating the walls* is not recognized.

In *Ballet,* I thought only in terms of the decorative, of simple surfaces covered with flat colors. I did that for *Skating Rink* and for *The Creation of the World.* In collaboration with Darius Milhaud and Blaise Cendrars, I created an African drama. Everything was transposed in it. As a point of departure, I used African sculpture from the classical period; as documents, the original dances. Under the aegis of three Negro gods twenty-six feet tall, one witnessed the birth of men, plants, and animals.

Plastic beauty is totally independent of sentimental, descriptive, and imitative values. Each object, picture, architectural work, and decorative arrangement has a value in itself, absolute and independent of what it may represent. Every *created object* can contain an intrinsic beauty, like all the phenomena of the natural order, which the world has admired since time began. There is no classification or hierarchy of the *beautiful.* The beautiful is everywhere, in the arrangement of a set

of saucepans on a white kitchen wall as well as in a museum. Modern beauty is almost always combined with practical necessity. Examples: the steam engine, which is coming closer and closer to the perfect cylinder; the automobile chassis, which, because of the need for speed, has been lowered, elongated, *streamlined,* and which has become a balanced relationship of curved and horizontal lines, born from the *geometric order.*

Geometric form is dominant. It penetrates every area with its visual and psychological influence. The poster shatters the landscape, the electric meter on the wall destroys the calendar.

These new values must all be plastically utilized in searching for equivalence. I conceive of two modes of plastic expression:

1. *The art object* (picture, sculpture, machine, object), its value rigorous in itself, made out of concentration and intensity, antidecorative, the opposite of a wall. The coordination of all possible plastic means, the grouping of contrasting elements, the multiplication of variety, radiance, light, brought into focus, life force, the whole united, isolated, and embodied in a frame.

2. *Ornamental art,* dependent on architecture, its value rigorously relative (almost traditional), accommodating itself to the necessities of place, respecting live surfaces and acting only to destroy dead surfaces. (A materialization in abstract, flat, colored surfaces, with the volumes supplied by the architectural and sculptural masses.)

It is necessary to distract man from his enormous and often disagreeable labors, to surround him with a pervasive new plastic order in which to live.

I find the state of war much more normal and more desirable than the state of peace. Naturally, everything depends on the position from which you look at it—whether hunter or prey. From the sentimental point of view, I seem to be a monster. *I want to ignore that viewpoint all my life.* It is an intolerable burden for anyone who does plastic work. It is a drug, a negative value as rhyme is for poetry. If I stand facing life, with all its possibilities, I like what is generally called the state of war, which is nothing more than *life at an accelerated rhythm.* The state of peace is life at a slack rhythm; it is a situation of getting into gear, behind drawn blinds, when everything is really happening in

the street where the *creator* must be. There life is revealed at top speed, profound and tragic. There, men and things are seen in all their intensity, their hyperactive value, examined from all sides, strained to the breaking point.

Before the war, my father took his cattle to Villette, guarded by dogs who snapped at their heels. Now that a steer costs six thousand francs, there are no more dogs. A while ago, a drink cost three sous. Today it costs three francs. Every object has become valuable in itself. There is no more waste.

A nail, a stub of candle, a shoelace can cost a man's life or a regiment's. In contemporary life, if one looks twice, and this is an admirable thing to do, *there is no longer anything of negligible value*. Everything counts, everything competes, and the scale of ordinary and conventional values is overturned. A nervous officer is finished and a cool-headed noncom replaces him. The valuable man, the valuable object, the valuable machine ruthlessly assume their natural hierarchy. Contemporary life is the state of war—that's why I profoundly admire my epoch. It is hard and sharp, but with its immense senses it sees clearly and always wants to see more clearly, whatever may happen. It is the end of obscurity, of chiaroscuro, and the beginning of the state of enlightenment. Too bad for those with weak eyes. The nebulous, the composition of nuances, is about to perish, and painters too must go through some change.

My literary preferences are for the men who have enough of a visual angle to see the whole spectrum of human drama without *blinders*. *Balzac, Dostoevsky* are two whom I always reread with the same fascination. Their work is a sphere, and one aspect of it is always hidden from me. It must be turned in order to be seen; so I turn it and there is always something new. They have a sense of the "close-up." Their work also contains the cinema of the future; there too, moving toward *personification through enlarged detail,* the individualization of the fragment, where the drama begins, is set, and stirs. The cinema competes with life in this way. The hand is an object with multiple, changeable meanings. Before I saw it in the cinema, I did not know what a hand was! The object by itself is capable of becoming something absolute, moving, and dramatic.

Specialization in literature, in the plastic arts, can offer nothing. Art produced exclusively from mind and taste occupies a considerable place in France. Even though I am French, these works escape me. I prefer works that have "dimension." Whitman, Rimbaud, Cendrars, in spite of the mistakes they do not always avoid, give us the "close-ups" that will express contemporary life in the future.

Propos d'artistes, Paris, 1925

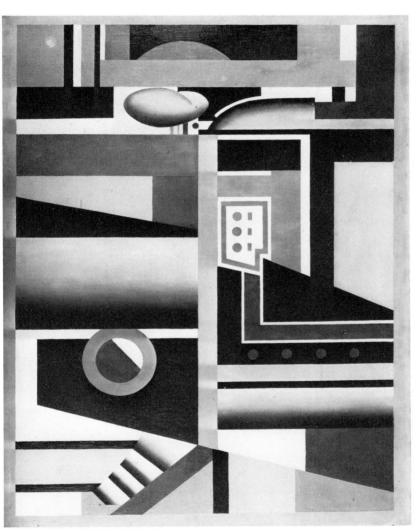

Mechanical Element (Elément mécanique), 1924. Oil on canvas, 38¼″ × 51¼″. Kunsthaus, Zurich.

Frames from Léger's film
Ballet Mécanique, 1923–24.
(*Photograph courtesy The
Museum of Modern Art,
New York.*)

68

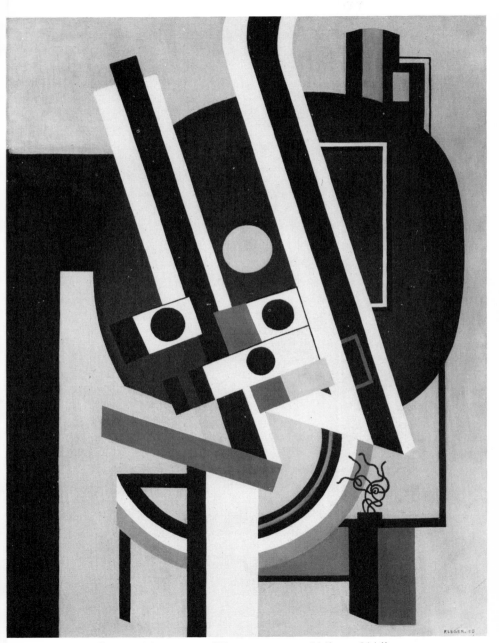

Composition, 1925. Oil on canvas, 51⅛″ × 38¼″.
The Solomon R. Guggenheim Museum, New York.

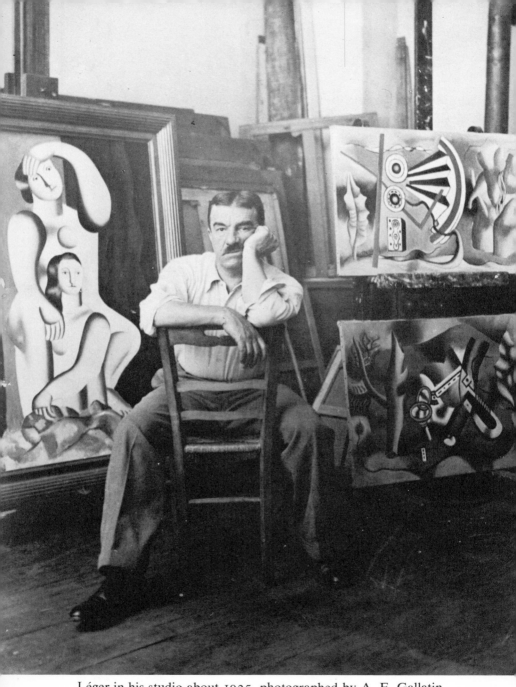

Léger in his studio about 1925, photographed by A. E. Gallatin.
(*Photograph courtesy The Museum of Modern Art, New York.*)

The Ballet Spectacle,
the Object-Spectacle

Until now, dancers, singers, stars of the music hall have all sacrificed the group spectacle to their own more or less authoritative personalities. We have seen and heard almost everything in this domain; the *realistic ballet* with its predominance of "human characterizations" has reached its peak. It can be varied, but the interest curve remains the same; it no longer rises. It is *stale*.

A stage set, music, lighting (bright enough) for a dominating accident, which is always spontaneously brought about. A man, a woman, with or without talent, asserts himself or herself and organizes the whole spectacle in terms of its theatrical value. We have believed in that, we have submitted to it as long as spectacle has existed. We ought to be able to emerge from this theatrical command and pass on to a different plane where the star is absorbed into the plastic ranks, where a mechanical choreography closely connected to its own scenery and music attains a whole, planned unity; where the scenery that has been immobile until now begins to move; where the spectacle's charm encompasses the entire stage.

The public itself inclines toward this theatrical concept because it offers them new effects and surprises.

The acrobat's "ever more dangerous" routine is intrinsically wrong, for the danger should never be a cause for attraction, but it does indicate the audience's interest in the new and unexpected.

Make a beautiful thing for those who don't expect it, and you are

the master of the stage and the crowds (Chaplin is inspired in this particular sense). You can figure out too often what Douglas [Fairbanks] is up to; you can rarely guess with Chaplin. That is an enormous coefficient of interest. If the human material and the mobile-scenery material are firmly hitched together, there is a considerable field for surprise. The surface is multiplied by ten, the background of the stage is also *brought to life*. Everything can move; "the human measure," which until now was dominant, disappears. Man becomes a mechanism like everything else; instead of being the end, as he formerly was, he becomes a means (the multiplication of means of effect).

If I destroy the human scale, if my scenery moves around, I obtain the maximum effect, I obtain a whole on the stage that is totally different from the atmosphere of the auditorium.

The following axiom must prevail in the making of spectacle: *Maximum interest is obtained when the theatrical creation is diametrically different from the visual aspects of the auditorium.*

All the genius of a dancer will not prevent a state of competition, of resemblance, between the spectator and him. Because of this, he forfeits 50 percent of his surprise effect.

Because the man in the audience and the man on the stage resemble each other, you have an inferior state of spectacle.

Once prejudice of the individual-as-king is gone, the means of attraction emerge from the shadows and are innumerable. Lights, projections of film, enter into play.

The mechanical state can be seriously considered, that is, the exact working details of gesture, movement, and projector.

The impact of parallel forces (20 performers moving together).

Contrasting forces can operate to the maximum.

Ten yellow acrobats cross the stage (fast rhythm) doing cartwheels, they return (same rhythm), the stage is dark; they are phosphorescent; at the same time (slower rhythm) the film projector animates the top of the set, raises the back curtain; the apparition of the beautiful object, moving or unmoving, that holds the stage. Time X. The staircase, the cartwheel, the display of unexpected invention that glitters and disappears.

To conceive of objects as the pivot of interest, objects so beautiful

that they have an enormous spectacle value, unknown and always sacrificed to the eternal star. The honor of having sensed the interest objects have on the stage belongs to the music-hall actors.

They did it timidly, they surrounded themselves with them, they didn't emphasize them, but anyway, it was there that I saw them for the first time. The juggler at the Olympia knows obscurely that he values his equipment for its spectacle value. For example, he doesn't ponder their value; all those beautiful things are behind him, he is in front and asserts himself.

The music halls are the only places where there is daily invention. They are an inexhaustible mine of raw material. It is only glimpsed, never fully worked out, but it is in force.

I know of nothing more beautiful than the "big top of the New Circus," and when the "little fellow," lost in that metallic planet where the spotlights shine, risks his life every night, I find him ridiculous, I don't see him any more, in spite of all his wishing to be seen, to be in a "state of danger"; the spectacle is elsewhere, all around him.

The contemporary event is the personality of the objects; they are coming more and more to the forefront. Man fades into the background and must direct their arrival.

There is something else besides "man, animals, and plants"; there are objects. We must reckon with them. They are stationary or animated. If I react when the acrobat turns a cartwheel, it is really because it is a tour de force. But wouldn't you say that the cartwheel itself crossing the stage enhances the spectacle, attains more beauty and provokes more amazement? Objects have a plastic strength that nothing can disturb.

Man, with his nerves and his imagination, breaks down and loses his willpower. The *directed* object offers up its plastic maximum without any waste. It is the fixed value.

The domination of the object is everywhere in contemporary life; the shop-spectacles have multiplied in the cities.

The pretty salesgirl behind her lottery booth at the fair fades before the bright multicolored ferris wheel—it is the beautiful object that is the attraction—each one has its time.

Bulletin de l'Effort Moderne, Paris, 1925

Popular Dance Halls

There are male and female dancers in France. There would be a French choreography if anyone wanted to take the trouble—it's not to M. Rouché's or Claridge's that you should go to find it.

Dance, like all the other national qualities, is exclusively the domain of the masses.

Paris and the provinces are its original source, but you must go out and look for it to find it. It is quite difficult. Since it is scattered in the four corners of France and in the Paris dance halls, you must have perseverance and a particular taste for those things. All these places are very closed, hostile to strangers and spectators, often dangerous. They are perfectly right. They are protecting themselves. They too are sensitive to matters of *ambiance,* atmosphere, and education. They have an education of their own, one that is very simple and human.

Most of the men one meets there are young; they have the look of well-groomed workmen. A white shirt, without a stiff collar, cuts off the mask at shoulder height. That gives the effect of a medallion. Only there have I observed men's profiles; the girls, too, are accentuated because of the severity of their flattened hair and made-up eyes. When they are dancing, they are clearly outlined against the bare-white background—one sees them as a complete figure; they stand very straight, backs to the wall, or sit at a table leaning on their arms like workers who are resting their bodies.

The men's dances are the most curious. Head against head, they

dance stiffly, holding each other at the sides, their hands flat, their necks glued to their bodies.

They prize their elegance, they care for it, they shiver in the winter, but their style is to wear neither a vest nor an overcoat.

Their clothes are neat and severe; it is this that creates the tragic and harsh atmosphere of the place.

They have their style and their tastes, they carefully choose their shoes and caps; their hairstyle is as studied as any woman's. They have a very definite, simple taste; they are cold and skeptical by the time they reach fifteen.

Their precocity is a result of their environment; it is completely natural that they begin to "work" the suburban villas by age sixteen. They certainly go into the factories at the same age. They have been reared in an environment where nothing is hidden. Painfully, knowing the truth about everything, they are men before their time, and this explains their decisiveness and their sense of purpose. Their eyes saw everything from the minute they were born. In that school, one is not young for long.

They make judgments quickly and well. Their likes and dislikes are decided instinctively in a matter of minutes. It is a perfect and total world that a faulty literature prevents us from seeing as it is. Before the war, I knew a gang in the dance halls of Grenelle who did shoplifting. I admired their operating procedures.

The chief, a little sixteen-year-old with dark hair and hard eyes, made the judgments and decisions. There were three of them. One was to serve as "decoy" for the grocer, and the two others to lift the merchandise. They were a homogeneous trio with intelligent and stanch discipline. An "invisible" tactic: they had accurately observed that everything depended on decisiveness and discretion. They worked in "the rhythm of the street" in broad daylight; their ploy was to avoid any glances by making no unusual gestures that might cause a passerby to stop and look. Their admiration for one of their own was expressed like this: "He's an ace—he's transparent."

The whole world is teeming with life, ingenuity, charm, and wit. A wit ready with the right word—the only right one, not bookish, untranslatable. It is a hundred times superior to our lamentable "professionals" of the salon, who compose their witticisms in advance and

bore humanity. Their strength is their purity. Their sense of truth—they do what they do very well, it's all over, well done.

I saw them in the war, most of them misunderstood by the officers and stupidly sacrificed; in the right spot, their effectiveness would have been astonishing.

So go to one of their dance halls. The door opens, you are immediately the target of every eye. The man who is entering is watched, weighed with infinite subtlety.

Once as far as the door, you gauge whether the situation is feasible or not.

In spite of my great familiarity with these places, I sometimes come to a standstill and I have to leave. No word or gesture is exchanged, but by the looks alone or the pause in the conversations, it's clear that "things won't jell," and you go away. Not that the situation would be dangerous (it can be), but your aim is frustrated; the spectacle stops, is changed; you break the fragile atmosphere that makes it worth seeing.

But once you are inside without a scratch, you will have the very distinct feeling of being with very pure Frenchmen, absolutely unalloyed, where all the traditions are preserved.

The dances are frank and lively, augmented with perfectly suited imaginative frills.

The couples touch each other very little. Whether slow or fast, they dance lightly, without any sexuality. The American dances and fashionable aberrations have had very little effect on them (at least in the very remote dance halls).

These places have a beautiful and tragic atmosphere, charged with intrigues of passion that are veiled or break out into the open with incredible swiftness.

The orchestra is simple: an accordion and some small bells attached to the musician's ankle. The one-man orchestra is stuck up against the wall in his shirtsleeves. He dominates the dancers. He plays the popular tunes of the moment, which he embellishes with his own creations. He is a perpetual inventor who loves his work.

No two of them play the same way, but all of them have a sense of rhythm, and their music is essentially for dancing.

Several times I've seen this happen: a couple—often two men—

thrusts itself forward. The orchestra sees them and plays for them. Those men must have been all over the world as sailors or outlaws. They have watched all the dances on earth. Their timing and their instinct for what is French produces a perfectly balanced arrangement that is very disciplined and without exoticism.

Two years ago, I met the inventor of the "whirling dance." Beginning in a slow waltz, it progressively gathers speed—then gradual crouching down until the knees touch the floor, then stretching up. With a rapid rhythm it begins again, the whole performance adorned with acrobatic embellishments just at the moment the dance threatens to become monotonous. This dance was a favorite in the Convention dance halls.

Those are the places where we must look for the sources of a new French choreography. It's nowhere else.

Bulletin de l'Effort Moderne. Paris, 1925

The Street:
Objects, Spectacles

Should the street be considered as one of the fine arts? Perhaps, but in any case, the *present* element, the central element of the street, is the object rather than the poster, which fades into a secondary position and disappears. *The direct accession of the object to decorative value* does not displease Jean Cocteau and comes as no surprise to his painter friends. It belongs to the realm of pure plasticity, the sculptural and constructive realm.

If the modern Paris street has a style, it is certainly due to this new taste for the object itself, for form.

From the day when a woman's head was considered an oval object to be emphasized, hair has disappeared and more care than ever is taken with make-up, the eye, the mouth . . . and, naturally, the store mannequin has followed the trend.

The age of the naked, of light. There is no longer a fondness for dubious mystical-Oriental seductiveness, for chiaroscuro.

The indiscreet spotlight, the studio klieg light. Sun. The detail isolated and enlarged a thousand times.

Economic pressure has brought the merchant to his knees before his merchandise. He has discovered it; he has perceived that his objects have beauty. One fine day, he put a shoe or a leg of lamb on display in his shop window, getting a perspective. His taste and imagination did the rest. A style was born, very contemporary—a revolution made without drum or trumpet. Then the store can be considered one of the fine arts, for it is majestically dressed by a thousand hands that daily

make and remake the modern stores' pretty scenery. The billboard is no longer a match for them. Only that one enormous object, the Cadum Baby, persists. The Cappiello poster remains the classic example of the mural billboard mistake. An automobile chassis, completely bare, put on the white wall . . . a harsh, exact age, incompatible with religious neurasthenia. Go along the street. Start from the center and go to the end, and you will see the reel unroll.

This aesthetic of the isolated object is difficult. It is fully realized only around the Opera and the Champs-Élysées. As one strolls along, it is amusing to see, on the sidewalks and everywhere else, the research and the continuous efforts that are being made to achieve this aesthetic.

The lower-class sections of Paris have not been able to follow the trend; they have kept their taste for diversity, intensity. There you find *the most possible in the minimum* space. In spite of this, they get results.

Let us go to the Temple district on the outskirts; here you enter the realm of shoes and ties. . . . Jack, from New York, Rue de Belleville, will seduce you with his poetry of caps. It is as pretty as an accordion tune. Every nuance is melodiously orchestrated. The gentlemen in this section are very uncompromising. Go in and watch a fitting, and you will have something to tell me.

You will find cubist slippers on the feet of the Chapelle dancers. Their shirts, which range from pale pink to yellow-orange, will dismay you a bit. This district is very late-eighteenth-century. There, style is dead.

All the great ages have striven for the vertical arrangement of the isolated object to obtain a decorative or plastic value.

This is the framework of the seventh-century mosaics, of the popular engravings of the twelfth and fourteenth centuries.

With the Italian Renaissance the taste for the subject drove out the taste for the object and destroyed style.

The beautiful pharmacies on the Boulevard Sébastopol, the horse-meat shops on the Rue de la Roquette, and, trapped in all that, over-

whelmed and absorbed by it, the good old store from the 1880s, which can move you to tears, hidden as it is in the shadow of a hundred equine hind legs lined up like soldiers, according to size, as if they were on parade.

Cahiers de la République des Lettres, Paris, 1928

Abstract Art

Color is a vital element, like water and fire. It is unquestionably an essential requirement.

One cuts flowers in the garden in order to have them in one's apartment, along with pictures. Pictures are art objects in which color counts for 60 percent.

Every pictorial school has utilized color. How it is used is the distinguishing factor.

"Local color" reigned until impressionism.

The impressionists began to theorize openly about the division of color (complementary colors), and they applied the principle toward a new plasticity.

Every impressionist work is based on a scientific observation. Naturally, the neoimpressionists appeared, tendentious and logical, to end that venture; and the impressionist school quietly faded away with a little theoretical game about complementary and constructive colors.

Cubism, born out of the need for a reaction, started out with monochromatic tones and did not become colorful until some years later.

But local color is regaining its [former] place. Local color produces more forceful color. Impressionism, which juxtaposed a red with a green, did not color; it constructed. This delicate construction could not do two things at once; it produced "gray." For example, a pure blue by itself remains blue if it is next to a gray or a *noncomple-*

mentary color. If it is put next to an orange, the relationship becomes constructive but does not color.

Too much color, no color.

Local color is then the question. This is what intrudes into the cubists' work and the work of the neoplasticists.

The latter are right to say that cubists' works cannot go as far as their own inquiries do. Personally, I have stayed at the "edge" without ever involving myself totally in their radical concept, which is the last word in tendentious research. The door remains half open; they have followed their experience as far as it will go.

To each his own work.

They are the true purists. Their analysis is complete. External activity is reduced to its simplest expression. Evolution had to go that far. They have created an indisputable *plastic fact.* Neoplasticism had to exist. It is done.

Whether one likes it or not is not the question.

I offer homage to these northern artists for their faith and unselfishness.

Confronted with the dubious pressures of "no matter what as long as it sells," these artists remain standing and continue their work in spite of the almost total lack of comprehension shown by the world. They are right, for they deal with certain concerns of their period, which is so complex in its aspirations.

Being antiromantic and deliberately inexpressive themselves, they have tried to "compensate" with a strict and traditional technique. They have daringly used as the "main character" the *colored plane,* which has obsessed painters since 1912; the geometric shape rigorously limits it, it cannot escape. Color is locked in and must remain fixed and immobile.

Neoplasticism signifies an almost total liberation from *ordinary pictorial concerns* through the artists' sense of reduction and restriction and through constraint of the chosen elements.

The cult of the *equilibrium* of geometric color has been pushed so far that it now gives the impression it has stopped, that nothing moves any longer.

That is how it seems, but that is not how it is.

It is a mute, essentially static art, which will always function for

some initiates who have freed themselves from the *ordinary* and are apt to be satisfied by a coefficient of beauty that does not change and does not even *seem visible*.

It is interesting that this problem of a new plastic rationalism should be resolved by northerners, whose recent traditions are madly romantic and full of vagueness. The contemporary worry about restlessness of precision and exactness in the pictorial domain is a delicate matter to resolve; if this worry has any future, it will go against the impressionist tastes that now dominate the contemporary world.

Pure abstraction, pushed by this *new spirit* to its outermost limits, is a dangerous game that must be played.

Neoplasticism is proof of it.

Abstract art is the most important, the most interesting of the different plastic trends that have developed during the last twenty-five years. It is definitely not an experimental curiosity; it is an art that has an intrinsic value. It is an art that has come into being and that responds to a demand, for a certain number of collectors are enthusiastic about it, proving that this tendency exists in life.

Perhaps the future will rank neoplasticism among the number of "artificial paradises," but I doubt it. This direction is dominated by the desire for perfection and complete freedom that makes saints, heroes, and madmen. It is an extreme state in which only a few creators and admirers can maintain themselves. The danger of this formula is its very loftiness.

Modern life, tumultuous and rapid, dynamic and full of contrast, is going to batter furiously at this frail structure, luminous and delicate, that calmly emerges from the chaos. Do not touch it, it is done; it had to be done; it will stay.

Cahiers d'Art, Paris, 1931

New York

The most colossal spectacle in the world. Neither film nor photography nor reportage can dim the amazing spectacle that is New York at night, seen from the fortieth floor. This city has been able to withstand all the vulgarizations, all the curiosity of men who have tried to describe her, copy her. She retains her freshness, her unexpectedness, her surprise for the traveler who is seeing her for the first time.

The ocean liner, cruising slowly, shifts the perspectives gently; one looks for the Statue of Liberty, France's gift. It is a small, unpretentious statue, forgotten in the middle of the port in front of this daring vertical new continent. You don't even see her, although she lifts her arm as high as possible. It's no use. Like a night light, she faintly illuminates enormous things that move, forms, indifferent and majestic, that cover her with their shadows. . . .

Six o'clock at night. The liner moves slowly forward. A mass, erect, tall, elegant as a church, appears in the distance, shrouded by fog. It is blue and rose, smudged like a pastel, closely compressed in a Gothic style, thrusting skyward like a challenge. What is this new religion?

It is Wall Street, which dominates this new world from its vast height. After six days of crossing the water, fluid and elusive, moving, yielding, you arrive in front of this steep mountain, the work of men, which slowly emerges and becomes sharper, takes shape, with its sharp angles, its ordered rows of windows, its metallic color. It rears up

violently above the level of the sea. The boat turns . . . the buildings slowly disappear, their profiles gleaming like armor.

This is the apotheosis of vertical architecture: a bold collaboration between architects and unscrupulous bankers pushed by necessity. An unknown, unplanned elegance emerges from this geometric abstraction. Squeezed into two metal angles, these are figures, numbers that climb stiffly toward the sky, controlled by a distorting perspective.

A new world. . . .

Brooklyn! Its massive piers, a play of shadow and light, the bridges, with their vertical, horizontal, and oblique lines. . . . The birth of New York in the light that increases little by little, as one advances into the city. . . . New York with its millions of lighted windows. . . . How many windows? What German will calculate that odd statistic?

Astonishing country where the houses are taller than the churches, where the window washers are millionaires, where football games are organized between the prisoners and the police!

The architectural severity is broken up by the myriad fantasy of colored lights. The great spectacle begins when they go on, and this radiant vision has that special something that no artist, however inspired, has captured, nor has any theater director had a hand in it. No one has "managed" its action. This moving play is performed by the houses inhabited by tenants like you and me. Those thousands of lights that astonish us are lighted by people who work humbly at their unrewarding daily jobs. Those huge buildings are strictly utilitarian, rational; their vertical thrust reflects economic reasons.

Those stories have been erected because land is limited and expensive and cannot be increased. Builders are compelled to construct vertically. There is no romantic sentiment in all this, no shadow of misapplied pride. All this astonishing orchestration is strictly utilitarian. The most beautiful spectacle "in the world"* is not the work of an artist.

New York has a natural beauty, like the elements of nature; like trees, mountains, flowers. This is its strength and its variety. It is madness to think of employing such a subject artistically. One admires it humbly, and that's all.

* In English in original.—Tr.

Within this multifarious and organized life runs a character indispensable to this limitless city: the telephone. It is the leading actor. It is part of the family. The American child makes it his plaything. He trains it like a doll, and the doll speaks, rings, and laughs. It constitutes an unbroken chain that ties this whole swift-moving crowded world together like mountain climbers.

If it suddenly died one day, there would be no one at its funeral because no one would be able to find out what day and time it was going to be held.

New York and the telephone came into the world on the same day, on the same boat, to conquer the world.

Mechanical life is at its apogee here. It has "reached the ceiling," overshot the mark . . . crisis!

American life is a succession of adventures optimistically pushed as far as they will go.

They have risked everything, tried everything; their achievements are the ultimate. Naturally architectural volume had to tempt them. *Everything that is seen*, above all. Architecture and light are the two poles of their plastic expression. In the baroque style they achieve monstrosities.

New York and Atlantic City have cinemas that are hard to describe if you have never seen them: an unbelievable accumulation of every European and Asian style, chaos on a colossal scale, in order to strike the fancy, advertise itself, and do "more than the one across the street." Hugeness in the game of "I'm richer than you."

Useless staircases, incalculable numbers of employees who are there to astonish you, attract you, and take your money. That is the aim of the whole dizzying show, which extends to both nausea and Beauty.

I adore this overloaded spectacle, all that unrestrained vitality, the virulence that is there, even in mistakes. It's very young. To swallow a sword smiling all the while, to cut off a finger because it's dirty. . . .

That's America at the extreme. Naturally, if I stop to reflect, if I close my eyes, I sense all the tragedies that lurk around this extravagant dynamism, but I came to look and I go on looking.

Letters thrown into the mail chutes on the fiftieth floor get hot from friction and catch fire by the time they arrive on the ground floor. They have to chill the mail chutes—too cold, and the letters will arrive with snow.

Everyone smokes in New York, even on the street. Some young girls maintain that smoking during a meal will distract you and thus prevent you from getting fat—an unexpected connection between cigarettes and elegance.

During the day New York is too severe. It lacks color, and if the sky is gray, it is a city of lead.

Why not put color on the houses? Why this oversight in the country with all these inventions?

Fifth Avenue could be red; Madison, blue; Park Avenue, yellow. Why not? And the lack of vegetation? New York has no trees. Medicine decreed a long time ago that green in particular is a color that is indispensable to life. We must live with color around us; it is as necessary as water and fire.

Clothing manufacturers could be compelled to put out a group of green dresses and green suits. . . .

Every month, a dictator of color would decree the monthly or quarterly colors—the blue quarter, the pink fortnight! Trees could be taken out for rides in the street for those who can't get to the country. Moving landscapes decorated with tropical flowers pulled slowly along by plumed horses.

Two o'clock in the morning, streets at random . . . a lower-class neighborhood . . . Avenue A or B . . . an immense garage for trucks, all alike, in rows of six, polished as if for a parade, like elephants, a motionless light. Nothing is moving. I go in and look around . . . a sound of ridiculous harness bells . . . in the back, off to the left, I discover the horse, all harnessed up. He is the only living thing in this iron silence. . . . The pleasure of touching him, of seeing him move, of feeling his warmth. This beast takes on so much value in contrast that I would have been able to absorb every noise that a horse resting could make: tiny sounds, never varying. I listened to his breathing . . . his delicate movements . . . his ears . . . his black eyes . . . a white spot on his forehead . . . his shining hoof and his knee that slowly shifted from time to time.

The last carriage horse. Soon he will be exhibited in a display window on Sundays and children will be amazed that Napoleon conquered the world mounted on that.

Visit the office of Corbett the architect* with [Friedrich] Kiesler. He is one of the greatest figures in American building. A fine, good-natured man, tall, uncomplicated. He tells me: "Accommodating 20,000 people living in one building, that is my current work." Don't think that the solution is only a question of the floor space! No, it's more complicated; it's a matter of the elevators. Maneuvering this army vertically! Bringing them down every day to the four dining rooms that are located sixty-five feet underground . . . and making all that work at the desired times.

The second thing is like a game, nothing more. Getting them outside without stopping traffic. . . . Six months of work. Ten specialized engineers haven't found the solution yet.

A specifically American problem—they are unbeatable in reasoning, in mass production, in numbers. Starting from numbers in order to make the whole comfortable. A New World!

They give the impression of never lingering over anything; a life where one thing follows another in swift succession. Destroy New York—it will be rebuilt completely differently. Furthermore, those buildings, what wonderful targets! To demolish New York! It's not possible that Marshal Pétain was not tempted for a second, a half-second, to do it. What a magnificent job for an artillery barrage. A question of war, isn't it, my dear general? I was at Verdun under his command, it's enough, but for the sport, for love of the profession! The Americans would be the first to applaud, and then what would you see? A little while later a new town would be built. Can you guess how? I'll give you the answer in thousands! In glass, in glass!

Their latest invention is this. Engineers have found a way to make glass out of *milk curds*; it's cheaper than concrete. You can imagine the problem! All the cows in America are working for the reconstruction of the capital!

A transparent, translucent New York, with blue, yellow, and red floors! An unprecedented fairyland, the light unleashed by Edison streaming through all that and pulverizing the buildings.

The lower-class neighborhoods are beautiful at any hour. They have

* Harvey Wiley Corbett was one of the principal architects of Rockefeller Center.—Ed.

a crudeness, such a wealth of raw materials. The Russian, Jewish, Italian, and Chinese neighborhoods. Third Avenue, on Saturday night and Sunday, it's like Marseilles!

Pink hats for the Negroes. Windows where a bicycle is suspended above a dozen eggs stuck in rows in green sand. . . .

Plucked chickens hung in a half light, displayed against a black background—a *danse macabre*!

A vigorous decorative life gives infinite value to the object on sale.

The demeanor of the unemployed: nothing distinguishes them from other people except that they walk more slowly. Huddled side by side in the little parks, they don't talk to each other. These crowds are silent. The individual remains isolated; he doesn't communicate. He reads or sleeps!

Wall Street during the day: it's been described too often, but go to see it!

Wall Street at night, Wall Street at two o'clock in the morning, under a cold, dazzling moon. The silence is absolute. There is nobody in the narrow streets, choked by the violent projection of sharp lines and perspectives that are infinitely multiplied toward the sky. What a spectacle! Where are we? A feeling of solitude may oppress you as if you were in a vast necropolis. Steps echo on the pavement. Nothing moves. Overwhelmed by this forest of granite, a tiny cemetery with tiny headstones so humble, so modest. Death becomes tiny before the exuberance of the life that surrounds it. The property occupied by that little cemetery is certainly the most expensive in the world. The "businessmen"* haven't touched it. It remains there like a resting place, a break in that torrent of life. . . . To solve death, the ultimate problem!

Wall Street sleeps. Let's continue our stroll. I hear a faint, regular murmuring. Is Wall Street snoring? No, it's a drill that is harmoniously beginning its work, work like a termite's. There's no noise. It's the only part of New York that really sleeps. It has to digest the day's numbers, the additions, multiplications, the financial and abstract algebra of these thousands of individuals focusing on the great problem of gold.

* In English in original.—Tr.

Wall Street sleeps soundly. Let's not wake it up. A hundred feet under-
ground, in the bedrock, the steel vaults of the Irving Bank. At the
center the safes with magnificent shining locks that are as complex as
life itself, a police room, where a few men keep watch. Ultrasensitive
microphones carry the slightest sounds in the street to them, and pick
up any noises from beneath the steel vaults of the modern bank. A fly
. . . they hear it flying. An old Negro ambles through the streets, sweetly
singing an old Southern tune. The song rises, losing itself among the
buildings, but it also descends into those microphones that quietly
register the old Southern song.

Wall Street is not sleeping. . . . Wall Street is dead. I pass the little
cemetery again. These are not the greatest banks in the world! No,
they are the proudest tombs of the families of great billionaires. There
rest the Morgans, the Rockefellers, the Carnegies. Like the pharaohs,
they have built their pyramids. They will be buried standing up, like
demigods. And as these modern giants become legendary and im-
mortal, a thousand windows have been cut out for them so that the
people know that perhaps they aren't dead, but that they breathe and
will return once again to astound the world with grandiose new ideas.

Wall Street is the image of America's daring, of this nation that
always acts and never looks behind.

New York . . . Moscow!

The two poles of modern activity. . . . Contemporary life is con-
centrated there.

New York . . . Moscow!

Moscow . . . New York!

Paris the onlooker!

Georges Duhamel* came to America with the notions of an average
Frenchman in his suitcase, and beside them, in the same suitcase, he
had his slippers. Maybe he couldn't use them, and that put him in a
bad mood. They don't use them here any more. That's why Americans
have pretty feet and are queens. You must never get angry at the train
that sends your hat flying as it speeds by at a hundred miles an hour.

Cahiers d'Art, Paris, 1931

* Georges Duhamel (1884–1966) was a French writer best known for his
Salavin cycle, a series of novels.—Ed.

The Wall, the Architect, the Painter

The contemporary world is, more than anything else, *drunk with understanding.*

A human pride born out of the astonishing achievements of the last few centuries wants to understand everything through logic or deduction. However, we must call a halt in the presence of the work of art—and remember that our sensory "instincts" come into play there.

The work of art is reserved for *those who feel*; it is their revenge on the *intellectuals*.

There is a tie between the artist who creates and the amateur who appreciates, a delicate atmosphere that is *inexplicable*, that is the vehicle for the great affections that gather around us. *It cannot be explained*, and it is exactly this rather mysterious aura that enables these works to endure and to be admired by men of other generations. The *permanent value* of the work of art is possible because no scholar, no intellectual has yet been able to put it *under his microscope* and explain the *reason for Beauty*. Let's hope that the analytic spirit may never penetrate into this domain because it would destroy that marvel, *the Beautiful*, which rises above the melee of tumultuous moral life.

The current trend toward "determinism," toward *clarity,* is difficult to check when it laps at the foot of the picture. But there are some ambiguities here that we must try to clear up. I am oversimplifying, but sometimes it is necessary to dot the i's.

It has never been a matter, in a work of art, of copying nature. It is

a matter of finding an equivalent for nature, that is, capturing simultaneously within the frame life, movement, and a harmony created by assembling lines, colors, and forms, independent of *representation*.

The harmony of the work justifies everything, and *not its more or less accurate resemblance to nature*. If imitation was worth anything, every good student at the École des Beaux-Arts who had supposedly learned to copy nature would be able to declare himself a *genius*. On the other hand, if you put several copyists in front of the same model, in the same light, at the same time, none of them will do the same thing; even several photographs of the same object, in the same position, will show different results. So what is this tale that the Academicians call "Nature"? *It doesn't exist*. We are all subjective; that is, we see the objects that surround us through our own eyes and *judge them within ourselves*. Each person is different inside, every judgment is individual, as is every taste. No one sees the same object in the same form. Therefore we must eliminate that famous point of *comparison* that makes intelligent men of judgment think it is satisfactory to *compare* the picture with nature. That's worthless. One cannot judge by comparison.

If you have, for example, a drawing by Ingres and one by Delacroix in front of you, it is not a question of comparing them and saying: "This one is better than that one." They are two drawings of the same quality, but different, and done by artists with contrary sensibilities. Your own subjectivity will incline you toward one or the other. You will prefer one or the other, but you must refrain from saying: "That one is better than the other."

The world is a victim of this enormous mistake because of the Italian Renaissance. The majority of human beings believe that it was *a greater epoch than the others, an epoch of progress*. There is no progress in art—and the Renaissance, which created this error in judgment because it made the point of *comparison* possible, is guilty and inferior. The great epochs before the Italian Renaissance are *free* from the viewpoint of Imitation. They invented their form (Gothic, Romanesque, Chinese, Indochinese, Egyptian, Aztec, etc.). Rather than being inferior to the fifteenth century, those epochs were infinitely superior to it in plastic execution. Michelangelo as a sculptor is the prototype of the grossest error in seeking for the *Beautiful* by copying

human muscular arrangement. A poor, twisted Christ of the twelfth century is infinitely more moving and more beautiful through the sensibility it contains than the leg of a statue by Michelangelo where the left muscle is in its prescribed anatomical position. Try as he may to make the muscles swell to give the impression of strength, *he achieves nothing at all.*

But the average man who wants to understand everything says to himself: "That's it. Even I can appreciate a work of art. Everything that is not as well copied as Michelangelo's work is inferior." This attitude must be destroyed without delay. The academic schools naturally have pounced on that idea and teach from that position. *It is so easy*, but all the same a little too facile.

A whole reactionary tendency today proposes to return to this order of things. They can't "let things be." We have before us centuries of admirable works of art. Public buildings and cathedrals, architectural styles immortalized by the opinion of time, and they would like to blow all that away with a gust of reaction. For the contemporary modernists are the faithful continuers of the pre-Renaissance periods that you all know about. We have borrowed our culture from them, our outposts lie on their shores. Impressionism, which came before us with names like Renoir and Cézanne, is our cradle. We have pushed the *liberation further*, but we have never gone beyond the areas that they make perceptible, and our work is closely tied to the earlier epochs.

The economic and social events to which we are linked have somewhat affected the scheme of artistic achievement. Easel painting, born with individualism, has become the current form for most pictorial works. It was the advent of individualism that imposed this form on us. To have the picture you like *for yourself*, in your house; to put together individual collections, that's where we are.

In the past, pictorial art was closely bound up with architecture— mosaics, frescoes. The painter-artist submitted to architectural limitations. This was the *great* order in antiquity, which I hope to see revived. Of course the creative position is no longer the same as it was then. The extreme freedom in *easel painting* has permitted some mistakes, but also wonderful inventiveness.

Architectural necessities restrict us to a given dimension. Individ-

ualism must suffer. You must work in collaboration. The simplified and rational architecture that is going to conquer the world must serve as a possibility for reviving this collective art that created immortal masterpieces before the Renaissance. The evolution of society may be tending toward this new order. Easel painting survives—and will always survive—but it can be broadened by the Renaissance mural.

Here we touch on the essential point of this lecture. The question is fraught with consequences and perhaps with argument. I ask the distinguished architects here to be kind enough to remember that I am their friend, that I deeply admire their architectural and social work, and that, among modern painters, I am perhaps the one who has the closest *contact* with the new builders. But I do not forget that I am a painter and I must tell them several small truths or what I think are such. If they are "moved" to respond, I cannot ask anything more.

Right now, there is a worldwide catastrophe that results from some *extreme excesses* with which we are now struggling.

America has gone too far in forgetting that raw material, and not its dollar-value, is important.

Ask an American:

What is cotton? *I don't know.*

What is the price of cotton? *I know.*

How much cotton is there in the world? *I don't know.*

What are your profits? *I know.*

Wall Street *has gone too far* in turning everything into speculation. Wall Street is an amazing abstraction, but catastrophic. *American vertical architecture has gone too far* in forgetting that a forty-story building must disgorge all its human content at the same time and at the same places. A traffic jam. New York, that colossal paradox, is the *slowest* city in the world.

The modern architect, he too, *has gone too far*, in his magnificent attempts to cleanse through emptiness. He had to do it. The young men whom I admire build, and it is new, with air and light—these are their new raw materials. They have magically dispelled the feeling of weight and volume that we have always suffered under. The intoxication of emptiness, revolution; for there is a revolution. Revolution and pride—a violent rupture with the previous state of things. An elite has followed them. Every revolution has its elite minority. *That is fine as*

far as it goes. It is an easel architecture, an individual architecture, that responds to a limited demand. But the formula is spreading. "Urbanism"—they want to give up the *easel* position, to become socially involved. Be careful! Here is the tragic point. The revolution that consists of destroying and stripping clean is finished. They are going to build, they are going to tackle the average man, the crowd, which until now *has surrounded itself with knick-knacks and wall hangings, which has lived in the decorative complex.*

In this new bareness, a gigantic unexplored pile of junk that was thought dead is coming back to life.

Modern buildings have put the individual "ahead of the wall" to such a point that the furniture itself fits into the wall. The wall swallows it and closes up; its surface becomes smooth again.

The stripping away goes as far as that; they no longer tolerate even the volume of the furniture. So, no more volume, no more form; an impalpability of air, of slick, brilliant new surfaces where nothing can be hidden any longer. Even shadows don't dare to enter; they can't find their places any more. It is a modern minotaur, drunk with light and clarity, who rears up before the little modern fellow, who has hardly gotten over his knick-knacks and his frills, and thinks of them all the time.

"Nature abhors a vacuum." The average man is lost in front of a large dead surface. He gropes around, he looks for a way to save himself. He gets dizzy, he is not prepared. *It is a revolution—which catches him unaware.* There he is, the average man, a human cipher before this pitiless new reality—the modern wall.

To distract you from this interior wall over which I am battling with my friends, I am going to talk to you about the exterior wall, bordering the roads of the world.

In many countries, above all in the north, people have a tendency to put color on the outsides of their houses. I admit that I prefer the village walls in my country or in the southern countries, where the houses *show their age like people.*

The old French villages carry the marks of time on their walls and their stones.

The north, young and less individual, colors, decks out, and restores things ceaselessly. It is the decorative life. No one admits his age. It is

less moving but more enjoyable. It is a kind of courtesy of the road, a pleasure that wants to hide reality, it is training.

But the other wall, the large, terrible interior wall that waits for you once you close the door, we must go on talking about that. Many architects want to keep it the way it is. They are going too far.

It is a revolutionary position and as such is in the *minority*, and our responses can profit from it. Artistically, *bravo*; it is a work of art. Socially, *it is dangerous*, because it is not work that takes society into account. My architect friends, we should be able to get together about this wall. You want to forget that painters are put into this world in order to destroy dead surfaces, to make them livable, to spare us from overly extreme architectural positions.

Why is what was possible during the eighth and twelfth centuries not possible today? Man *has not changed*. It is terrible, but accurate. *Objects change. Taste changes.* Food changes, but there is the famous matter of *quantity* that doesn't change.

I think, my dear architects, that you have reached *the irreducible quantities.*

Men always eat the same amount, always sleep the same amount, they always live and die after about the same lifespan.

They want their quantity of livable space inside. The problem is deeply human, especially when you are dealing with the "average person." The "limitations" become evident; the necessities assert themselves. If you destroy, in time you must invent the famous *"value of substitution."*

There is a gap between the tendency of the new architecture and the average, habitable city dwelling. It is a dangerous empty space, a point at which the worst reactions may infiltrate—and find reasons for developing.

The elite has followed you, agreed, that's easy enough; but the others, the average group, *has not been able to*. You set off at top speed, with heads held high, and a disdainful expression toward an ideal end that I admire profoundly, but in this race toward absolute Beauty, you have to glance behind yourselves all the same. You are alone, *they haven't been following you!*

You have to stop and ask yourself to what extent that world that is out of breath, which you no longer see behind you, to what degree it is

capable of *fitting in with your rhythm* and this new *standard of life.*

Out of pride, you haven't wanted to call in the painter who is waiting at the foot of the stairs. Nevertheless, this decent, modest fellow, amazed at your speed, would have served to fill in the gap between your theoretical concept and the obligations imposed by human limitations.

He is waiting for your decisions. The painter, this enemy of the dead surface, can get along with you. He accepts the No. 2 spot; he is king of the easel painting. Don't interfere with that. He is God himself. There he also has his pride, his "obstinacy"; *if you don't want to deal with that, leave him alone.* But with you, my dear architect, in part-nership, he will accept your measurements, your limitations—perhaps as much as 50 percent. My dear painter, you will say to him with a slightly haughty air, here I would like 11½ feet by 4 feet in *bright colors.* Good, my dear architect, he would say modestly, I will do that for you.

What must be achieved is an agreement among *the wall—the architect—the painter.* It would have been possible to arrive at this. You abandoned the partner, and some slight difficulties appeared be-cause of the split. There has been a violent reaction against which we must fight *all together*; we must go into battle.

You have wanted to dispense color yourselves. *Allow me* to tell you that in an era like ours when everything is specialized, that is a mistake on your part.

The carpenter does not make wrought iron, that I know. What right have you to dispense color? The era of the specialist condemns you. The contract among the three of us, the wall, you, and me, must be adhered to.

Why have you broken it?

I am not angry, and I am waiting. I think the event is going to happen and that, arm-in-arm, the wall, you, and I, we will achieve the great modern works that are to be done.

The case will be even more certain when a public building must be constructed:

a house?

a factory?

a palace?

Three problems—have you solved them? Isn't there a little too much speed in the execution of your plans, which I find a little too much alike for these three problems? Carried away by your momentum, I think you have oversimplified a little too much.

The public work, the public building, is offered to the "average people," *who always run after you.* Are you going to take them into account? It is not a matter of *lowering yourself* in order to meet their desires. Never, the matter is on a higher level than that. It is not a matter of making "demagogic concessions," no. It is a human necessity that requires that in works or achievements affecting the people, the masses, the men who direct or commission these works must listen to the heartbeat of the masses. Under the pain of risking the worst mistakes, you must be able at least to watch them and listen to them breathing. The masses are full of good intentions, more perhaps than you think. Get in touch with them. You are members of society, my dear architects, and that enlarges enormously your position as artists: when one says social, one says human. You must not be afraid of getting your hands dirty while pondering the vital and essential qualities that these people possess. I repeat, the "public building" is more than social; it is for the people.

The Romanesque and Gothic cathedrals were for them. Their imposing plastic mass has stirred and held man in past centuries. Let's consider them, their planes and their surfaces: color and sculptural form simultaneously achieved beauty and a collective meaning, for the whole work is a unity. Freedom of detail, even obscene detail, was allowed; it had to be social, human, to combine laughter and seriousness. The Greek dramatists and Shakespeare understood this; their colossal but varied works mix the comic and the tragic, the beautiful and the trivial. Have they lost their unity by doing that? I don't think so. The public building remains intact and fulfills the desires of the masses.

How do you imagine the popular building? The day you decide, I'll beckon to you, and I'll bring my friend the sculptor with me, and I'll stop you. All three of us must enter into this matter together. That day they won't interfere. The painter rises to his feet and shouts truths like these, truths that should be written on the sky in letters of fire.

Color is a vital element, as essential as *water and fire.* It is a raw

material as useful as wheat. A red, a blue, do you know what that is, my dear architects? It is the equivalent of a steak, and just as necessary.

Color is essential, I repeat, *you can't live without it.* But who is responsible for dispensing color? We are. You've tried to do it, you have made planes seem to be in motion through the addition of tones. That is no longer the question. Color demands more than that, it is for us to activate color, working in a close relationship with you.

Our cathedrals, as I have told you, are the result of intelligent and sensitive collaboration. They are the achievement of many people. We must redraw the contract.

Color is not merely a simple, skin-deep satisfaction. I reject that; it is vital. Even animals are sensitive to it. Experiments have been made with certain insects; they were put in cages with colored surfaces— these insects choose their own color—when they are taken away from them, they come back to their own colored cage. Man is like that too, with his original instincts repressed, more or less admittedly in love with color.

This vast problem has not yet been fully explored in all its depth. It is a psychological concern rather than a matter of plastic satisfaction. Its action in society is as important as that of music; it must be developed.

Unpublished, 1933

Speaking of Cinema

Cinema is thirty years old; it is young, modern, free, and has no traditions. This is its strength. It sprouts in every corner of the district, like the brats of the poor, like the bistros; it is on an equal footing with the street, with life; it is in shirtsleeves. Mass-produced, ready-made, it is collective.

The American studios now build auditoriums made to order for it. It doesn't yet seem to be at ease there; that will come, it is going to adjust. It is becoming wealthy, but its extravagance is "nouveau-riche" and forward. It's all very modern.

Next to it, in the same street, the theater appears to be a slow, solemn old contraption, a little musty, tired out and going on foot.

The cinema and aviation go arm in arm through life. They were born on the same day. . . .

Speed is the law of the world.

Cinema is winning because it is rapid and quick. It is winning because it belatedly scrapped the junk of programs and curtain. Tragedy or comedy is swallowed up in one gulp without the blink of an eye; it fits very naturally into the contemporary rhythm.

Let's recognize that it possesses astonishing means, riches that it squanders at random. It has just been given a voice, the human voice; the image talks, is colored, seems to be three-dimensional.

Every month a new invention is added to the others; there is a pile-up of them. It swallows things the wrong way; it stuffs itself like a pauper who has suddenly become rich. . . .

The theater, modest and without hope, stays with its traditional heritage. The gap between the theater and the cinema is accentuated every day; the theater remains stationary; the cinema runs on at top speed, at the risk of falling on its face; it is young. . . . It is naturally romantic, it must astonish, distress, make us laugh and cry; it is full of sex with its beautiful girls and handsome boys who embrace each other in a close-up with mouths a foot wide and who stop in the nick of time to enable imagination to put the finishing touches on the story in the darkened theater. . . .

Only romantic deeds in wholesale quantities can stir the crowds. Cinema has to be popular in order to win the game, popular like a war, an earthquake, a beautiful ship, a victorious general.

Cinema must be in this class of events in order to be able to live and pay off the enormous sums of money it owes and consumes every day.

In the theater, the character is everything; the actor or actress has total responsibility for the performance, with all the chances or weaknesses that the situations involve. If the performer has a head cold, the play is postponed. Fragility! Can you imagine the Screen at the mercy of such petty calamities!

The cinema: here are complicated machines with the lighting fixed and planned. They put the little fellow in a certain position . . . and the beautiful glittering machine comes into action. . . . It is going to play with him, catch him full face, in profile, from above, below, and inside (X rays), in detail, in fragments, lying down, standing up, out of focus or sharp, any way you want. This will be swallowed, digested, and put on the screen in a tragic, comic, or plastic form; you can choose. . . .

The cinema is the machine age.

The theater is the horse-and-buggy age.

They will never understand each other, and let us hope that they don't, for the mixture is deplorable.

In spite of all its strength, its methods, its banks, its calculating machines, its light, the cinema has not killed the theater. The theater is still standing. Heyerhold has proved it at the Théâtre Montparnasse and

Crommelynck in his own controversial works. These two men have not mixed things together; on the contrary, they reacted against them; they weren't afraid. They understood that their life can remain beautiful and secure if they avoid contact. . . .

The theater continues. It is going to become invaluable and restful; people will speak more softly there than on the screen. Cinema wants to swallow it up; it will swallow nothing. They are not of the same world. Film swipes actors from the theater, but the actors turn to film only to "make a buck," once, that's all. They don't "give a damn" about it, for they realize that they are not made for this new gadget designed for spectacles. They act badly and sloppily. With all their vanity and pride, they are in their element only before the footlights in flesh and blood.

Cinema could be the worse for going and looking next door for what it should make itself. It ought to put up its own factory for silent and talking actors and not try to use theater people. Why don't these rich corporations have experimental studios where they can look for talent, so they could carefully avoid individuals who have been traditionally trained, theater people; where they would use an iron rod to train wholly new human material.

The strength of the silent comedians like Chaplin and Buster Keaton is their wonderful ignorance and their powers of instinct. They sensed that opening their mouths was stupid from the moment that cinema failed to record their words, and because of this they have become the most popular.

Now that the cinema talks, it's another story. Wait a little while. The "aces," I hope, are going to emerge and show us something new. A little patience. They will come to us from Russia or America, from countries where the human animal is "raw material," as remote as possible from the old and noble Latin traditions. But don't hope for anything from those ladies and gentlemen at the Comédie Française. . . .

It is the race for the "average" and the financial pressure that from time to time make the film industry not give a damn. Because it must make money by whatever means, it is too anxious about its audience, about success. It doesn't dare take "risks." Since they know that if they

have an attractive boy and a charming girl as the stars, they will have a success, they gamble on them to win. The rest isn't important; a scenario is patched together, and the trick has worked. All the same, it is a little facile; even the "average" stoops below the vulgar. . . . The theater never "falls" to the same extent. The "average" theatrical production is superior and often closer to true emotion.

True emotion, the thing that strikes home, is difficult to convey on the stage, for it is the opposite of the decorative life that we cultivate in order to hide and cover up the truth.

Diplomats invented the monocle to prevent their faces from reacting and thus admitting something. "A pair of pants is right when it has no creases." Manners were invented in order to "cheat on the merchandise."

Fear of the truth is the basis of the social organization. "The decorative life" suits it like a glove, conceals it, and people love to go to relax in this deceitful situation. Very few people like the truth, with all the risks it involves, and yet the cinema is a terrible invention for producing truth when you want. It is a diabolical invention that can unfurl and light up everything that has been hidden. It can show a detail magnified a hundred times. Did you know what a foot was before seeing it live in a shoe under a table, on the screen? It is as moving as a face. Before this invention, you never had the shadow of an idea about the personality of fragments.

Cinema gives "the fragment" personality; it sits in a frame, and thereby creates a "new realism" whose implications may be incalculable.

A collar button, put under the projector, magnified a hundred times, becomes a radiating planet. A brand-new lyricism of the transformed object comes into the world, a plasticity is going to be built on these new facts, on this new truth.

To feel the truth and to dare to express it.

I have dreamed of doing a film of "twenty-four hours," about an ordinary couple in an ordinary trade. . . . Some mysterious new apparatus makes it possible to film them "without their knowing about it." They are subjected to an acute visual inquisition during those twenty-four hours, with nothing escaping the camera: their work, their

silence, their private life, their love life. Show the film unpolished, with no editing. I think it would be a really terrible thing that everyone would flee from, scared to death, calling for help as if confronted with a worldwide catastrophe.

Cahiers d'Art, Paris, 1933

An amusement-park photograph of (*left to right*) Oswald de Andrade, Tarsila do Amaral, Yvette Farkou, Fernand Léger, Constantin Brancusi, and Maximilien Gauthier, July 14, 1926. (*Photograph from the Archives of Tarsila do Amaral.*)

Léger in his studio about 1935. (*Photograph courtesy of Editions des Trois Collines, François Lachenal, Geneva.*)

Léger at his desk about 1937, photographed by Maywald.

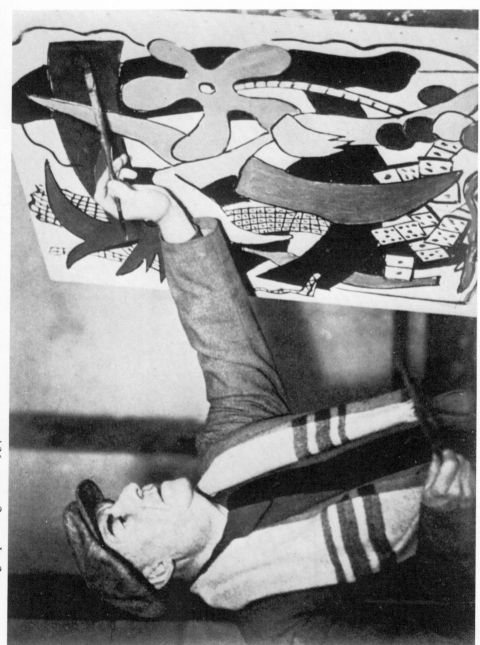

Léger painting about 1937.

The New Realism*

During the past fifty years the entire effort of artists has consisted of a struggle to free themselves from certain old bonds.

In painting, the strongest restraint has been that of subject matter upon composition, imposed by the Italian Renaissance.

This effort toward freedom began with the Impressionists and has continued to express itself until our own day.

[This battle is worth following, worth being studied and closely observed, for it is always very contemporary. It is a kind of revolution with extremely important consequences. The feeling for the object is already in primitive pictures—in works of the high periods of Egyptian, Assyrian, Greek, Roman, and Gothic art. The moderns are going to develop it, isolate it, and extract every possible result from it. Allegiance to the subject is no longer honored. The framework that dominates all Renaissance art has been shattered.]

The Impressionists freed color—we have carried their attempt forward and have freed form and design.

Subject matter being at last done for, we are free. In 1919 the painting *The Town* (*La Ville*) was executed in pure color. It resulted,

* This essay is based on a lecture delivered by Léger at the Museum of Modern Art, New York. Part of the lecture appeared in *Art Front* in 1935; sections appearing in brackets were drawn from the unpublished French text.—Ed.

according to qualified writers on art, in the birth of a world-wide publicity.

This freedom expresses itself ceaselessly in every sense.

It is, therefore, possible to assert the following: that color has a reality in itself, a life of its own; that a geometric form has also a reality in itself, independent and plastic.

Hence composed works of art are known as "abstract," with these two values reunited.

They are not "abstract," since they are composed of real values: colors and geometric forms. There is no abstraction.

[In this new phase, compositional freedom becomes unlimited. A total freedom, permitting compositions from the imagination in which creative fantasy can emerge and develop. This *object*, which was encased in the *subject* matter, becomes free; pure color that could not be asserted independently is going to emerge. It becomes the *leading character* in the new pictorial works.]

Subject matter being destroyed, it was natural that the problem of the movie scenario should be taken up next. Two art films were completed between 1923 and 1924. The *Ballet Mécanique* and *Entr'acte*.

Freedom was achieved in every realm—the *Ballet Mécanique* set out to prove that it was possible to find a new life on the screen without a scenario, through making use of simple objects, fragments of objects—of a mechanical element, of rhythmic repetitions copied from certain objects of a commonplace nature and "artistic" in the least possible degree. Montage is purposeful contrast through slow motion and speed-up. It aims to work out in the movies an interest in the isolated object on the screen, as well as in painting.

Entr'acte likewise expresses the will toward freedom. It is the expression of the Dada era. The desire to flatten out everything that is solemn, respectable, too much taken-for-granted, too indisputable—and thus to open the door to the freest fantasy.

These two films are a landmark in the history of plastic revolutions.

This analysis of the isolated object can go beyond simple artistic and pictorial relations. I should maintain, for example, that, from the dramatic viewpoint, a single hand which slowly appears on the screen and reaches toward a revolver is more dramatic than if one beholds the whole actor.

[A foot in a shoe, under a table, projected and magnified ten times, becomes a surprising fact that you have never noticed before. It takes on a reality, a new reality that does not exist when you look at the back of your leg unconsciously while you are walking or sitting. An isolated cloud, alone in the blue depths of the sky, often has a pattern and relief of a richness that you might not discover when it is part of the landscape. Scientific research also has enabled artists to isolate this new reality. Underwater plants, infinitely tiny animals, a drop of water with its microbes magnified a thousand times by the microscope, can become new pictorial possibilities or permit a development in decorative art.

[One then understands that everything is of equal interest, that the human face or the human body is of no weightier plastic interest than a tree, a plant, a piece of rock, or a pile of rope. It is enough to compose a picture with these objects, being careful to choose those that may best create a composition. It is a question of choice on the artist's part. An example: if I compose a picture and use as an object a piece of tree bark, a fragment of a butterfly's wing, and also a purely imaginary form, it is likely that you will not recognize the tree bark or the butterfly wing, and you will ask "What does that represent?" Is it an abstract picture? No, it is a representational picture. What we call an abstract picture does not exist. There is neither an abstract picture nor a concrete one. There is a beautiful picture and a bad picture. There is the picture that moves you and the one that leaves you indifferent. A picture can never be judged *in comparison* to more or less natural elements. A picture has a value in itself, like a musical score, like a poem. Reality is infinite and richly varied. What is reality? Where does it begin? Or end? How much of it should exist in painting? Impossible to answer.]

A hand—a leaf—a revolver—a mouth—an eye—these are "objects."

The sentiment of beauty is completely independent of our comprehensive faculties—emotion, admiration, belong to the realm of sensibility.

"What does that represent?" has no meaning. For example: With a brutal lighting of the finger-nail of a woman—a modern finger-nail, well-manicured, very brilliant, shining—I make a move on a very large

scale. I project it enlarged an hundredfold, and I call it—"Fragment of a Planet, Photographed in January, 1934." Everybody admires my planet. Or I call it "abstract form." Everybody either admires it or criticizes it. Finally I tell the truth—what you have just seen is the nail of the little finger of the woman sitting next to you.

Naturally the audience leaves, vexed and dissatisfied, because of having been fooled, but I am sure that hereafter those people won't ask any more of me and won't repeat that ridiculous question: "What does that represent?"

There was never any question in plastic art, in poetry, in music, of representing anything. It is a matter of making something beautiful, moving, or dramatic—this is by no means the same thing.

If I isolate a tree in a landscape, if I approach that tree, I see that its bark has an interesting design and a plastic form; that its branches have dynamic violence which ought to be observed; that its leaves are decorative. Locked up in "subject matter," these elements are not "set in value." It is here that the "new realism" finds itself, and also behind scientific microscopes, behind astronomical research which brings us every day new forms that we can use in the movies and in our paintings.

[One does not explain art. It is in the domain of the sensibility, which can and must be developed. I had an opportunity to talk with the French doctor Perrin, and he told me: "For us, too, 80 percent of our scientific discoveries come from the realm of pure sensibility." Deductive logic is cold and has never given us anything other than solemn and academic professors.

[Education is possible. It exists. There is proof of that in the evolution of modern decorative art. The merchants and the manufacturers felt that this famous *object* had advertising value. They arranged window displays showing the objects of their trade in their most favorable light—5 pairs of stockings set on a colored backdrop made more of an effect than 200 pairs piled up on top of each other. The whole commercial world understood; they use the *advent of the object*.]

The commonplace objects, those of the *Ballet Mécanique*, objects turned out in a series, are often more beautiful in proportion than many things called beautiful and given a badge of honor.

It is also "new realism" to know how to employ in decorations raw materials such as marble, steel, glass, copper, etc.

At this point, I cannot refrain from commenting upon two recent feats which possess considerable importance as modern creations. I mean—a French feat, the steamship *Normandie*, and an American feat, Radio City. The *Normandie*, unfortunately, fails to fulfil our hopes from the viewpoint of interior decoration. It is a retrograde conception which belongs somewhere between the taste of the eighteenth century and the taste of 1900.

[It seems a shame to have to say this in front of an American audience, but] the French, who have a heavy artistic tradition behind them, often make such errors. They forget that they constructed the Eiffel Tower fifty years ago—and that's just too bad! Naturally, it's always easier to look backward, to imitate what is already done, than to create something new.

Radio City, on the other hand, is the true expression of modern America. Apart from certain decorations which, to my mind, are not architectural, the rest is absolutely perfect. The raw materials I spoke of above are used there with a great deal of talent and appropriateness. The steel door is very much in place in a marble frame.

America knows how to make things luxurious while making them simple. And it is a social luxuriousness, luxury through which crowds circulate. It was necessary to discover that—and it has been done.

To create luxury by means of complication and piled-up decoration, that is all old art. To create luxury with simplicity, that is the modern problem, and Radio City has solved it.

Color, being a new powerful reality, ought to be kept "under surveillance," whenever it comes in contact with architecture. It ought not to overflow nor encroach upon the walls, as in the case of the monuments of the Italian fifteenth century. The architect ought to defend himself against the painter who has too great a tendency to "slap it on thick."

Once these conditions can be taken for granted, it ought to be possible to achieve the unity of three arts: architecture, painting, and sculpture.

We shall see some day, I hope, vast modern monuments that will stand as the Acropoles of tomorrow.

Art Front, New York, 1935
(Translated by Harold Rosenberg, unpublished in France)

The New Realism Goes On

Each art era has its own realism; it invents it, more or less, in relation to preceding epochs. Sometimes this is a reaction, at other times a continuation of the same line.

The realism of the Primitives is not that of the Renaissance, and that of Delacroix is diametrically opposed to that of Ingres.

To undertake to explain the why and the wherefore is out of the question. The thing is obvious; the reasons for it would likely muddle rather than clarify matters. What is certain is, that there is no one era possessed of a beauty that is typical, a higher kind of beauty, which might serve as criterion, basis, point of comparison. When the creative artist is filled with doubt, there is nothing to justify his seeking to attach himself to some standard of judgment set up in the past. He must run his own risks. His loneliness is great.

Such is the drama lived through by all men upon whom has been laid the destiny of inventing, creating, constructing.

The mistake of the schools lies in having sought to set up a hierarchy of quality (the Italian Renaissance, for example); this is indefensible.

Realisms vary by reason of the fact that the artist finds himself always living in a different era, in a new environment, and amid a general trend of thought, dominating and influencing his mind.

For a half-century now, we have been living in an extremely rapid age, one rich in scientific, philosophical and social evolutions. This

speed has, I think, rendered possible the precipitation and the realization of the new realism, which is quite different from the plastic conceptions that have gone before.

It was the Impressionists who "broke the line." Cézanne in particular. The moderns have followed by accentuating this liberation. We have freed color and geometric form. They have conquered the world. This new realism wholly rules the last fifty years, in the easel picture as well as in the decorative art of street and interior.

As for those pictures which made possible this evolution, the common reproach is that they have been snatched up by the dealers and the big collectors and that the people have no access to them. Whose fault is it? That of the present social order. If our works have not made their way among the people, the fault, I repeat, is that of the social order; it is not due to any lack of human quality on the part of the works in question. Under such a pretext as the latter, they would have us burn our bridges, coolly pass sentence of death upon that painting which brought us our freedom—a freedom so hard won—and turn our steps backward, God knows where. The names of Rembrandt and Rubens are evoked.

Under the pretext that we are to attempt to win at once the wholly admirable masses, whose instinct is so sure, and who are merely waiting to grasp the new verity—under such a pretext, they would have us start those same masses backward from century to century, traveling at first by rail and, later on, by horse and buggy and by cart, until they end up "going in for the antique" on foot. This is an insult to these men of a new world, who ask nothing better than to understand and to go forward. It is officially to pronounce them incapable of rising to the level of that new realism which is their age—the age in which they live, in which they work, and which they have fashioned with their own hands. They are told that *le moderne* is not for us; it is for the rich, a specialized art, a bourgeois art, an art that is false from the bottom up.

It *is* possible for us to create and to realize a new collective social art; we are merely waiting for social evolution to permit it.

Our tastes, our traditions incline to the primitive and popular artists of before the Renaissance. It is from this same Renaissance that individualism in painting dates; and I do not believe there is any use in

looking in this direction, if we desire to bring into being a fresh mural art, one that shall be at once popular, collective and contemporary. Our age is sufficiently rich in plastic materials to furnish us with the elements. But unfortunately, until new social conditions shall have been brought about, the people will fail to benefit from those elements.

I should like to say a word as to leisure—the creation and organization of leisure for workers. That, I take it, is the cardinal point of this discussion. *Everything depends on it.*

At no period in the history of the world have workers had access to plastic beauty, for the reason that they have never had the necessary time and freedom of mind. Free the masses of the people, give them the possibility of thinking, of seeing, of self-cultivation—that is all we ask; they will then be in a position to enjoy to the utmost the plastic novelties which modern art has to offer. The people themselves every day create manufactured objects that are pure in tonal quality, finished in form, exact in their proportions; they have already visualized the real and the potential plastic elements. Hanging on the wall in the popular bals-musettes, you will find *aeroplane propellers.* They strike everyone as being objects of beauty, and they are very close to certain modern sculptures.

It would require no great effort for the masses to be brought to feel and to understand the new realism, which has its origins in modern life itself, the continuing phenomena of life, under the influence of manufactured and geometrical objects, transposed to a realm where the imagination and the real meet and interlace, a realm from which all literary and descriptive sentimentality has been banished, all dramatization such as comes from other poetic or bookish tendencies.

Modern architecture, which came into the world with modern painting, offers them the possibilities of an existence that is infinitely superior and rational, compared to that afforded by previous forms. Lurçat's communal school at Villejuif is, as I see it, a hopeful precedent. And it is an altogether different life for workers that is made possible by Le Corbusier's two great gifts to us: the white wall and light. Let us learn to make use of all this, to cherish it, and let us see to it that, *here too*, we take no backward steps by putting up the hangings, the wall-papers, and the gewgaws of the year 1900.

The working class has a right to all this. It has a right, on its walls,

to mural paintings signed by the best modern artists. Give it time and leisure, and it will make itself at home with such paintings, will learn to live with and to love them.

What kind of representational art, may I ask, would you impose upon the masses, to compete with the daily allurements of the movies, the radio, large-scale photography and advertising? How enter into competition with the tremendous resources of modern mechanics, which provide an art popularized to a very high degree?

An art popular in character but inferior in quality—based upon the excuse that they will never understand anything about art, anyway— would be unworthy of them. On the contrary, quality is the thing to be sought, in an art that is interior and easy to live with. We must look for a field of plastic beauty that is quite different from the one just described.

This does not mean that painters may not place themselves at the disposition of those who get up popular affairs—by way of arranging the color scheme, for instance, unleashing color where this is desirable —pure color, dynamically laid on, may visually destroy a wall. Color brings joy; it may also bring madness. In a polychrome hospital, it may be a curative agent. It is an elemental force, as indispensable to life as water and fire. It may exalt the impulse to action to an infinite degree; it may well stand up to the loud-speaker, being of the same stature as the latter. There are no limits to its use, from the slightest shading to a dazzling burst.

In this domain, where it is a question of manifesting life's intensity under all its aspects, there are some wholly new possibilities—scenic, musical, in the way of color, movement, light, and chant—that have not as yet been grouped and orchestrated to their fullest extent. The man of the people comes into the world with a feeling for beauty. The ditch-digger who prefers a blue belt to a red one for holding up his trousers is making an act of choice. His instinctive judgment passed upon manufactured objects is esthetic in character. He will say "the pretty bicycle," "the nice car," before he knows whether or not it will function. This in itself indicates an acceptance of a fact: the new realism. Seductive shop windows where the isolated object causes the prospective purchaser to halt: the new realism.

All men, even the most stunted, have in them a potentiality of

meeting the beautiful half way. But in the presence of the art work, the picture or the poem, if their leisure—I must insist upon it—does not permit them to cultivate this potentiality, they will go on, all their lives, forming their judgments by comparison. They will prefer Bouguereau to Ingres, for the reason that Bouguereau is the better imitator. Judgment by comparison is not valid; every art work calls for an individual appraisal, it is an independent whole; and if men are given assistance, they will succeed in making such an appraisal. The human masses, demanding their place in the sun, the man of the people—let us not forget that they are poetry's last great refuge.

The man of the people it is who invents that mobile and ever new form: popular speech. He lives in an atmosphere of incessant verbal invention. While his hand is tightening a bolt, his imagination runs ahead, inventing new words, new poetic forms. All down the ages, the people have gone on inventing their language, which is their own form of realism. This language is unbelievably rich in substance. *Slang* is the finest and most vital poetry that there is. Popular actors, popular singers make use of it in the neighborhood theatres. They are the masterly inventors of it. This verbal form represents an alliance of realism and imaginative transposition; it is a new realism, perpetually in movement.

And is this class of mankind to be excluded, then, from those joys and satisfactions which the modern art work can give? Are the people to be refused "their chance" of rising to a higher plastic level, when they themselves every day are inventing a new language that is wholly new? That is inexcusable. They have the right to demand that the time's revolution be carried out, and that they in their turn be permitted to enter the domain of the beautiful, which has always been closed to them up to now.

Art Front, New York, 1937
(Translated by Samuel Putnam, unpublished in France)

Color in the World

Color is a vital necessity. It is raw material indispensable to life, like water and fire. Man's existence is inconceivable without an ambience of color. Plants and animals are naturally colored; man dresses himself in colors.

His action is not merely decorative; it is also psychological. Connected with light, it becomes intensity; it becomes a social and human need.

Feelings of joy, emulation, strength, and action are reinforced and expanded through color.

Color functions in the defense of animals by camouflaging them. Grimacing and violent on a Chinese or an African mask, it is frightening. Its useful and vital effects have hardly been explored.

The world has always been concerned with color; the clothing of the Middle Ages is dazzling.

The eighteenth century grasped all its nuances, but the countryside, the towns remained gray and colorless. Suddenly after the war, walls, roads, objects became brilliantly colored. Houses were decked out in blue, yellow, red. Enormous letters were inscribed on them.

It is modern life, shattering and brutal.

How did this come about?

Let us go back before the war.

At that time, there were few colors on the walls; the street was calm. The countryside had its trees, its plants, its flowers; they were brought into the home; they were part of the family. A yellow canary, a red flower were colored events.

The war came. The war was gray and camouflaged; light, color, tone were forbidden on pain of death. A life of silence, a nocturnal, groping life; everything the eye could register and perceive had to be hidden and disappear.

Nobody saw the war—hidden, disguised, creeping on all fours, earth-colored—the useless eye saw nothing. Everyone "heard" the war. It was a vast symphony that no musician or composer has yet equaled: "Four Years Without Color."

1918: Peace. Man, exasperated, tensed, depersonalized for four years, finally raised his head, opened his eyes, looked around, relaxed, and rediscovered his taste for life. A frenzy of dancing, of spending . . . able at last to walk upright, to shout, to fight, to waste. . . . Living forces, now unleashed, filled the world.

The yellow canary and the red flower are still there, but one no longer sees them: through the open window, the wall across the street, violently colored, comes into your house. Enormous letters, figures twelve feet high, are hurled into the apartment. Color takes over. It is going to dominate everyday life. One will have to adjust to it.

The man of 1921, having returned to normal life, retains inside himself the physical and moral tension of the harsh war years. He is changed; economic struggles have replaced the battles at the front.

Manufacturers and merchants face each other brandishing color as a weapon of advertising.

An unprecedented, confused riot of color explodes on the walls. No curb, no law has come to temper this overheated atmosphere that shatters the retina, blinds us, and drives us mad.

Where are we going? Quite simply, we are going toward a rapid evolution in external plastic life, which will develop logically until its means are exhausted, until something else is discovered.

Moreover, the child adapts himself to this new environment very well; he evolves in it like a fish in water. He was born in it, he has not known the nuances of tone on tone, the sweet grisaille of the prewar years; the atmosphere of Corot is strange to him. Color is before him

while he is in his cradle, and the photographic montages, the giant figures that adorn the cinema, seem completely natural to him. The adult must acclimate himself in turn.

The need for a rest makes us go for a while to the quiet countryside, but for only a few days; life, intensity regain the upper hand. You plunge in and settle down.

I think that, if one wanted to, one could organize this whole riot of colors. There is a possible plan for distributing colors in a modern town: a red street, a yellow street, a blue square, a white boulevard, some polychromed buildings.

On ocean voyages, while leaning on the boat's railing, confronted by the immense monotony of the water's surface, I have often thought how astonishing it would be if I suddenly spied a sea serpent, a hundred yards long, luminous and colored.

The world courts intensity. Speed is the contemporary law. It flows over us and dominates us; this is a transitional era; let us accept it as it is.

But let us recognize that a new plastic life is born out of this chaos. A new order is trying to emerge. In a certain way, the street organizes itself. By the street, I mean the shop windows, the window displays that become spectacles. There a desire for order is set up. Instead of a thousand objects piled up on top of each other, ten are shown, well presented, to best advantage, and the arrangements are attractive, as well, more so than the old style was.

Quality replaces quantity. The shopkeeper has understood that the object he sells has an artistic value in itself if he knows how to make the most of it. This is the beginning of a new plastic order, a new popular art. It is a supremely important event.

The development of the art of window display precedes the renaissance of mural art. Murals turned out to be one of the very new aspects of the 1937 Exposition.

Modern painters, who have all produced easel pictures over the last fifty years, are invited to tackle the problem of the mural.

It must be acknowledged that they are hardly prepared for it. The event is significant because it means the resurrection of collaboration among three arts—architecture, painting, and sculpture; teamwork toward more or less social goals.

Like the painter, the architect is facing a new problem. Will he know how to resolve it?

A state of discipline, of mutual concessions and restraints, will have to operate in three directions. It is a great gamble, and we can no longer avoid it. I have always thought that the architect's profession was incomplete insofar as it has not resolved the interconnection among the three fundamental plastic elements.

An architectural structure is composed of live surfaces and dead surfaces. The dead surfaces are reserves of repose; they will not be touched. The live surfaces are organized for form, for the painter and the sculptor.

The architects of the Italian Renaissance lacked willpower and allowed painters and sculptors to encroach on their terrain. Certain Roman palaces and buildings are unbearable because of the accumulation of paintings and sculptures that took over every restful surface.

Nevertheless, the problem is workable enough, since volume and color—which can be regulated and distributed—are reduced or increased according to the demands of light or surface.

A very well-lighted section of a structure will have subdued colors and a dark section the opposite.

If the facts of construction necessitate voluminous masses—columns, reliefs—then a rather unassertive accompanying color can be utilized, an architectural liaison that is static or dynamic, depending on the need to be fulfilled.

One needs to spread colors around a building.

Let us avoid, if you really want to, the question of pictures with expressive educational or social significance, of which, I hope, the fewest possible will be seen. Let us take up the problem at its starting point: *the need for color*. Man loves color and has a horror of emptiness and blank walls. That we know. People are going to cover the walls. But as much as possible it should be done simply, through the application of color with no significance other than color itself (perhaps evocative objects can operate within it); color is in itself a plastic reality. It is a new realism.

A highly organized plastic order, the opposite of the confusion seen in the advertising that mangles modern towns.

The ideal would be to reach a sensation of "beauty," of balance, of physical and moral satisfaction.

Because of the encounter among the three arts that took place in 1937, perhaps it would be well to talk a little about it.

I am addressing myself to comrades, to friends who, with us, have led the battle for the modern for twenty years:

Under the same formula of art, it is possible to devise concepts for housing, factories, public buildings.

Some painters for whom I am speaking here think that this is oversimplifying the question and believe that the three aims demand very different concepts. The architect addresses himself to the average man. Let us follow him. He leaves his home, he goes to his factory or to his office, and he passes a palace or a public building or a factory. He is able, with difficulty, to conceive that these three structures resemble each other.

Among the intimacy of his apartment, the rational organization of the factory, and the probable need for the spectacle of the public building, I believe there is room for three different styles. This is the question.

The modern monument will certainly be spectacular and magnificent as far as the exterior goes. One can conceive of the interior as beautiful, tranquil, and balanced—a result that has never been achieved except in certain primitive periods.

Color can enter into play with a surprising and active force without any need to incorporate instructive or sentimental elements. A wall can be destroyed by the application of pure colors. This can be simply illustrated. A wall can be made to advance or recede, to become visually mobile. All this with color. As I said before, one can create a colored accompaniment.

The composer Erik Satie was haunted by the desire to achieve music that would be an accompaniment, a music with no purpose that glides along undemandingly, that is heard but not listened to. He said that social contact would be considerably improved if we knew how to solve this problem of acoustic possibilities, for example, in a restaurant dining room, a public place, or in a household.

Two people are seated at the same table, they chat together but not all the time. They did not come to the café to listen to music, so one

must devote oneself to "furnishing" their silence, preventing it from becoming embarrassing, keeping them from breaking the silence when they don't feel like it.

Intelligent and fugitive background music that flows over you without involving you too much, that allows you to talk or to be silent in a nondeliberate atmosphere.

Background music that is not listened to but is present anyway and is responsible for "furnishing" the embarrassing silences.

Satie was right.

The problem can be the same in architecture if you want. Incidental painting. It is a new arrangement. There are others.

The question is not resolved, but one can imagine a real satisfaction from this new and modern procedure. Contemporary industry puts absolutely remarkable ornamental and decorative materials at our disposal—colored glass, multicolored cement, steel, bronze; all the alloys—aluminum, duraluminum, and others. These materials intrinsically have considerable plastic vitality, an active and decorative richness that can be used in modern architectural interiors. That is part of the realm of "incidental art."

The work of art will be the orchestration of all these plastic elements harmoniously grouped together.

The modern machine creates beautiful simple objects, without ornamentation. They will be put to use.

Let us not forget that the popular judgment on this was handed down a long time ago.

It says spontaneously, "the beautiful airplane," "the beautiful car"— because of the practical form and beautiful materials that I have mentioned.

It is somewhat precious to observe that the instinctive judgment of the masses is always an expression of beauty.

Having to know whether something can be of use to them, they say: "The beautiful bicycle!" Why? That is not explained.

Popular judgment is free only at the moment when it is confronting the everyday object. The rest of the time it is falsified by traditional education. There is a profound tragedy here that separates the modern artist from the people who are nevertheless so instinctive and so creative. The people are a poet. Poetry, abandoned by the ruling

classes, has taken refuge with them. There the people invent freely.
Every morning they invent their language, which is slang. Slang is
spontaneous poetry, the mobile and elusive verbal poetic image.

The people live in a continually poetic atmosphere. They live in the
middle of modern objects that they judge beautiful, pretty, magnifi-
cent: cars, airplanes, machines. . . . Why couldn't they be qualified one
day to understand modern art? Why won't their need for beauty reach
that far?

There is a difficult and agonizing problem for modern painters freed
from the representational subject, whose pictures are understood by the
elite who own their works and by museums; these same artists are
currently confronted with the invitation to express themselves and to
work for new collectivities. . . . What are they going to do?

These masses, who are finally going to attain leisure time after
centuries of struggle, these masses who will be able to stop, look
around, reflect, what are we going to do with them? First they must be
given time to cultivate themselves. They ought to begin in grade
school. Children ought to be surrounded by beautiful objects
and beautiful pictures, so that when they become adults their artistic
formation will be much easier. Children's drawings are generally beau-
tiful and always very inventive. Children do not copy nature. They
invent until the age of eight; then comes the intelligence that destroys
the creative instinct, and they copy, and nothing of quality remains.
The masses must educate themselves.

They must be able to go to museums. A classification will be estab-
lished in their minds. Slowly they will evolve toward beautiful things
. . . provided that the contemporary artists do not rapidly turn out an
inferior art for them under the pretext that it will be understood more
readily. You must have faith in the masses and let them climb very
gradually. It will be long, for the plastic arts are the result of the
cultures of different races and civilizations. It will be difficult, for as
yet there is no example of the masses having had access to the
beautiful and to its expression.

The people of the ancient worlds were never able to liberate them-
selves sufficiently to be able to enjoy works of great quality. It was
always a cultivated elite alone that had the right to the advantages of
artistic works.

The people have submitted to and accepted the Egyptian, the Roman, the Gothic; the whole Middle Ages, so rich in collective arts, have entirely eluded them.

We are reaching a period when, I believe, this event will become possible; it is a beginning. An artistic culture is about to be born. A decorative art, a mural art, will be achieved. This will be the collective art of tomorrow. But this new art will still depend on individual creation.

Easel painting dominates and will dominate the contemporaneous artistic evolution for a long time yet. The isolated man, insofar as he is an individual creator, will control the direction of the arts and the plastic occurrences for a long time to come. The easel painting is his proper means of expression. It is the art object that is valuable in itself, depending neither on architecture nor on social movements, whatever they may be.

It embodies the plastic life organized in a frame, with its limits and its restricted emotion. It is the rare and precious object, more than a jewel, more than a diamond, more than gold or silver; it is a throbbing essence, enclosed in a frame.

In every country of the globe, immense palaces have been built to preserve and receive these pictures. Churches of Beauty, a religion of the picture wherein the history of a country, a race, a civilization is inscribed in an infinitely more just, more profound manner than in the books filled with battles and generals. The frontiers of civilizations are marked by their works of art. Latin expression will never be confused with Nordic expression. Geography lays down the law, and geography is immutable.

If a foreigner wants to know France, I would advise him to visit the Louvre rather than the Military Museum.

The easel picture always dominates its epoch.

All the minor arts, decoration, window display, publicity, fashion, are entirely dependent on it. The easel picture profoundly expresses the tendencies of a country's sensibilities. For example, if one wants to survey French painting from the fourteenth century to the present, two currents, two schools, are distinguishable: one classic, starting with the primitives and including Poussin, David, Ingres, Corot, Rousseau, who express themselves through a technique utilizing local color.

The other, more romantic, current, which begins in the eighteenth century and includes Delacroix, the impressionists, and the surrealists, employs diffusion of color to express a tendency opposite from that built upon local color.

The battle is still taking place and always will. The modern school, the School of Paris, which is very individualistic, nevertheless reflects one or the other of these two tendencies; they overlap, intermingle, and react against each other. This collision of the two trends creates a plastic vitality that saves the country's creative genius. Let us hope that this duality will always exist, that it clashes, that it struggles, even hates itself. It is an assurance of creative vitality.

Behind this closely interwoven battle, the minor arts wait patiently for the game to be decided so that they in their turn may start behind the winner. In this realm of the arts of taste that will stamp an epoch of perhaps half a century, a hair style, a hat, a kind of make-up will appear without our really knowing how or why.

A street will be transformed in the types of its spectacles—a music-hall revue, an international exposition. Its appearance will have a common standard; a governing idea of taste will make this whole immense and very varied production harmonious. Where does it come from?

Look for its origins, rummage around a little among the individual productions, the key works of painting, sculpture, music, which saw the light several years earlier and were exhibited or presented in expositions or in galleries.

Look carefully and you will find in some picture by a creative artist the origin of, the solution to, this problem. Ten years earlier, maybe five years earlier, the initial feat was achieved, shown; the minor arts saw, absorbed, and used it, and took maximum advantage of it. Only then were they able to begin the conquest of their epoch.

For fifty years they will be responsible for decorative ideas, taste, and fashion.

For example, where should we look for the tradition of the pictorial works of the last twenty years?

This tradition is very far from impressionism, which gave birth to it. You must go further back, skipping the nineteenth, eighteenth, seventeenth centuries, to the sixteenth century; that begins to link up. Our

traditions—if one really needs to name them—are the high periods, the primitives, the Egyptians, the early Greeks, and the popular arts.

The reason for this is that the state of total modern liberation finds its counterpart in the periods that flowered under the same situation of creative liberty.

The Italian Renaissance, which imposed imitation upon the art of imagination, weighs heavily on the average taste.

Naturally it is easy to judge by making comparisons with it, but that proves nothing.

Very much to the contrary, the sensuality and the spectacular qualities of fifteenth-century works do not destroy the older, preceding works that have instructed them in beauty.

Time, which puts everything in its place, ranks a picture by Poussin very much higher in the hierarchy of values than a picture by Fragonard, a Memling higher than a Rubens, a Piero della Francesca higher than a Veronese or a Titian.

But time and duration are necessary in order to rank these works definitely.

Let us take our time.

In this fast-moving and complex life that shoves us around, slices us up, we must have the strength to remain unhurried and calm, to work beyond the disintegrating elements that surround us, to conceive of life in its unhurried and peaceful sense.

The work of art needs a temperate climate in order to be realized fully.

In the mounting speed that is the law of the modern world one must work out fixed points, stick to them, and work slowly toward the work of the future.

We live in a magnificently dangerous period where man is importuned from all sides.

If one accepts everything, one is lost. One must know how to weigh one's abilities and take only what is useful and necessary: how to choose, how to resist when necessary, to withdraw, to halt before this universal momentum.

We live in a very rich period with an overflowing life that never stops, day and night, that offers you its monstrous temptations.

A crazy speed sweeps the world along and carries it into a whirlpool

where thousands of individuals will be hopelessly drowned like butterflies.

A dangerous and magnificent life for those who can swim through this beautiful chaos as if it were the sea—"not letting it swallow them up."

A world of men, of the shadows of men, swarms around us; broken, rejected, they have not been able to resist the negative and destructive forces that every society carries within itself.

I want to pay homage to all those unhappy people—those paroled prisoners, those who are abandoned, all those who wanted to live free, who wanted to shout the dangerous truth—those who did not want to take to the streets and who were its victims. They wanted to strike out against the façade of hypocrisy and lies on which societies are built. They are found in prisons, in asylums, under bridges, I am sure, these specimens of admirable and fallen humanity who did not have the strength to cross that average, reasonable, stifling barrier that the bourgeois class erects across life in order to prevent them from going through. Some of them have succeeded in crossing the barrier; these are today's creators and achievers; through energy and talent, they have asserted themselves, but mark it well that these men are from the same family as those I have just mentioned. . . . The same desire for liberty and truth led them toward their goal, and they attained it. They asserted themselves and reign in turn over a world of enemies obliged to recognize and accept them.

I know that *collective forces* are on the march, that the individual as king must be swallowed up, must fall into line, that individual egotism has often taken advantage of this situation; but in the marvelous sphere of creativity where the state of genius functions and is realized by individuals, I say: "Take care."

The honor of a modern society will be evidenced by its being strong and generous enough to proffer the luxury of not interfering with individuals whose work will be recognized and admired later on. Never mind the few mistakes that can slip by; the good will pay for the bad. By that I mean that a free way must always be left for artists. This way is the one that leads toward Beauty—toward the work of art that is above social and economic battles.

The artists of the Middle Ages had to produce instructive, historical,

descriptive, and dramatic works. The epoch demanded it: there were no printing presses, no circulation of books, no cinema or radio.

Our epoch possesses these three great means of social expression for propaganda and partisan struggle. So let us agree to release the Painter from these restrictions that no longer have a justification. We are in the battle anyway. Let us encourage the people, the clerk, the worker, to liberate themselves.

Fight for your leisure, your freedom; you are right. Once these freedoms have been acquired, you will be able to cultivate yourselves, to develop your sensibility, and to appreciate the beauty and newness of the modern arts.

Why does a minority of the ruling class own our pictures and get all the pleasure from them? Because they knew how to profit from their leisure time. Do the same thing. Snatch as much time as possible and you will find us at the end of the road to organize this hard-won leisure.

The work of art should not participate in the battle; on the contrary, it should be the resting place after the strife of your daily struggles, in an atmosphere of calm and relaxation where your developed sensibility will enable you to admire the works, the pictures, without compelling you to ask negative questions such as "What does that represent?" "What does that mean?"

A beautiful work does not explain itself. It does not want to prove anything; it appeals to the sensibility, not to the intellect. Above all, it is a matter of loving art, not of understanding it.

What is Reality in plastic art?

Each epoch has its own—Courbet's realism is not the impressionists', and ours is not the one that is coming after us. What that will be cannot be proved.

You say "the beautiful bicycle" without looking first for the reason you say it.

You won't prove to me that it is beautiful simply by demonstrating it.

It is the same thing with a work of art. A beautiful sunset cannot be explained either, and art does not consist of copying that beautiful bicycle and that beautiful sunset.

The natural phenomenon or the beautiful object cannot be copied;

the artist must make something as beautiful as nature, but not by imitating nature.

Is slang, the poetry of the people, a copy of the standard terms listed in the dictionary? Not at all; it is the opposite, its words are invented.

It is the same thing with pictorial art.

Your leisure time will allow you to develop yourself, to appreciate, to love the new art that now still baffles you. Have patience, you will be helped and guided.

We are the present. The future belongs to you.

Europe, Paris, 1938

The Human Body
Considered as an Object

As long as the human body is considered a sentimental or expressive value in painting, no new evolution in pictures of people will be possible. Its development has been hindered by the domination of the subject over the ages.

But for the last six years, plastic courses have been liberated. The impressionists were the first to reject the fetters of noble subjects—and they gradually allowed interest in the "object" to appear.

In contemporary modern painting, the object must become the *leading character* and dethrone the subject. Then, in turn, if the person, the face, and the human body become objects, the modern artist will be offered considerable freedom. At this moment, it is possible for him to use the law of contrasts, which is the constructive law, with all its breadth.

This law of contrasts is nothing new. If one looks at the past, one can observe that even if traditional painters did not use it, at least they had an inkling of it in the composition of their pictures.

Giotto, with a decorative sense, opposes his human figures to architectural structures. Poussin, in *The Rape of the Sabines*, and Delacroix, in *The Entry of the Crusaders into Jerusalem*, both proceeded in the same way. But in all three cases, the emotional significance of the subject, the fetters of the subject, obliged them to sacrifice the surrounding composition and to give special prominence to the figures.

Poussin came closer to dealing with the problem because of his propensity for the classical. *The Rape of the Sabines* has extremely strong dynamic movement for its period. The concentration of figures is radically opposed to the geometric elements of the architecture. In abstract language, *The Rape of the Sabines* is a "battle of straight lines and curves."

We arrive at our own epoch. The subject is no longer *the leading character*; a new element, the object, replaces it. At this moment, to the mind of the modern artist, a cloud, a machine, a tree are elements as interesting as people or faces. So new pictures, important compositions will be made from an entirely different visual angle.

The law of contrast dominates human life in all its emotional, spectacular, or dramatic manifestations.

In literature and in the theater, it has already achieved some fairly advanced developments. Shakespeare uses it quite overtly in a number of plays (contrast by inserting a rapid burlesque scene into a dramatic or sentimental plot).

All work, in any area at all, is involved for the most part with a purely decorative value if it does not resolve this constructive conflict. Naturally it is a *disruptive* and antiharmonious device, but in this fact resides the difference between major plastic art and decorative art.

All great periods of painting have always been followed by a minor, decorative period that they inspired. Industry and decorators have known how to popularize them.

Without wishing to play the role of a prophet, I see no other way out for the future except a *powerful*, human *painting* that can embrace all plastic methods, both old and new. All this within an absolute order, guided by a tranquil will that knows where it is going.

Every curious and surprising experience has been tried. Above all traditional constraints, in unlimited freedom, a plastic anarchy has been born. It is very seductive; the streets have no more sidewalks, everything is thrown in together; it is dazzling and imprecise.

In the midst of this romantic confusion it is hard to find one's bearings. Is it a beginning? Is it an ending? "The ghost of David prowls in these parts."

Out of the ranks of minor artists who have risked their necks during these past five terrible years, some will emerge to settle the question.

They are to be trusted. People are capable of infinite possibilities when they have suffered pressures and constraints. When those bonds are relaxed, there is an accumulation of energy and potential that bursts out with a wholly new strength. Perhaps astonishing pictures, made by God knows who, will be found in the back of a barn. They are to be trusted.

One of the most damaging charges that can be made against contemporary modern artists is that their work is accepted only by a few initiates. The masses cannot understand them.

There are several reasons for this situation. The minority of privileged individuals who can be interested in these works is made up exclusively of people who have the leisure to see and look, to develop their sensibilities. They have free time at their disposal.

In 1936 and 1937, I had an opportunity to talk about these issues in working-class and community centers. "You work for the rich," they shouted bluntly at me, "we're not interested in you."

Their objection was wrong because it was too simplistic. The matter is a little more complicated.

The situation is created by the existing social order. Factory workers and clerks have very limited leisure time. They cannot be asked to spend their Sundays shut up in museums. Private galleries and museums close their doors at the very time when the workers leave their shops, their factories.

Everything is organized to keep them away from these sanctuaries. Time must be made available so that this majority of individuals can be interested in modern works. As soon as they have time, you will be able to watch the rapid development of their sensibilities.

The people have a poetic sense in themselves. They are the men who invent that ceaselessly renewed verbal poetry—slang. These men are endowed with a constantly creative imagination. "They transpose reality." What then do modern poets, artists, and painters do? They do the same thing. Our pictures are our slang; we transpose objects, forms, and colors. Then why don't we meet each other?

On the other hand, if you examine the backgrounds of creative artists, you will see that all or nearly all of them come out of a working-class or lower-middle-class background. So what? Between

these two poles, however, there is a society that does absolutely nothing to bring about this meeting. All the same, painting, like everything intellectual, requires a period of time for adaptation. There is a preliminary period of quite painful confusion, during which taste and choice must be formed and exercised. This does not happen in five minutes. It takes longer than choosing a necktie. It is not a question of special preparation. Education or instruction has nothing to do with artistic arrangements. Art books can no more give rise to an artistic vocation than they can manage any longer to control the restlessness of our young workers or clerks seeking the satisfactions and emotions of art. People who are very intelligent and rich often fritter away their leisure time. Those who are instinctive are closest to the goal; they are motivated by need and not by curiosity. The masses are rich in unsatisfied desires. They have a capacity for admiration and enthusiasm that can be sustained and developed in the direction of modern painting. Give them time to see, to look, to stroll around. It is inexcusable that after five years of war, the hardest war of all, men who have been heroic actors in this sad epic should not have their rightful turn in the sanctuaries. The coming peace must open wide for them doors that have remained closed until now. The ascent of the masses to beautiful works of art, to Beauty, will be the sign of a new time.

Of the various plastic tendencies that have developed during the past twenty-five years abstract art is the most important, the most interesting. It is not at all an experimental curiosity; it is an art with an intrinsic worth, one that has come to fruition and that responds to a demand, because of certain number of collectors are enthusiastic about this art. This proves that the abstract tendency is part of life.

I believe nevertheless that it has contributed all that it can contribute. Creatively speaking, it seems to me to be at a standstill.

Its vitality was proved by its utilization in commerce and industry. For almost ten years we have seen issuing from factories linoleum printed with colored rectangles crudely imitating the most radical contributions made by those works. It is a mass adaptation; the cycle is complete.

Perhaps the future will rank this art among the "artificial paradises," but I doubt it. This tendency is dominated by the desire for

perfection and total freedom that makes saints, heroes, and madmen. It is an extreme state where only a few creators and their admirers are able to hold their own. The danger of this formula lies in its very loftiness. Models, contrasts, objects have disappeared. What remains are very pure, very precise relationships, some colors, some lines, some empty spaces without depth. Respect for the narrow, rigid, sharp vertical plane. It is a heroic attitude that flourishes in a cold greenhouse. It is true purism, incorruptible; Robespierre draped the goddess of Reason in it. It is indisputably a religion; it has its own saints, disciples, and heretics.

Modern life, tumultuous and full of speed, dynamic and full of contrasts, comes to batter furiously at this delicate and luminous edifice, which emerges coolly from chaos. Do not touch it; it is done; it had to be done, it will remain.

If its creative development seems to me at an end, this is not the case with its pictorial possibilities in architecture. Mural art, which was fully developed in the Middle Ages and during the Renaissance, has undergone a decline. Easel painting dominates the nineteenth and twentieth centuries.

It appears from certain social and artistic indicators that a renaissance of mural art is on the horizon. Monumental art can and must utilize this new conception, and expand it.

The young architects who are going to rebuild shattered Europe will have to look at things in this way. This art must be placed in the great structures. It is static through its very expression. It respects the wall, in contrast to a dynamic conception that itself destroys the wall.

It will be the measure of balance.

Montreal, 1945

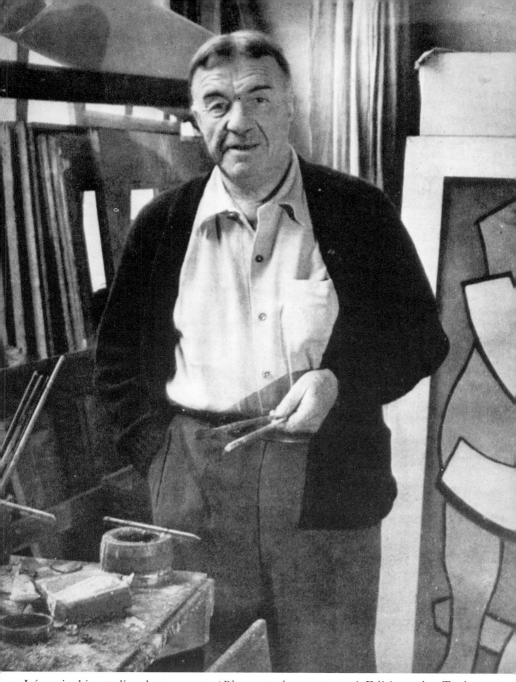

Léger in his studio about 1947. (*Photograph courtesy of Editions des Trois Collines, François Lachenal, Geneva.*)

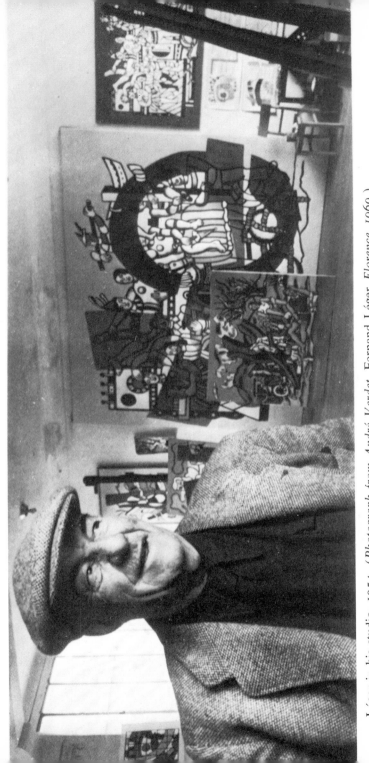

Léger in his studio, 1954. (*Photograph from André Verdet, Fernand Léger, Florence, 1969.*)

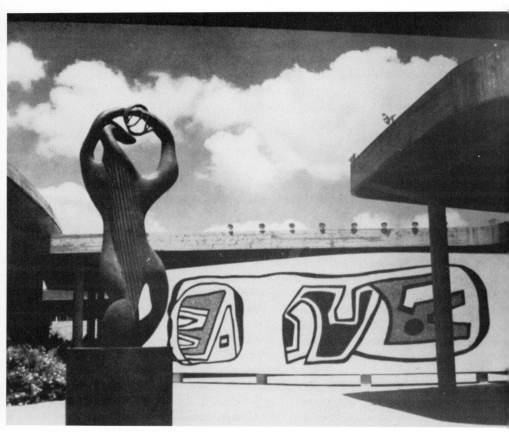

Mural at the University of Caracas, 1954.

The Painter's Eye

It is necessary to live in intensity, not day by day, but hour by hour; necessary to seize the new event just at the moment when the search-light sweeps in on it. The eye must be quick and sharp. There's no time to blink or to flutter your eyelids, or then it's too late. The difficulty is to make a choice among all the numbers that pass by.

The time to choose, here's the chance to wait for the right oppor-tunity, a chance that is like a sequence in slow motion during which the eye and the ear function as a machine. The specialists finally understand that the study of these two major organs is important. (It seems that no two ears are alike.)

If you are a solidly established, functional fellow, your choice will be made instantly, and you will be the winner of this sacred lottery.

Quickly grab what you need; quietly swallow and digest the morsel of your choice and quickly take off to shout about something, some-where that's good for you.

That operation is the one that refines riches, unparalleled raw ma-terial, full of overflow and squandering, trampled beauties, astonishing joys all appearing and disappearing by turns.

In the past a trip, a book, a reader, a catastrophe, a sunset required time, had a length, a breadth, a volume. It was completely satisfying. Now objects are no more than fragments of objects. They take part in the great sentimental or descriptive subjects only with the help of violence.

The New World? . . . A little five-and-ten-cent store. In a provincial city in America three nice salesgirls greet you—a Chinese, a Negro, and a white.

The year is 1946, a dangerous year, burning like a starting point.

Variétés, Paris, 1946

Art and the People

Making contact between the People and the work of art is a problem that is in the air, everywhere; but in order to be able to talk to the people, you must be close to them. Very few of us are close to them.

I have had one occasion to know them, not in Paris or in my studio, but in the war. Perhaps it is cruel to say this but, for me, the 1914–18 war was lucky. It allowed me to discover the People and to change completely. I had the luck not to be knocked around, I was no happier or unhappier than anyone else, and I could watch everything that was going on around me.

I was drafted into the engineer corps, and, as you know, it is made up of workers, laborers, miners. Imagine the shock: I emerge from my studio, from the frontiers of art, and I land in the midst of my laborers (and don't think that they keep open house), and I worked with them for the whole campaign. . . .

It was there that I truly understood what a man of the people is. He is a very orderly guy, so much so that I discovered that I myself was completely messy by comparison. Let's take, for example, the simple act of packing a knapsack: my boys put 33 lbs. in their bags when I could get only 17 into mine. . . . I assure you that I learned a lot.

I also learned their language, for they had a language, a slang. Each

activity has its own slang. We painters have words and expressions that are our own, but our slang is mostly our pictures.

It is because of this that a way must be found for us to understand each other.

So the problem is to renew the ties. Now, what are the reasons that have prevented us from being in contact until today? First, there is the very bad education they have received. You know that the evolution of painting led to a period called the Renaissance. Before that, there was an "invented," imagined painting (Romanesque painting, for example, is not an imitation of nature, and the Egyptians likewise invented their forms in their period). In the Middle Ages, there were no statues of Saint Sulpice; there were only "five things" appreciated by an elite and "accepted" by the People.

The problem has become more complicated since the Renaissance. Why? Because the Italian Renaissance came up with the idea of copying, of imitating the human form. Then what happened? Judgment "by comparison" was established: from that time, what is well copied is beautiful.

The poor Douanier Rousseau, although he himself was an extraordinary artist, said to me once: "David is staggering, but Bouguereau is even more terrific. Have you seen his reflections on water?" Everything depends on education, and education, all the education given in the schools, is bad. All the teachers say: "Look at the Renaissance. It is the highest point our civilization has reached. It is progress!" Everything bad comes from that assertion. There is no progress in art. An Egyptian statue is as beautiful as a picture by Raphael or a canvas by Michelangelo.

The People then flung themselves at imagination, and you know very well that imitation contributes nothing. When you have spent six months at the École des Beaux-Arts, you know how to do a portrait: all the École pupils know how to do a portrait of their grandmother. That doesn't prove that they have any talent.

The Renaissance style was assisted by money. It was the art of the middle class, who in turn wanted to own some pictures. They had their portraits done, their mistresses' portraits done; they put a more or less sensual still life in their dining rooms. *Easel painting* ratified the rupture with the people. Before all those Renaissance pictures,

there had also been larger mural paintings that the people could see. From the Renaissance on, "only" rich people have had pictures, which have been shut up more and more in private collections or in museums. Now, as you know, museums are places that close at six o'clock—exactly when the workers get out of their workshops.

At the time of the Popular Front, we said: "Something must be done." There was the eight-hour work day, the forty-hour week, etc. We said to M. Huisman, the director of the Beaux-Arts: "Open your museums in the evening." He replied: "You'll ruin me with the cost for the guards." Finally the museums were opened, and in the evening people flocked to get in.

Now more leisure time must be created for the workers. Contemporary society is very harsh, and the workers do not have the indispensable freedom to see, to reflect, to choose. If they have gained several hours so that they can get cleaned up, dressed, and do a lot of errands, it does not seem that they have gained enough time to come as far as us.

Above all, don't start assuming that the People don't care. When a man of the people gets dressed, he chooses: he chooses a blue tie or a red tie. He spends a lot of time making his choice. He has taste. He must be permitted to develop this taste. . . .

At that time, Vaillant-Couturier* was President of the Commission on Fine Arts; at any rate, something could be hoped for from him. Unfortunately, he was always very busy, and he died too soon. I was never able to catch anyone more than the third-ranking official, but we talked things over: "It is the problem of childhood that we must reexamine." Yes, in school the children must be given the opportunity to draw. You know that children make wonderful drawings. In America I saw drawings by Russian children that outshone the work of professionals. There is an unparalleled freedom in children's drawings. Beautiful pictures and good reproductions must be hung in the schools; every year there should be a competition for the best draw-

* Paul Vaillant-Couturier was a cultural spokesman of the Communist Party in France, founder of the Maison de la Culture, a left-oriented meeting place that organized support for the Spanish Civil War and other causes it shared with Moscow. Editor of *L'Humanité*, a Party organ, he died in 1937.—Ed.

ings, which should be reproduced by stenciling and hung on the walls. Can you understand the pleasure the children would get from seeing their own pictures on the walls? Besides, we tried this experiment in 1937, in Le Corbusier's pavilion. We found some very charming children's drawings; I had them enlarged by some students, and it was magnificent!

I also made a curious experiment in Normandy. I had a small nephew who liked to make drawings like my paintings (but much freer!), and so in turn, I redid a picture in the style of his drawings. That was very useful for me.

In the end, I think that courses and lectures don't help much. What pays off are the pictures themselves, seen in slides. I was able to confirm this in America. The Americans have more curiosity than we do; when there is an exhibition at a museum, they go to it on Sunday. I saw one Van Gogh exhibition. People were beating the doors down to get in; you saw chauffeurs, all kinds of people there.

Speaking of exhibitions, I have an amusing story about something that happened to me. It was in Chicago. I had some canvases on exhibition in the museum that were pretty strongly colored. One day someone telephoned me to tell me to come to the museum where some people were clamoring for me. I made my way down there, and I found myself faced by six very elegant blacks, musicians in a New York band. They began to dance in front of my pictures and wanted to buy one to use it as a backdrop for their jazz band.

In other respects, the radio does much less for us than it evidently does for music. You hear great musical works on the radio. At the present time it can be said that all the famous composers have become popular. It's much harder for us painters.

Excuse me, but I am going to return to the 1914–18 war. So I arrived there with some pals and find myself faced with those guys, those cannons, those airplanes, all that brand-new material. I felt one last hope: to be inspired by the objects that surrounded me. And I went on from there.

First I began with some drawings. Then I put in colors, definitely the most violent ones I had ever used. I needed to do it: we had been living in so much grayness during that war, in so much mud! It was at

this period that I started to use pure color; at the same time this happened: I managed to liberate color.

With Robert Delaunay we led the battle; we worked to liberate color. Before us green was a tree, blue was the sky, etc. After us color became an object in itself; today you can use a blue square, a red square, a green square. . . . I think that there is quite an important revolution in this—one that gradually manifested itself in advertising and in the art of window display—and that in this way we have somewhat influenced the decorative art of our time.

By the 1925 Exposition an enormous struggle was already over. Do you remember the extremely simplified structures in which we exhibited our pictures with their pure colors? Architecture had already been cleaned up; it was a purist epoch.

I think that the workers and the masses have no idea of the difficulties that we have in creating. They have no idea of what a hard time we had in 1908, 1909, and 1910, when we were casting about for a "way out."

In conclusion I want to tell you what I felt in returning to France, the joy I have had in rediscovering my country. You who have been plunged into the last five dreadful years may have lost your perspective a bit.

We landed at seven in the evening at Le Havre, a dead city. There were only a few French people in the streets, and we said to each other: "This is pretty bad." We asked a railroad clerk: "Where can we get something to eat?" He gestured toward a small light in the distance. "That's a restaurant. Maybe it's not closed yet." It was closed. Then the clerk took us to his house. There was a little stew left over from the noon meal, and he said to us: "I don't know if it's still any good. It has to be warmed up very carefully." Well, I can assure you that this little stew was astounding.

I get to Paris. Of course, none of the exteriors looks the same, but I see a poster for a film: *The Children of Paradise.* I went to see this film, and for me, fed up with American movie stars, it was a marvelous thing. The film was magnificent and full of poetry. I think that in 1937 the poster wouldn't have stayed up for more than three weeks. I assure you that the people have made a great advance in France. I

assure you that a magnificent evolution has come about. Maybe you who have stayed here don't feel it. Me, I have faith in France. For painting there is still a lot to do, but poetry is already going beautifully. Me, I have faith in France, and I swear to you that I am not wrong.

Arts de France, Paris, 1946

Modern Architecture and Color

Colored Space

Color is a human need like water and fire. It is a raw material indispensable to life. In every period of his existence and history, man has associated it with his joys, his acts, and pleasures.

Flowers are brought into the house; the most common objects are colored—clothes, hats, make-up. In everything that calls for the decorative impulse in daily life it is color which is of the principal interest. Inside and out it is everywhere triumphantly imposed. Modern advertising has embraced it, and the roads are framed in violent colors that break the landscape. A decorative life is born from this dominating preoccupation, [and it is imposed on the whole world].

Therefore it is the function of color—static or dynamic, decorative or destructive—upon *architecture* which is the purpose of this essay. The possibilities for a re-orientation of mural painting should now be utilized.

A blank wall is a *dead, anonymous surface*. It will take life only from shapes or colors that will give it life or destroy it. A colored wall becomes a *living element*.

This transformation of the "Wall" through color will become one of the most exciting problems of the new architecture. But before approaching the modern mural, color must first be set free. But how is one

to liberate color? Before the developments in painting of the last fifty years a color and tone were bound completely to an object, to a representational form. A dress, a figure, a flower, a landscape was obliged to be of a certain color. Then—so that architecture could command it unreservedly, so that the wall could become a new field for experience—it became necessary to extricate and isolate color from the objects that held it prisoner.

It was about 1910 that Delaunay and I began to liberate pure color in space. Delaunay developed in his own individual way, keeping the relationships of pure complementary colors (it was really the continuing of a larger and more abstract approach than that of the neo-impressionists). I was seeking my own way in the opposite direction—avoiding as much as possible complementary relationships, and developing the force of pure local colors.

I obtained rectangles of pure blue and pure red in the painting *Woman in Blue*, 1912. In 1919, in *The City*, pure color incorporated into a geometric design was realized to the maximum; it could have been static or dynamic—the important thing was to have isolated a color that had a plastic activity of its own, without being bound to an object.

It was modern advertising art that first understood the importance of this new quality—the pure tone from the pictures took hold of the roads and transformed the country-side. A mysterious abstract symbol of yellow triangles, blue curves, red rectangles spread before the motorist to guide him on his way. This was the new object. Color was free; it had become a new reality; the color-object had been discovered.

It was at this time that architecture also learned how to use this free color both inside and out. Decorative wall-papers began to disappear. The white wall suddenly looked quite naked. An obstacle, a dead-end—experience began to turn toward colored space.

The apartment that I shall call the "habitable rectangle" begins to emerge. The prison-sensation turns towards unlimited colored space. The "habitable rectangle" becomes the "elastic rectangle." A light blue wall recedes, a black wall advances, a yellow wall disappears. Three appropriate colors laid out in dynamic contrast will be able to destroy the wall.

Destruction of a Wall

New possibilities are unending. A black piano for instance in front of a light yellow wall produces a visual shock which can cut the rectangle in half. The visual and decorative revolution will be still stronger if we arrange the furniture in the apartment unsymmetrically.

Our visual education is symmetrical (fig. 1). Modern decoration can become entirely new if we use a-symmetry (fig. 2):

From a fixed dead arrangement, without play or fantasy, one comes into an entirely free domain. We have all been educated in this symmetrical tradition, and how heavy it is! The proletariat—along with the middle class—is still completely tied to this traditional order.

A simple anecdote will demonstrate the force of this habit. When I lived in the Paris suburbs I had in my room a very large piece of antique furniture on which I arranged some ornaments. I always enjoyed placing them unsymmetrically—the most important object on the left, the others in the center and on the right. I had a maid who used to clean the room every day. When I came home in the evening she had always re-arranged the objects with the largest in the center and the others symmetrically placed on either side. It was a silent struggle between us which could have gone on indefinitely, because she considered that my ornaments were "in disorder."

Perhaps it would take a round house to obtain "space and the visual destruction of the wall." The angle is a geometrically resistant force which it is hard to destroy. Externally the problem is vaster but also more novel.

The external volume in architecture, the sensations of weight and distance, can be reduced or augmented through the use of color. A bridge can become invisible and weightless through color-orchestration. Thus the "exterior block" is open to attack as was the interior wall. Why not undertake a multi-colored organization of a street—of a whole city?

During the first world war I used to spend my furloughs in Montparnasse where I happened to meet Trotzky and we often talked about the thrilling problem of a colored city. He wanted me to go to Moscow; the idea of a blue street, a yellow street aroused his enthusiasm. I think it is in the housing-projects, where the workers live, that the need of color is strongest for the creation of artificial space. Nothing has so far been attempted. The poor man's family could feel the freedom of space, even with a fine art-work on the wall. They are first of all interested in color and light. These are the necessities of life. It is free color that is essential to urban centers.

An urban center: a gathering of 1,500 inhabitants. A multi-colored problem inside and out. A graded arrangement of static façades leading perhaps to a pleasant court in the center—and in this court possibly some spectacular monument, moving and luminous—as important as the church which temporal catholicism has imposed so well upon every village. Free color will play its part with the new modern materials, and light will violently orchestrate the whole. Light and color can exert untold psychological influences. A modern factory in Rotterdam furnishes an instance. The old factory was blackened and sad. A new one was completed, light and many-colored. The result was as follows: without any remarks to the workers, their appearance became quite altered—neater and more tidy—they felt that an important event had occurred of which they were a part. Color and light had created this new evolution. It is not an external act—it can, through rational development, change a whole society.

Paris, the 1937 Exposition. The organizers summon several artists to think up some sensational point—some spectacular effect that would bring in visitors and permeate the memories of strangers long afterward. I suggested *Paris Completely White*; I asked for 300,000 unemployed to clean and scrub the façades. Create a white and lumi-

nous city—in the evening the Eiffel Tower, like an orchestra-leader, playing the most powerful projectors in the world upon the streets (airplanes could have cooperated in creating this new fairyland)! Loud-speakers would diffuse melodious music in key with this new colored world . . . my project was thrown out. The cult of the old patinas, of the sentimental ruins, the taste for ramshackle houses, dark and dirty but how picturesque! The age-old dust that covers moving recollections from history did not allow my project to be realized. . . .

The multicolored hospital—cure through color—an unknown world that has begun to interest young doctors. Green and blue wards for the nervous and sick, others yellow and red to stimulate the depressed and anemic.

Color, like music, holds the magic which envelops truth. Men who love truth, who think of living with it in the raw, without retouching, are rare indeed. Creators of all denominations know how difficult it is to use color, how dangerous it is to put on too much. Expressive force lies in truth. A work of art is a perfect balance between real and imaginary facts.

Pure color is more realistic than the half-tone; but most people prefer the half-tone.

Color is a two-edged sword; either it runs amuck when it is unchained, without restraint, or it lightly envelops objects with an aura of good taste that we call the "decorative life."

The future certainly cries out for the collaboration of the three major art-forms—architecture, painting, sculpture. No period since the Italian Renaissance has understood this artistic collectivity. It is our own which must take up the problem again under a different aspect. The successive liberations which, since impressionism, have allowed modern artists to escape from the old restrictions (subject, perspective, imitation of the human body) permit us our own realization of entirely different architectural ensembles.

New materials, free color, freedom to invent, can entirely transform the problem and invent new spaces. Above all we must avoid the sickening profusion and heaping-up of art-works that made the Renaissance a period of unparalleled confusion.

Every day one hears the word "Beautiful." "The Beautiful Bridge," "the Beautiful Automobile," the attempts at beauty expended upon

strictly utilitarian structures show the great human need to escape through art. We use the same term for a beautiful sunset; there is the same word for natural beauty as for manufactured beauty; so let us build a monument to the beautiful. Why not? We can realize it, using the freedom acquired in the major art-forms: color, music, form, all have been liberated. When we evoke former epochs that have produced so many magnificent temples the result expresses only the past civilization. It is unthinkable that our own will not realize its own popular temples. Architecture has at all times been the plastic expression to which the people of the world have been most sensitive—the most visual, the most grandiose. It dominates perspective and halts the view. It can be aggressive or welcoming, religious or utilitarian. In each case it is at our disposal with as much freedom as ever. The exaltation of 80,000 spectators at a football-match is not the end of a civilization. A temple for contemplation is as authentic a need as the great sport-spectacles.

To realize a "dazzling spot," to unite the sentiments behind the brilliant lighthouses, the bell-towers, the religions, the need for verticality, the great trees, and the factory-chimneys. Enthusiastic man lifts his arms over his head to express his joy in the height. To make high and free. To-morrow's work.

American Abstract Artists, New York, 1946
(Translated by George L. K. Morris, unpublished in France)

How I Conceive of the Figure

This essay could just as well have been called "The Bunch of Keys in Léger's Work" or perhaps "The Bicycle in Léger's Work." This means that for me the human body is no more important than keys or velocipedes. It's true. For me, these are plastically valuable objects to make use of as I choose.

It must be recognized that the pictorial traditions that precede us— the figure and the landscape—are burdened with influences. Why? It is the landscape where one has lived, they are the figures and portraits that adorn the walls, whose sentimental value at first made possible the flowering of a considerable number of good, bad, or questionable pictures.

In order to see clearly, it was necessary for the modern artist to detach himself from this sentimental bond. We have gotten over that obstacle: the object has replaced the subject, abstract art has come as a total liberation, and the human figure can now be considered, not for its sentimental value, but solely for its plastic value.

This is why the human figure remains purposely *inexpressive* in the evolution of my work from 1905 until now.

I know that this very radical concept of the figure as object shocks a great many people, but I can't help it.

In my latest canvases, you may find that the human figure will have a tendency to become the major object, taking the place of figures tied

to subjects. The future will tell if that is plastically better or if it is a mistake. In any case, the present structure is always dominated by contrasted values that must justify this evolution.

Louis Carré Gallery, Paris, 1949

A New Space in Architecture

In order to discover the start of this event, we must return to the past: 1923 and 1924 are, I think, the years that saw this revolutionary arrangement in interior and exterior architecture fulfilled or at least be born and take shape. The 1925 Exposition provided preliminary contact with the general public. This international public display had two goals: to mark the end of *art nouveau*, the 1900 style (a glut of decoration), and to make the white wall appear with all the consequences it involved: a new, habitable rectangle or a false start. What was going to happen on this white wall?

This habitable rectangle, though freed from decorative values, was a rectangle all the same, with its precise boundaries; the rectangular prison cell has always existed. Light had taken possession of it. The object, the individual, exhibited in this new atmosphere, became visible, took on its total value, height, and volume. One became aware of its true dimension within the four walls.

At about this period, modern painting also was constantly evolving. It had escaped from the subject, even from the object, and a period of recrudescent abstraction saw the light of day. A total escape—which achieved the liberation of color—"that was the event." Before this, a color was still tied to a sky, a tree, an ordinary object. Now, it was free; a blue and a red had a value in themselves; they could be arranged.

The white wall was there, present. Why not?

We are in 1925, the International Exposition. Mallet-Stevens, an architect, had asked me to put a wall design in pure, flat colors into his project for an embassy. I had done it, I think, in 1923–24. The white wall accepted its partial destruction through applications of color; naturally the choice of colors had to be established. This was done, and the permanent, habitable rectangle of four white walls became an elastic rectangle. I say elastic because each color applied, even when shaded, has a mobile effect. Visual distance became relative. The rectangle disappears, its boundaries and its depths eroded. Free color has found its application. The modern individual now finds himself in a vital arrangement that is entirely renewed. Psychological action has been set in motion by itself. An interior evolution is taking place slowly and unconsciously.

Color is a vital necessity, like water and fire. You can't live without color. It has multiple effects, and during this same period doctors began to study the possible effects of colored surroundings on nervous and neurasthenic patients. A cure through color was on the way. Its advantage in terms of practical exterior application no longer escapes urban architects.

The idea of multicolored towns had come to me during the 1914–18 war, on one of my leaves. I had met Trotsky in Montparnasse. He was enthusiastic about this idea. He envisioned the possibility of a polychrome Moscow.

But if you think of a town, a street, a house as a whole in relationship to a colored exterior effect, considerable possibilities immediately present themselves. For example, the coldness of the ground floor of an apartment building is relieved if color comes into play, even the building's volume is lessened. Sooty, grim outlying districts can thus be transformed into gay and luminous sections.

In 1937, during the Exposition, I had the idea of using the 300,000 unemployed to scrape every house in Paris. The project was to "create an astonishing event" for visitors to the fair. Paris, all white, and at night, airplanes and spotlights inundating the city with vivid shifting colors. Why not? My project was not accepted; nevertheless, it was the only way to create a new event on the scale of an international exposition. Although the "blow" was struck in France, its practical results were worked out elsewhere in Europe.

The consequences of the new rectangle were more rapidly developed in the northern countries. In Finland, the workers uncomplainingly accepted the colored walls that had been built for them. In Scandinavia, Holland, Germany some interesting buildings were made. From a general point of view, we find ourselves confronting the problem of color distribution for a stadium where the disorder created by the advertising signs that devour the walls can become a rational plastic order. We must strive for that. We must start to organize and classify the demand for color. Ordered quality instead of chaotic quantity. Each individual has his color; whether he is conscious or unconscious of it, it asserts itself in his choice of everyday appurtenances: furniture, fabrics, and style of dressing. The new space in which these ordinary objects are going to function is itself going to be influenced by the new environment.

It is a revolution, one of the strangest of the peaceful kind given to today's man to achieve.

Art d'Aujourd'hui, Paris, 1949

Mural Painting
and Easel Painting

I am talking here about two essential orientations of painting: mural painting, i.e., that which is adaptable to architecture, and easel painting, which came into the world with the Italian Renaissance.

At the beginning of civilization, men decorated everyday objects with patterns, figurative lines (animals, images, trees). The further back one goes into the origins of things, the more one discovers man concerning himself with figurative art. The work of art seemed as important as water and fire. There is no age, however remote in time, without plastic expression.

In the eleventh and twelfth centuries of the Christian era, Jesus Christ was the force behind the most powerful social movement—a social liberation. The church, which informs itself, knew how to adapt itself admirably.

When men do not know how to read or write, the visual image takes on considerable importance; the cathedrals and the monasteries were completely decorated.

In this civilization, there were no subjects other than the life of Christ or of the Virgin and the Saints. Because of the number of illiterates, it was a matter of explaining religion to them.

When printing was invented, society's comprehension forged ahead. The people are taught to read and write; the book takes the place of the popular image.

The book frees Art and makes possible Art for Art's sake, an escape from reality. The imagination becomes primary, and the subject is no more than a means (a total reversal of the way things began).

We reach the Italian Renaissance. The great social revolution: kings, aristocracy, and clergy are at war with the individual, liberated through "new wealth." The Renaissance marks the birth of capitalism (colonies, etc.). From then on, the individual can have what the prince had been able to possess. The liberated man wants to have his portrait, or a landscape he loves.

The religious subject is abandoned—a break with the previous period. There is a change from collective life to individual life. Titian and Veronese are models of the new sensuous painting.

There is a loosening toward freer painting, but it is tied to the bourgeoisie who turned the picture into something with speculative value. The bourgeois, who understands and loves his pictures, invests capital in them that is going to increase in value.

Note that this does not hinder or prevent the evolution of painting.

Art for Art's sake (that is, without a subject) and abstract art (that is, without an object) have been severely criticized, but it certainly seems as if their time is coming to an end. We are witnessing a return to the broad subject, which must be comprehensible to the people.

The people, tied down, bent over their work all day long, without leisure activities, are completely overlooked by our bourgeois epoch; that is the tragedy of today.

In our time, architects have produced a substantial revolution, of which very few of them are aware: they have destroyed the architectural décor of the "1900 Style" (the 1925 Exposition).

Recently I worked with Le Corbusier on two large mural compositions with no subject, in pure color. Then the idea developed of finding a *new space* in architecture.

Now we have moved toward a complete clean-up of architecture, and we find ourselves confronting a blank, bare wall. But such a wall is like a waiting room. Most people cannot live surrounded by white walls.

We had the idea that some colored walls (yellow, red) would be a "coverup"—without disregarding the visual effect of distance or closeness that color creates on the wall. I have called that "the destruction

of the wall" or "the elastic wall." In this way *another space* is created.

We have returned to the mural painting of the Middle Ages, with the difference that our painting is no longer a description but the creation of a new space. This was in 1925, but the revolution was the doing of only a few.

The only place where it has had an effect on the people is Finland. I went there with my friend, the architect Aalto. Low-income housing had been built there for technicians and workers. All the walls were colored. Well, the workers were very well behaved and did not touch the walls, but the technicians felt the need to hide them by, for example, pasting wallpaper on them.

In the wake of the revolution, the easel picture pursues its own path, in its own way, without worrying about other painting—by abandoning noble subjects, which have been replaced by the object, which has been replaced in turn by abstraction (which is where we are now).

This total liberation has produced Abstract Art.

It occupies such a place in our lives that even the easel picture tries to satisfy itself with abstract relationships.

I can say this, having been one of those who have done it. If we return to the object, it is because the easel picture must be extremely rich and contrasted.

I believe and I maintain that abstract art is in trouble when it tries to do easel painting. But *for the mural the possibilities are unlimited.* In the coming years we will find ourselves in the presence of its achievements.

Social factors condition art, and society changes slowly, but surely.

It is incontestable that, not having leisure activities, the worker cannot be satisfied with pictures offering only relationships between colors and objects: *this is the tragedy* and it is very difficult to resolve.

Before the war, at the time of the Popular Front, Vaillant-Couturier came to see me. "This is a unique occasion to reveal the riches of art to the people," he said.

I came to know the people in 1914, I discovered them with their admirable qualities; but how can they achieve anything? Everything is against them (the museums all close at five o'clock, which is the time when they could go to them).

I asked if I could go and make reports, to give firsthand lectures in the north, in Lille, among the workers. I went there. There were about a hundred in the audience, engineers, *not a single worker*. The result was: nothing.

Vaillant-Couturier insisted. I said to him: "It is necessary to develop competitions in the schools, to award a prize for the best drawing, to enlarge it and to decorate the class with it in order to interest them in art." (Children's drawings are *very free*; we are only at the frontier with children's drawings.)

But Vaillant-Couturier died and nothing happened.

I went to my friend Huysman: "It's ridiculous that your museums close at five o'clock." He opened them at night, and the workers came; but there you are. They looked at only one picture: they had to wait in line before the Mona Lisa. She was the star, as if it were the cinema. Consequently, nothing came of it.

At the present time, because of the desire to come closer to the workers, some painters, even some in my school, have returned to pictures with a subject.

But it is not enough to wish, it is necessary to have the power, and that is extremely difficult.

Certain mediocre painters quickly slap some large works together and *confuse everything*.

The people judge by comparisons: "The hand that has been most closely imitated is the most beautiful," which is false.

Unhappily, one thing is certain: in the evolution of the work of art, quality is secondary for those who direct the only interesting social movement of our time.

It is very difficult to reach people through quality. We now have the ways to reach them, and that is serious.

In Russia, efficiency is sought rather than quality. Perhaps it is necessary, I do not know about this. *But for us it is tragic.* And with these mediocre painters who confuse everything.

Nevertheless, *the people are a poet*. They have created a language, a slang, which is authentic poetry (the middle class has never invented a word of slang).

As for our painting, it too is slang, but it has no connection with the other.

I will stop here.

I believe I have touched on a tragic and universal point that must interest us all and that each of us must seek to resolve.

Unpublished, 1950

The Problem of Freedom in Art

The problem of freedom in art can no longer be considered controversial, if one is willing to admit that abstract art, the ultimate expression of this freedom, has reached its highest point, where everything that could be achieved in plastic escape has been achieved, where the very object that was valuable to the Cubist masters as a substitute for the subject has taken flight. We find ourselves thus faced with Art for Art's sake one hundred percent.

This attitude of liberation, which was necessary, as neoimpressionism was necessary for impressionism, is played out. The subsequent reaction and the possibility of creative continuity in the face of abstract art seems to be developing as a return to the subject. This seems natural enough to me.

Abstract art is not diminished or rejected because of this, but it must in turn become a collective architectural expression, especially as the paintings of the great primitives were.

Mural painting, one of the richest means of plastic expression in past times (fresco-mosaic), must be maintained as a pictorial accompaniment in which abstract art has an important place. The return to the subject, rather than destroying the abstract, must join with it on the walls of the future and create the greatest mural flowering of modern times.

Freedom in the arrangement of lines, forms, and colors allows a resolution of the architectural problem of supportive or destructive

colors. A melodious arrangement "supports the wall," a contrasted arrangement destroys the wall. There are modern architectural imperatives.

The efforts of current painters have succeeded in freeing color—form and line offer us extremely fresh possibilities for plastic application. The "new subject" finds its place in this new order, an exceptional place, I believe, where the continuity of easel painting's intensive discoveries must not be abandoned—quite the opposite.

New subjects, envisaged with the contribution of the freedoms that previous experimentation has offered, must emerge and establish themselves without any relationship to the old subject matter, not even to the best of it.

There is a modern primitivism in the intense life that surrounds us.

Visual, decorative, and social events have never been so intense, so involved, so much the covert suppliers of new plastic documents. Current scientific creations reveal a limitless field of unknown plastic forms. The cinema has confronted us with the human fragment, the emotive close-up of a hand, an eye, a face.

The contemporary painter must disclose his sources in all that. A fragment enlarged a hundred times imposes a *new realism* on us that must be the departure point for a modern plastic revolution. The classical landscape is revolutionized, transformed by those metallic pylons whose natural contrast is the clouds.

All this loud and garish advertising can be rejected on the pretext of "protecting the landscape." But where does the landscape begin? The moment a house or a telegraph pole appears, there is no more natural landscape. And so?

Modern life is so different from life a hundred years ago that contemporary art must express it totally.

Unpublished, 1950

Modern Painting

What seduces the enlightened amateur and shocks the uninformed public is the freedom of composition manifested in the modern picture. This freedom of composition is due to the fact that we have treated the subject, that age-old crutch, with no respect. The École des Beaux-Arts, the Academicians, the Institute are committed to the subject and to the most accurate possible representation of what they call reality; to the imitation and, if possible, the copy of nature.

Modern painting, on the contrary, rejects the subject and composes without taking natural proportions into account. Here is where the present revolution is.

It was the impressionists who started it. In 1860, even in 1850, these great artists were interested only in seeing the color relationships in objects. For Renoir, for Cézanne, a green apple on a red cloth was only a color relationship between a green and a red. That seems like nothing, but this little act was the beginning of the pictorial revolution.

The so-called moderns, the fauves, the cubists, the surrealists, have simply developed this freedom and emphasized it.

Everything is connected; impressionism made fauvism possible, etc.

Do not think, however, that all those different schools destroy one another. On the contrary, I repeat, they are connected, but there is an internal reaction of one against the other. I say internal because life is

made up of contrasts—and it is completely natural for the strict cubism of 1910 to follow upon the exuberant colors of fauvism.

The overrefined century of Watteau and Fragonard was followed by David, dry and precise. The pointillism of Signac and Seurat was the end of impressionism. A reaction had to take place; the grays, blacks, and whites of cubism came as a contrast [to what preceded them]. Yet in spite of these profound reactions, there is a tradition that binds this entire French chain together.

So you see the plastic life developing all through the centuries with sensitive reactions and counterreactions of one style to another.

That famous question of the subject, of the imitation of nature, dominates the whole plastic question and creates anxiety in the uninitiated. The Italian Renaissance, in coming closest to this imitation, created the confusion about it.

The feat of superbly imitating a muscle as Michelangelo did, or a face, as Raphael did, created neither progress nor a hierarchy in art. Because these artists of the sixteenth century imitated human forms, they were not superior to the artists of the high periods of Egyptian, Chaldean, Indochinese, Roman, and Gothic art who interpreted and stylized form but did not imitate it.

On the contrary, art consists of inventing and not copying. The Italian Renaissance is a period of artistic decadence. Those men, devoid of their predecessors' inventiveness, thought they were stronger as imitators—that is false. Art must be free in its inventiveness, it must raise us above too much reality. This is its goal, whether it is poetry or painting.

The plastic life, the picture, is made up of harmonious relationships among volumes, lines, and colors. These are the three forces that must govern works of art. If, in organizing these three essential elements harmoniously, one finds that objects, elements of reality, can enter into the composition, it may be better and may give the work more richness. But they must be subordinated to the three essential elements mentioned above.

Modern work thus takes a point of view directly opposed to academic work. Academic work puts the subject first and relegates pictorial values to a secondary level, if there is room.

For us others, it is the opposite. Every canvas, even if nonrepresen-

tational, that depends on harmonious relationships of the three forces—color, volume, and line—is a work of art.

I repeat, if the object can be included without shattering the governing structure, the canvas is enriched.

Sometimes these relationships are merely decorative when they are abstract. But if *objects* figure in the composition—free objects with a genuine plastic value—pictures result that have as much variety and profundity as any with an imitative subject.

Unpublished, 1950

The Circus

Spend your vacations with the same people. Two hundred kilometers away they have changed the cut of their trousers, that's all. So take your bike, and stay a little while. Turn right, lose yourself among the back roads, get to know the local inhabitants; they are like you and me, just as clever as you are, maybe even more so, but in other ways. The world is round. There's no need to go to China. Don't expect to find a generation of peasants that's down on all fours. That's over. Everyone is standing properly and is beginning to give up bowing down to the rich; they are rich too. Open the gate. Now go in. Your arrival has long since been announced by the dogs. They are their electric doorbell.

It's a story about plain metal seen in the sun or under the spotlights. It is transformed into a kind of glittering animal, clamorous, dazzling, in motion. A bike is an object in action in the light. It commands the legs, arms, a body that moves under it, beside it, above it.

Rounded thighs are incorporated into it; they are its levers, which rise and fall quickly or slowly. In the light, it loses its form and becomes a colored magic that is like the breech of a 75 cannon exposed in bright sunshine.

When there are pretty girls on the road or four acrobats in the ring who come straight at you or who spin overhead, it is a complete spectacle as graceful as the waltz of the *Six White Horses*. But four

legs are missing. The tour de force lies in its very instability. The bike or the acrobat can't be stopped. This is the risk, the adventure of this accurate, mad little mechanism.

Lightly it brushes past the car on the road; a hair to the right or left, and it will be destroyed by the four-wheeled beast. An imperceptible slip on the circus platform or in the turn made fifteen feet above the floor, and it is on the ground with a little blood around it. The acrobat becomes a human serpent who, standing or lying, above or below, rides through, rises up, goes backward, rears up like a horse, wheel in the air.

The bicycle seems to be alive; an animal who refuses to go forward or back, a will that man must take into account. In watching the maneuvers of this spectacular object, naturally dance comes to mind. Its contact with the floor is reduced to two extremely fine points; the bike rides on those points. Transparent and agile, it must go down, as well as backward, as well as upward, and when the acrobat, head down, resumes his position while crossing the wire, it is certainly more risky than dance but it is in the same family.

Since the world is round, why do you want to pretend it's square?

From a man's head and a woman's body and a tree's form, which are described by a play of curves, to the hoop that rolls along on the sidewalk and the wheel a worker carries on his shoulder and the pie on the little baker's head, we pursue the fabulous adventure of the circle winning the corner lottery.

Under the sun and under the moon, in the gently shifting clouds, everything turns in circles, and here are the children singing rounds and the Tour de France [the bicycle race around France] and its bicycles and the eyes that watch them and guide them on the roads, on the roads of France that unroll aimlessly, winding through the wheat, oats, plump cows, and birds.

The wheelbarrow rolls on its wheel; thanks to Monsieur Pascal, it's already an old story.

Everything is round. The head meets the tail, the beginning touches the end.

Life is a circuit. You want to go on a trip, but you return to your starting point.

The straight line is round, and the longest way from one point to another.

The merry-go-round revolves in front of the circus, like a huge mushroom, the horses turn, the rider turns, the churches ascend toward the sky in Gothic arches.

Birds, insects, airplanes, a mosquito, everything that flies in the pockets of the sky, on its blue background or its background of clouds, roll up and unroll through the branches of a tree, in free space.

The machine makes things geometric; as a worker who was explaining his job on the assembly line said: "Here, it comes out round or square. You have no choice."

I've often dreamed of a round building, of living in a sphere. I don't see why technology couldn't make this possible.

There is a visual and tactile satisfaction in a round form. It is really evident that the circle is nicer. One of its advantages is that it can be moved more quickly; it rolls. If you are pushing a square box, with all the difficulties it involves, and if there is a kid beside you who is playing with a ball, you notice it!

Water, the mobility of the human body in water, the play of sensuous enveloping curves—a round pebble on the beach, you pick it up, touch it. The stores that sell round shiny objects are the ones that make the passersby stop. The child will choose a round piece of candy, and the manufacturers cater to this demand.

Go to the circus. Nothing is as round as the circus. It is an enormous bowl in which circular forms unroll. Nothing stops, everything is connected. The ring dominates, commands, absorbs. The audience is the moving scenery; it sways with the action in the ring. The faces are raised, lowered; they shout, laugh. The horse goes around, the acrobat shifts his position, the bear jumps through his hoop, and the juggler throws his rings into space. The circus is a rotation of masses, people, animals, and objects. The angle, unpleasant and sharp, looks badly out of place there.

Go to the circus. Leave your rectangles, your geometric windows, and go to the country of circles in action.

It is so human to break through restraints, to spread out, to grow toward freedom.

The ring is free. It has neither a beginning nor an end. High above two tightrope walkers in close-fitting yellow and pink tights catch the light. The finely shaped human body, functioning in every sense, seen from below as foreshortened, turns, delicately framed by moving shadows.

It may or may not be dangerous. If there is no net, the attraction is greater. A spider stirring in his web. Below is the audience, their lighted heads slowly turning, from side to side, caught, hanging onto the movements of the pink tights. The light on all those round faces, their eyes riveted on the small, dangerous point. There is a roll of drums, then silence; it has begun. Three perilous somersaults, in empty space, a hand that probes space, barely catches another hand. It's finished. Applause bursts out, mounts, and dies away like the sound of hail on a roof. The audience melts and blurs. It is the end of a mass anxiety that was concentrated on a single point. The performer acknowledges the applause, bowing politely from his trapeze, which gently rocks back and forth like a boat on the water.

In the Barnum Circus, in New York, which has three rings, forty aerialists spin more than a hundred feet above the ground.

If one falls, the music swells and grows more intense, the spotlights shift, and while he tumbles through space, you are already watching the next attraction in another ring.

A minor accident that must not interfere with the rigid organization of the spectacle.

The acrobat disappears nimbly, with no noise, as he appeared. In the shadows, he is an upside-down figure that gently balances itself; a mouth that becomes the center of a face, the eyelids beating in that anguished face, an arm, a foot, a hand that searches for something to hold on to; all that in a space with no protective restraints.

To escape from the ground, to leave it, to touch the tip as little as possible, the farthest tip. To inhabit upper space means to have wings, a half-measure, an ambition to leap across space in a single bound. What grace is in the assemblage of curves and softened angles. Static and not interfering with the scenery, the dance blends with the colored background.

Carefully studied movement, its fixed phases, where a leg prudently returns to the floor after having risked space, lifted at arms' length, the

free balancing of two round and pleasing limbs, the dynamic aggression of a collective mass that assaults the spectator. Speed, elevation, the instantaneous return to the floor and departure again; that with color, with lighting, with music to support the agile mass of feet, hands, and bodies. Light is the mistress of the forms; it dissects them or outlines them, mixes them, halts them.

The speed captures the motionless audience. It is most still when the action is furious. It luxuriates in this rapid, frothy interplay. This is what it came for.

Man's most beautiful conquest goes placidly round and round the ring; it makes its way without noticing the numerous feats accomplished on its back. It is a warm and moving springboard where feet can perch very well; it is a rich, silky luxurious carpet. A horse is a beautiful thing.

The horses at the old Médrano—six white ones so you had to climb way up with the masses into the highest seats to grasp the spectacle: a white ballet against a yellow background where their elegance effortlessly unfolded. It was a parallel play of six white spots. They loved to turn in disciplined circles, some behind the others; to meet, return, fan out again in response to the subtle signal of the whip that didn't touch them, but seemed to. Discreet signs, completely understood, graceful maneuvers, interplay of legs, departure; only one remains. It is the star performer. The music: *The Horse's Death.* Sentimental and mournful music.

The beast is slowly diminished, elongated, swallowed up by the ring. He stirs again—his head is the last part to obey. Abruptly at the command of the whip, he rears up, rising on his hind legs, he walks aware of his effect.

The horse follows the man who, walking backward, whip held high, encourages and supports him. The horse is at his full height—the man is tiny; he knows it; the horse dominates the arena and exits showered with applause, which he understands.

"The white ballet" is one of my most lively memories from the time when we spent our evenings at the Médrano, with Apollinaire, Max Jacob, and Blaise Cendrars.

A painter confronted by this spectacle feels really powerless to resolve it on his canvas.

The ring is invaded. Neuter masses, creeping; it is the Augustes, the majestic clowns who fill the interval between two acts. They shuffle along the ground, touching the audience, attacking it. It is horizontal, awry, everything is too wide or too long; they come after the beautiful rider all ablaze on her clever horse. The acrobat has left the trapeze; the clown mimics his work. He hangs by one hand, falls, gets up, and makes a sight walking backward that raises a storm of laughter.

A multicolored face, an eye, a nose, a mouth that doesn't look like a nose, a mouth, an eye any longer. Pants that fall down and are hitched up. A light that appears on top of his head. That's the clown.

To make the feet talk, to make a knee laugh, to fall sixty-five feet without a scratch, to create ugliness, something not human, a surprise, that's the Clown again.

Mr. Dependable, always there, leading the fun.

Furious music suddenly erupts and overwhelms the noises of the crowd. This nebulous, inconsistent crowd suddenly assumes meaning, direction; a current is set up, picks up speed, and casts those who are undecided onto the sidewalk. The collective march moves toward a goal: the circus parade.

It begins. The gate money is tied to this parade, so it is persuasive and dynamic. The instruments are making as much noise as they can. The huge bass drum defends itself against the trombone, and the cornets are against the small snare drums. All this hullabaloo is projected from a raised platform. It hits you right in the face, right in the chest. It's like a magic spell. Behind, beside, in front, appearing and disappearing—faces, limbs, dancers, clowns, scarlet throats, pink legs, a fire-eating Negro, the acrobat who walks on his hands, and that music associated with the glare of the spotlights that sweeps over the whole, aggressive bunch, that makes all those white faces with their staring eyes approach, become caught, and climb the steps that lead them to the ticket booth, and on with the music! And it begins again to swallow up the undecided. The sweating bodies, the tights that are no longer pink, a roll of drums and cornets. And the hesitating figures jump up and walk.

The ticket booth swallows up the money. "Hand us the cash."

They keep on coming in and always will. They scramble in until the tent is ready to burst.

People are turned away. The parade has won.

Your future is in your hand, give me your hand. Miss Athena, Miskoreska, Damia will tell you your fate. In the shadows of the circus, at a respectful distance, the mysterious little booth has spread out its web like a spider; it waits patiently for its victims, they are eternal.

Go in and look around: four steps, some hangings, a stove with no coal, a table, the waiting cards, the long hands, an inscrutable face, betraying neither race nor country, still and fixed in the silence of the colorless draperies. Nevertheless an atmosphere, magic for four pennies; undoubtedly something will happen.

The Future is as old as the world.

Calculated silences, delays, the horoscope of your destiny.

A young blond man—and the cards slide softly on the tablecloth. This dark-haired woman who fills your dreams—and the geometric cards fall, full of meaning and pitiless. A king, the ace of hearts, the ace of spades, slowly they are all laid out, pointing their route and defining your destiny. Is that the same woman who went in a few minutes ago? We do not recognize her.

The eternal story of an anguished face searching for something to hold on to, some bearings in a life that no longer wants to hear anything.

Children have always completely understood that it is a great event when the circus arrives in their village. Adventure—going further—doesn't arrive at an appointed time. There is a magic about the freedom of this structure that is moved and built in a night, that appears and disappears like something miraculous, fugitive, free. It was the marvelous that arrived. I always remember it by a poster on the walls of my tiny Norman village.

Children invented the round. Since the great natural spectacles such as clouds, waves, the sun, and the moon preside over our childish wonder, I tell myself that I am in harmony with nature when I am on my bike, which rolls sweetly along, capriciously rocked by the curves

in the road. I am absorbed by it, I am not at all a revolutionary character. I have accepted. I have inscribed myself on the side of the dominant forces, effortlessly, naturally.

Why have eyes in the back of your head when you can turn your head, this round head that moves, with its eyes, its mouth, set on a neck that is round like a tree. All that in a confined or unlimited space, where the straight line cannot be drawn, where birds and airplanes circle harmoniously in a sky that slopes gently toward the horizon.

We live in space more than ever, man pushes out in all directions. He tries to escape, to leave the ground of limitations; competition is set up over the flight from the solid, the concrete. Nervous instability grips the world. Everything moves and breaks free from its traditional limitations. Fixed, stationary elements, resting places, settled situations are shattered and abandoned.

Everyone stands with shifting and worried eyes that rapidly dart from right to left, behind and in front of us. Our modern space no longer looks for its limits; from hand to mouth it is obliged to accept a domain of unlimited action. We plunge into it, we live in it, we have to survive in it. A dangerous life, the acrobats' protective net has disappeared; it is the life of game facing the hunter's gun.

Nevertheless we would like to see the film run in reverse: the sanctuaries shut again, the lights put out, the hierarchies and mysteries resume their place, and respect for the great natural forces rediscovered.

An oak tree that can be destroyed in twenty seconds takes a century to grow. The birds are always marvelously dressed, progress is a word stripped of its meaning, and a cow that nourishes the world will always go two miles an hour.

Le Cirque, Paris, 1950

Mural Painting

The easel picture continues on its course. It is a strictly individual creation. It loses its public value and is buried in a private apartment.

It was born in the Italian Renaissance, along with the advent of individualism and capitalism.

It temporarily lowered the status of the primitive periods, which were dominated by murals and collective works.

Until our time, the easel picture has unquestionably been the witness in plastic terms of the subsequent periods.

But there is something that takes on growing significance; it is the call for "mural painting." This is going to manifest itself in a collective form: it will lose its frame, its small size, its individual and portable quality in order to be adapted to the wall in conjunction with an architect who commissions it.

He will consult with the painter to decide its placement and prominence. It can be either an accompaniment to the wall or a destruction of the wall.

Once the plans have been worked out, a decision is made collectively, and the execution is given over to artisans working in mosaic, fresco, stained glass, or an adaptation in paint.

The history of this architectural collaboration goes back to 1924 or 1925. At this time, modern architects freed the wall from its cumbersome *art nouveau* (1900 style) décor. The walls emerged, bare,

white, to the satisfaction of the public and of the enthusiastic pro-
ducers.

However, it was very quickly demonstrated that most of the people
who were going to live in these places found white walls difficult to
accept.

That is when the contact between architects and painters became
significant.

It is a curious thing that Robert Delaunay and I, who had led the
"Battle for Free Color" in 1909–12, were the ones who entered into
the game.

After numerous experiments the battle came down to a matter of
bringing about acceptance of a value-color—a blue, a red, a yellow, as
a value in itself, as value-object.

I remember the 1925 Exposition when the architect Mallet-Stevens
had asked us to execute two canvases representative of this trend. I did
an abstract picture composed of pure colors within rectangles.

When the architects decided to look for ways to dress up those
white walls, they adopted colored walls (walls of color), and my
colored rectangles were conceived in conjunction with architecture.
(In my own mind, that canvas had never been meant as an easel
picture.) It was, I believe, at the beginning of the adaptation of color
for architecture. This new habitable rectangle with its walls of color
became for me "an elastic rectangle," for certainly the visual feeling
of "fixed dimensions" in these rectangles was destroyed by color. A
new space was created.

If you set up an arrangement of furniture or objects in an asym-
metrical way in this new space, you produce a genuine revolution in
the interior. This revolution is not only plastic in nature; it is psy-
chological as well.

This freedom, this new space, can help, along with other social
means, to transform individuals and to alter their way of life.

Let us leave the colored walls, let us imagine interiors in free colors
in order to avoid the word "abstract," which is wrong. Color is true,
realistic, emotional in itself without having to tie itself closely to a sky,
a tree, a flower. It has intrinsic value, like a musical symphony; it is a
visual symphony, and whether it is harmonious or violent, it must be
accepted equally. The modern crowds have already been awakened;

through posters, shop windows, and displays, they are already used to objects presented alone in space.

I believe that the acceptance of these large mural decorations in free color, which is possible very soon, could destroy the cheerless soberness of certain buildings: stations, large public spaces, and factories. Why not?

Besides, this question is completely separate from the evolution of the easel picture. At the present time it is a courageous direction, for its path is full of traps and difficulties, distinctly leaning toward a return to "great subjects." That, it seems to me, is the normal, logical direction for the contemporary evolution of easel painting after the whole gamut of explorations that have been made since impressionism.

On the other hand, a comparative judgment between mural painting, as I conceive of it, and this easel painting should not be rendered at any time.

These are two entirely different roads that contemporary painters are interested in exploring. For my part, I can very easily see a large easel painting enhanced by accompanying color in contrast with the colored note of the developed subject.

Tapestry has made considerable strides recently; it is a sign that the road is going to be wide open.

Derrière la Miroir, Paris, 1952

New Conceptions of Space

The problem of mural space is the most important of the problems of space.

When architects finally cleared the walls of every vestige of the 1900 style, we found ourselves confronting white walls. A blank white wall is perfect for a painter. A white wall with a Mondrian on it is even better. Around 1925, I painted abstract paintings and I think that this kind of painting can find its logical development only in mural painting. Abstraction is an extreme position that you cannot maintain because you cannot make progress. But walls were not made only for painters. Too many people found themselves out of their element, lost in the face of such a radical transformation of their visual habits.

It was then that we called in colors, with their property of being perceived at a different distance by observers. A wall can be made to advance (a dark wall), recede (a pale-blue wall). It can even be destroyed (a yellow wall). The habitable rectangle becomes an "elastic rectangle."

This discovery had a practical consequence among its possibilities: it can improve the most humble housing by giving extra space to cramped rooms.

I have used this solution for more specifically pictorial space. Separated objects—I take away the table that Braque and Picasso kept—which, depending on the color chosen for them, advance or recede on

the canvas, and the background color as well, create a new space through movement, with no effect of perspective; the space, an imagined space, is born of rhythm. It is for the painter to vary rhythms and colors to obtain expression. Finally, a transparent space can be suggested by preserving distinct lines and colors.

In *The Builders* I tried to get the most violent contrasts by opposing human figures painted with scrupulous realism to the clouds and the metallic structures. I don't know whether I succeeded, but I think anyway that it was a quarrel to provoke.

XX^e Siècle, Paris, 1952

Color in Architecture

The problem is not as simple as it might seem, because when all is said and done, the position of modern painters is divided into two tendencies: the easel painting and the adaptation of color to architecture. I myself am trying to make a more and more precise distinction between the two positions. I know that a great many painters don't think about this, but I do.

The easel painting is a work, an object in itself that defines its own limitations and that is as much at home today in Tokyo as in Berlin. It travels, it circulates, it has its own place, while architectural painting becomes a collective art.

Imagine an architect who comes to see you and says: "There you are, I will need color in my building." If he is a man you can communicate with, you accept the fact that he tells you the place and even the colors that he would like. Now we are in a complete collective. The execution of the thing can even be left to technicians, whether it be for ceramics, frescoes, or mosaics.

In the last four years, I have had a certain number of commissions of this nature, notably—and this is quite strange—for stained-glass windows and church façades.

Let us go back to the beginning. The problem was clarified in 1922 or 1923, when modern architects had cleaned up—there is no other

word—*art nouveau* architecture (1900 style). We found ourselves facing bare walls. The architects were delighted. But a house is not solely for them; it is made to be lived in by the owner and others. So they found a very limited number of people willing to live with these white walls. Then what happened? Here I will tell you a story that involved me, for there was something similar between what I was doing at that time and the architects' anxieties about their walls. I remember that at the 1952 Exposition I had worked on some abstract pieces in pure color that were very rectangular, and Mallet-Stevens, one of my friends, a Belgian architect (who is now unfortunately dead), came to my house and saw a big square picture totally abstract, done in quite strong color, in rectangles. He himself presented a project for an embassy at this exposition, and he said to me: "I would very much like to have that picture in my house." So I put the thing where it was not at all appropriate, in his house, but where at least it constituted an attack, a presence.

After that, contacts were established with some architect friends, and I believe it was at that moment the problem of color on the walls was born. That served as a transition for the client who was alarmed by the bare walls and said: "It's a hospital!"

Since I had been enlisted, I thought that it had to be carried out as well as possible, and I found a term for it: "creation of a new space." It is certain that, if you have a back wall that you cut into thirds, and you cover one third with a color different from that on the other two thirds, the visual relationship of distance between you and the wall disappears. You create another distance that can be different if, for example, one part of the wall is yellow and the other blue. The yellow recedes and the blue advances.

It is a kind of law: colors advance or recede from the sensory point of view. Naturally, if you destroy the habitable surface, what I call "the habitable rectangle," you make it into another rectangle that has no physical limitations and cannot be measured.

If, at the same time, you arrange the furniture asymmetrically, for example, if you put the fireplace a little to the right or the left instead of putting it exactly in the center of the wall, and on the left you have an important piece of furniture while on the right a smaller one—in

short, the reversal of our grandmothers' eternal arrangement—you create a complete revolution in the house. But it is hard to do. I remember for me this turned into a sort of game with a maid. Every time I came home and looked at my mantelpiece, for example—where I had arranged the objects with the largest on the right, a smaller one in the middle, and different-sized one on the left—when I returned, I was sure to find everything in an absolutely symmetrical order, with the biggest thing in the middle. She was a very traditional girl.

This tradition is heavy, weighty. The great revolution, the new space, is this: no longer putting the clock in the middle and the porcelain vases with candelabra on each side.

That is where we were when we started, twenty years ago. Now times have changed, and the spread of color in the world is something unimaginable. The streets, the countryside, those impressionist landscapes, which were so melodious and pleasant, have suddenly seen Dubonnet signs appearing everywhere. The melody got all fucked up—there is no other word—it is fucked up by those billboards and high-tension wires that slice through the clouds and the trees. We are in a landscape of total contrasts, which is our new epoch.

We are now in the presence of an enormous event. I believe that never—not even in the Middle Ages, if we admit that the stones were multicolored—has the world been so full of color as it is now. It has become anarchic. The walls—they no longer exist, everything is shifting, everything is destroyed.

Do I hold myself responsible for this? I don't know anything about it. Some art critics have said: "The Society for the Protection of the Landscape is going to blame Léger one of these days, for he is one who is guilty of unleashing all this color." But I have had no hand in it. Of course I use very strong colors in my pictures, and I have students working with me who make their living by turning out posters and window displays. Well, I have never made a poster or a window display in my life. I did not know that in the street I was in my own world.

It can't be helped. It has nothing to do with advertising; advertising promptly pounced on pure color and used it commercially. We are faced with a situation so chaotic that it makes me ask myself whether

there shouldn't be a kind of order to it all. There is order in the subway, but there is none on the walls. It is the disorder that is part of every revolution at the beginning. The time has come to try and bring order to this anarchy, I believe.

Let me return to the collaboration with architects. This is the major problem because, putting the exterior anarchy aside, we are confronted at the present moment with a call for order in interior color. Easel painting dominated the world absolutely during the whole period of the school of the 1830s and the impressionist school. Then there was a kind of stagnation, and immediately after we saw the full possibilities of collaboration between architects and painters. That began around 1925. I believe that the time has come to examine these modern developments very seriously, because notwithstanding them, everything must be done harmoniously, with appropriate relationships; the architect's power must not be diminished, and his desire to destroy the wall or simply have an accompaniment to the wall must be taken into account. We are in an extremely interesting period. I don't want to say, as certain people do, that I consider it an experiment; it is a very important plastic fact.

In my opinion, abstract art is perfectly suited for large mural decorations. I have discussed it, for example, as a possibility for the United Nations. Mr. [Wallace] Harrison said to me: "We would like something from you for the UN Building in New York." He came to see me with his model, and we discussed more or less representative pictures. We settled on something abstract, and I did two large panels, about thirty-three feet by thirty-three, for the UN. It is the most recent major thing that I have created; it was something that really had to be done.

I believe that if one wants to create space in architecture, it is necessary to stay within the given conditions of color distribution. There we are truly in partnership with the architecture. Architecture cannot be considered as a foil on which to hang pictures. That is the error of the past. A state of collaboration must be established.

I think that is the correct position. I know that it is very controversial, and even most abstract painters I know say: "But not at all, we are doing easel pictures."

That is their concern. I just go on doing my easel picture with

objects, and I conceive more and more of accompanying the mural in abstract terms, and always closely linked to the architect, who has his own idea; it is a matter of making our two ideas coincide. This inclination causes us to reach the same result as the architecture that is liberated, that becomes luminous and bright.

I can give you as an example an old factory in Rotterdam whose renovation made it extremely luminous and bright. Here we get into the domain of the psychological influence of color and light upon individuals. In fact, the workers, without anything having been said to them, became better groomed when they worked in this renovated factory; they have even assured me that the workers talked more and were gayer. Colored walls and clean walls produced a very definite influence on individual morale.

The same has been shown in Finland. A dozen years ago, the architect Aalto had some important commissions, and I went to spend two months there with him, where he built modern apartments for engineers and workers. He thought about the problem of walls of color. What happened when the engineers or workers found themselves among those walls of color? Well, our fine gentlemen, the engineers, put up wallpaper with parakeets while the workers didn't touch anything (of course, perhaps they didn't dare to). And the influence of color and light affected them; their clothing was better cared for. Aalto was enthusiastic, and he said: "All in all, the people aren't bad."

Here, then, are two cases where observations have been made of a change in men's clothing and even a psychological change that goes quite deep.

While we are on the subject, I can also tell you a story about doctors imagining a medical cure through color. Five or six years ago, I gave a lecture in Lyons, and afterward, even though it had lasted quite a long time, a group of young men leaped on me. I said to myself, "They must be Lyonnais painters." Not at all. They were medical students. They said to me: "We noticed in a review that you mentioned a cure using color. That interests us." And I spent the rest of the evening talking with these kids. They proposed an experiment: if you put a disturbed patient, a highly nervous person, in a red room with a moving light for eight hours, he would become completely

insane, they told me. I replied: "Don't bother; we must produce the opposite effect."

This is all I have to say to you about the importance of color in the world. Its importance surpasses any limits yet conceived.

Problèmes de la couleur, Paris, 1954

The Spartakiades

Lots of people, friends, had told me: "Léger, you've got to see *The Spartakiades*, it's for you." So I went to it. I am still under the influence of this grandiose public demonstration, the enormousness of this classic achievement. I say classic because it is an ordered event understood and felt by an entire country, a whole people who are the actor in it.

The morning parade, which lasts for four hours, was in itself a popular collective achievement beyond the customary scope.

I too will remember those four hours: 100,000 Czechs—maybe 150,000—men and women, parading rapidly, effortlessly. Miles of thighs, feet, raised arms, blond faces—the Czechoslovak Republic is blond—smiling in the sun. The hands holding flags, flowers, or standards make a violent contrast to the march of this conscious collectivity.

The dazzling costumes from the different provinces are all there. It is history in motion.

The stirring vision of the athletic teams from all the factories, the groups in their dark-blue work clothes holding their tools over their heads, some with unassembled parts representing their production in process. At moments, tied to the rhythm of the parade, they shout out precise, distinct slogans; real "spoken choruses" reach us head on. These are clear and simple truths: what they have done, what they will do, what they hoped for. All that in progress on their own ground, their land for which they have fought so hard, where they have

cleaned and restored everything. They are on their feet now; it is their work, and they make you realize it.

Look at them carefully. They are men and women confident of their future. The whole country is there. You see the old men and women, very much in their proper place. They aren't old any longer; believe me, at this moment they are young, and that is deeply moving. I tell you that they are all there. The athletic teams from the military services in shorts, with their bronzed sculptural bodies, and this affirmation of life and hope.

You pass through the crowds that line the sidewalks, crowds full of magnificent strong, plump, and laughing children, in order to go higher, even higher in the city, toward the stadium where 20,000 athletes await us, 20,000 men and women in action.

Here it's something entirely different. A massive geometry asserts itself: a geometry of curves, rectangles, circles, diamonds, and squares opposing one another and changing in an order of contrasts, a new order. From the start it is abstract. A flexible geometry, whose conductor is the sun. The most astonishing thing for a painter is the action, however simple, of the bodies which rise and fall; but their backs are red, their chests white, their legs yellow. It all begins to become a vast melody of color and nuance changing gradually in ways you cannot anticipate. It glides, moves away, comes nearer in an organized geometric pattern that is never broken. It's like water in light, like fog at moments, a colored fog that rises, sinks, and disappears without leaving a trace. Something that has never been seen, never thought possible. It flows to infinity, regroups, stops, divides, always in an unbelievable order, precise to the second, to the thousandth of a second. Only the great sports parade in Moscow can be compared with it.

These two great events pinpoint the new values of a modern world, in their order, their discipline expressed with good humor and joy by these thousands of free men and women. It is a great event.

This collectivity, so magnificently achieved, from the economic, political, or social viewpoint, has been able to produce, besides the daily necessities, this spectacle, the most gigantic to be seen in the world.

Paris, 1960

Documentation

A Bibliographical Guide to Léger

by Bernard Karpel,
Chief Librarian, The Museum of Modern Art, New York

There has been a selective and even exhaustive series of bibliographies on Fernand Léger since the 1920s. In view of the fact that the most authoritative documentation was prepared by my former Assistant Librarian Hannah Muller in two major editions, and subsequently updated through other hands until 1966, another comprehensive restatement seems unnecessary. However, the versions of 1949, 1953, 1956, and 1962 are listed in the *Bibliographies* section, which provides enough additional data to satisfy even the Ph.D.

Consequently, my concern has been to direct those interested, whether amateur or scholar, to the accessible sources, to introduce a number of useful citations to bring more recent materials into the record, and by selective coverage to indicate the contemporary evaluation of Léger's place in the world of modern art. In view of the obvious bias of this series—*The Documents of 20th-Century Art*—emphasis has been given to English materials that should be available in American libraries.

References have been grouped as follows: *Bibliographies: 1928–70* (bibl. 1–12).—*Léger Anthologies* (bibl. 13–20).—*Articles by Léger Available in English* (bibl. 21–51).—*Monographs and Major Catalogues* (bibl. 52–81).—*General References* (bibl. 82–125).—*Articles and Catalogues on Léger* (bibl. 126–189).

Bibliographies: 1928–70

1. Thieme, Ulrich and Becker, Felix. *Allgemeines Lexikon der bildenden Künstler*. v. 22, Leipzig, Seemann, 1928. pp. 566–67. Continued in supplement: Vollmer (bibl. 7).

2. Bazin, Germain. [Léger: notice biographique et bibliographique]. *L'Amour de l'Art* (Paris), no. 9, pp. 237–38, Nov. 1938. Also published in consolidated edition: René Huyghe, ed. *Histoire de l'art contemporaine*. Paris, Alcan, 1935. This edition reprinted 1968 by Arno Press, New York.

3. Muller, Hannah B. Bibliographie. In Douglas Cooper. *Fernand Léger et le nouvel espace*. Geneva-Paris, 1949. pp. 167–83. Grouped into: Propos de Léger.—Interviews avec Léger.— Livres, revues, collections.—Catalogues et notices des expositions. The first comprehensive bibliography supplemented by the documentation in Kuh (bibl. 5). Basic source for revision and updating, sometimes acknowledged, sometimes not.

4. Zervos, Christian [Bibliographie]. In his *Fernand Léger*. Paris, Cahiers d'Art, 1952. pp. 90–92.

5. Muller, Hannah. A selected bibliography. In Katharine Kuh. *Léger*. Urbana, Ill., University of Illinois Press, 1953. Selection of references from Cooper (bibl. 3), plus new citations before and since 1949. "For complete coverage . . . consult both bibliographies." Classified groups same as bibl. 3. Listings are included, revised and updated, in Mathey (bibl. 6), Guggenheim (bibl. 9), etc.

6. Mathey, François. Bibliographie. In *Fernand Léger*. Paris, Musée des Arts Décoratifs, 1956. Similarly in his Haus der Kunst, Munich version, 1957, pp. 43–72, i.e., Muller updated from 1949 to 1956 and rearranged in chronological order within each section.

7. Vollmer, Hans. *Allgemeines Lexikon der bildenden Künstler des XX. Jahrhunderts*. v. 3, Leipzig, Seemann, 1957. Supplements Thieme and Becker (bibl. 1).

8. Delevoy, Robert L. Bibliography. In his *Léger*. Geneva, Skira, 1962. pp. 124–32.

9. Solomon R. Guggenheim Museum. *Fernand Léger.* New York, 1962. pp. 103–11.

 Bibliography, based on Muller and Mathey, follows similar groupings but omits newspaper notices and many exhibition catalogues.

10. Nickels, Bradley J. [Léger dissertation. Indiana University, 1966]. See bibl. 69.

 Bibliography includes *Appendix H:* Writings and statements Léger (pp. 379–84) credited to Mathey (bibl. 6), Delevoy (bibl. 8), and Guggenheim (bibl. 9). Also *Bibliography,* pp. 385–92, which includes references both *by and about* Léger.

11. Tate Gallery. *Léger and Purist Paris.* London, Nov. 18, 1970–Jan. 24, 1971.

 Selected bibliography, pp. 106–107, includes not only Léger references but also "contemporary texts."

12. Paris. Musée National d'Art Moderne. *Fernand Léger.* Oct. 16, 1971–Jan. 10, 1972.

 Expositions, 1912–71.—Bibliographie sélective: textes, monographies, articles, manuscrits (1969), pp. 189–93.

For Viking edition and related variants, see bibl. 16, 16a, 17; other bibliographies passim, e.g. bibl. 74, 79.

Léger Anthologies: Conversations, Essays, Lectures, Quotations

13. Léger, Fernand. *Bekenntnisse, Gespräche.* Zurich, Die Arche, 1957.

14. Léger, Fernand. *Propos et Présence.* Paris, Gonthier-Seghers, 1959.

15. Léger, Fernand. *Mes Voyages.* Paris, Editeurs Français Réunis, 1960.

16. Léger, Fernand. *Fonctions de la Peinture.* Paris, Gonthier, 1965. Preface: Roger Garaudy. Thirty-four essays in five chapters. Sources, chronology, bibliography. From the series Bibliothèque médiations, now published in The Documents of 20th-Century Art (1973). See bibl. 17.

16a. Léger, Fernand. *Mensch, Maschine, Malerei.* Bern, Benteli, 1971.

"Title des Originales: *Fonctions de la Peinture.* Übersetzt und eingeleitet von Robert Füglister." Bibliography (no. 1–33). Chronology (1881–1955). .

17. Léger, Fernand, *Functions of Painting.* New York, The Viking Press; London, Thames and Hudson, 1973.

 Translated by Alexandra Anderson. Edited and introduced by Edward F. Fry; preface by George L. K. Morris; bibliography by Bernard Karpel.

18. Chalette Gallery. *Fernand Léger: The Figure.* New York, Apr. 1965.

 Edited and translated by Dr. Madeleine Lejwa. Includes "A propos of the human body considered as an object" and other translated extracts (18 sources listed).

19. Nickels, Bradley J. [Léger dissertation. Indiana University, 1966]. See bibl. 69.

 Appendices A–G (pp. 314–78) include French originals or English translations of fifteen Léger texts.

20. Vallier, Dora, comp. La vie fait l'oeuvre de Fernand Léger: Propos de l'artiste recueillis. *Cahiers d'Art* (Paris), 1954, v. 2, pp. 133–72.

 Condensed in J. Charpier and F. Seghers: *L'Art de la Peinture.* Paris, Seghers, 1957, pp. 623–27 [English edition: New York, Hawthorn, 1965].

 See also comparable citations following, e.g. Descargues (bibl. 60).

Articles by Léger Available in English

21. À propos of the human body considered as an object. *In* Chalette Gallery. *Fernand Léger,* 1965 (bibl. 18).

22. The aesthetic of the machine [extract]. *In* Theories of Modern Art, pp. 277–79 (bibl. 89).

 From *Bulletin de l'Effort Moderne* (Paris), Jan.–Feb. 1924.

23. Aesthetics of the machine: the manufactured object, the artisan and the artist. *Art and Literature* (Paris), no. 11, pp. 156–64, Winter 1967.

From *Bulletin de l'Effort Moderne* (Paris), Jan.–Feb. 1924.

23a. Apropos of colour. *Transition* (New York) no. 26, p. 81, 1937.

24. Beauty in machine art. *Design* (Columbus, O.) v. 39, pp. 6–7. Mar. 1938.

25. Byzantine mosaics and modern art. *Magazine of Art* (Washington, D.C.), v. 37, pp. 144–45, Apr. 1944.

26. Calder. *In* Curt Valentin Gallery. Alexander Calder: Gongs and Towers. New York, 1952. pp. 6–7.

27. Chicago. *Plans* (Paris), v. 2, pp. 63–68, Jan. 1932.

28. Color in architecture. *In* Stamo Papadaki. Le Corbusier. New York, Macmillan, 1948. pp. 78–80.

29. The esthetics of the machine, manufactured objects, artisan and artist. *Little Review* (New York), v. 9, no. 3, pp. 45–49, Spring 1923; v. 9, no. 4, pp. 55–58, 1923–24.

 Translation: *Bulletin de l'Effort Moderne* (Paris), no. 1, Jan.; no. 2, Feb. 1924. Similar to bibl. 22, 23. Also no. 1 translated by Nickels, pp. 343–46 (bibl. 69).

30. Film by Fernand Léger and Dudley Murphy, musical synchronism by George Antheil. *Little Review* (New York), v. 10, no. 2, pp. 42–44, Autumn–Winter 1924–25.

 Also contents title (bibl. 34).

31. A letter [1922]. *In* Léger and Purist Paris. pp. 85–86 (bibl. 76).

 Translation: Correspondance [1922]. *Bulletin de L'Esprit Nouveau* (Paris), no. 4, Apr. 1924.

32. [Letter to a friend. 1955]. *Quadrum* (Brussels), no. 2, pp. 79–80, Nov. 1956.

 Dated Aug. 2, 1955 (Lisores, Orne). French text and facsimile of letter, pp. 77–79. Brief introduction by J. M. Translation, pp. 79–80.

33. The machine aesthetic—the manufactured object—the artisan and the artist. *In* Léger and Purist Paris. pp. 37–92 (bibl. 76).

 Translation: *Bulletin de l'Effort Moderne* (Paris), no. 1, Jan.; no. 2, Feb. 1924. See also bibl. 23, 29.

34. Mechanical ballet. *Little Review* (New York), v. 10, no. 2, pp. 42–44, Autumn–Winter 1924–25.

 Contents title. Caption title: Film by Fernand Léger and Dudley Murphy (bibl. 30).

35. Modern architecture and color. *In* American Abstract Artists. New York, 1946. pp. 31, 34–35, 37–38.
36. The new landscape. *In* Gyorgy Kepes. The New Landscape in Art and Science. Chicago, Theobald, 1956. p. 90.
37. The new realism. Lecture delivered at The Museum of Modern Art. *Art Front* (New York), v. 2, no. 8, pp. 10–11, Dec. 1935. Translated by Harold Rosenberg.
38. The new realism. *In* Robert Goldwater. Artists on Art. New York, Pantheon Books, 1945; London, Kegan Paul, 1947. pp. 423–26.
39. The new realism goes on. *Art Front* (New York), v. 3, no. 1, pp. 7–8, Feb. 1937. Speech read at the Maison de la Culture, Paris. (bibl. 44). Translation by Samuel Putnam.
40. A new realism—the object (its plastic and cinematographic value). *Little Review* (New York), v. 11, no. 2, pp. 7–8, Winter 1926. Composed in 1925. Also in bibl. 104. Extract in *Theories of of Modern Art*, pp. 279–80 (bibl. 89).
41. On monumentality and color. *In* Siegfried Giedion. Architecture, You and Me. Cambridge, Mass., Harvard University Press, 1958. pp. 40–47.
42. Notations on plastic values. *In* Fernand Léger [an exhibition at the Anderson Galleries]. New York, Société Anonyme, Nov. 16–28, 1925.
43. Painting and reality. *Transition* (New York), no. 25, pp. 104–108, Winter 1936. Translated from "La Querelle du Réalisme" (Paris, Editions Sociales Internationales, 1936). Extracts of lectures by Aragon, Le Corbusier, and Léger at the Maison de la Culture. Also in bibl. 39.
44. Painting and reality (contribution to a discussion between Aragon, Léger and Le Corbusier). *In* The Painter's Object. Edited by Myfanwy Evans. London, Gerald Howe, 1937. pp. 15–16, 18–20. Reprint edition: New York, Arno Press, 1970. Text from *Transition* (bibl. 43).
45. [Painting and reality: extract]. *Daedalus* (Cambridge, Mass.), no. 1, pp. 87–90, Winter 1960.

Published as a "statement" here as well as in book edition of
the magazine titled *The Visual Arts Today*, edited by Gyorgy
Kepes.

46. Polychromatic architecture. *In* Léger and Purist Paris. pp. 95–96
(bibl. 76).
 Translation from *L'Architecture Vivante* (Paris) no. [4], pp.
 21–22, Winter 1924.

47. Popular dancing. *In* Léger and Purist Paris. pp. 93–94 (bibl. 76).
 Translation from *Bulletin de l'Effort Moderne* (Paris) no. 12,
 Feb.; no. 13, Mar. 1925.

48. [Program notes for *Le Ballet mécanique, 1924*]. London Film
 Society. Programme Notes, No. 2. Feb. 23, 1933.
 Leaflet to accompany showings by private film group; text
 attributed to Léger. Reprint: London Film Society Notes. New
 York, Arno, 1972.

49. The question of 'truth.' *Architectural Forum* (New York), v. 70,
 pp. 138–41, Feb. 1939.
 Also bibl. 133.

49a. Relationship between modern art and contemporary industry. *In*
 Modern Art in Advertising: An Exhibition of Designs for Con-
 tainer Corporation of America. Chicago, Art Institute of Chi-
 cago, 1945. pp. 4–5.

50. Revival of mural art. *The Listener* (London), v. 18, no. 450,
 pp. 403, 409, Aug. 25, 1937.

51. This is how it starts. *In* Beyeler Gallery. *F. Léger.* 1970. pp.
 11–13 (bibl. 53).

 Also note interviews: Howe (bibl. 153), Pity us! (bibl. 165),
 Warnod (bibl. 187), etc.

Monographs and Major Catalogues

52. Bazaine, Jean. *Fernand Léger: peintures antérieures à 1940.*
 Paris, Galerie Louis Carré, 1945.
 On the occasion of an exhibition held Jan. 16–Feb. 5, 1945.

53. Beyeler Gallery. *F. Léger.* Basel, Editions Beyeler, 1970.
 Contributions by Blaise Cendrars, René Jullian, André
 Maurois. Extracts from Léger: "This is how it starts," pp.

11–13; notes passim. Chronology, sources of the notes, selected bibliography. Trade edition of exhibition held Aug.–Oct. 1969.

54. Carré, Louis, Galerie. *La Figure dans l'oeuvre de Fernand Léger*. Paris, June 6–July 10, 1952.

 Texts by André Maurois: "Mon ami Léger," and by Léger: "Comment je conçois la figure." Catalogue sur vélin by Mourlot (1000 copies); list of 15 paintings (1912–52) and 10 drawings.

55. Carré, Louis, Galerie. *Le Paysage dans l'oeuvre de Fernand Léger*. Paris, Louis Carré, 1956.

 Includes "Entretien de Fernand Léger avec Blaise Cendrars et Louis Carré."

56. Cooper, Douglas. *Fernand Léger: contrastes de formes 1912–1915*. Paris, Berggruen, 1962.

 Introduction (2 pp.); 16 illus. (col.). Collection Berggruen no. 37, May 1962.

57. Cooper, Douglas. *Fernand Léger: dessins de guerre, 1915–1916*. Paris, Berggruen, 1956.

 Text by Blaise Cendrars: "La grand copine." Catalogue of 44 facsimile plates (pt. col.). Edition: 650 copies.

58. Cooper, Douglas. *Fernand Léger et le nouvel espace*. Text in French and English. London, Lund Humphries; Geneva-Paris, Trois Collines, 1949.

 Usually cited, even by H. B. Muller, without reference to the English insert and compound publishers. Presumably, the first printing lacked the English insert. The translation covers only chap. 2–4 (pp. 31–140) of the French text. Documentation includes illustrated books, magazine illustrations, exhibition list. Major bibliography by Hannah B. Muller, now a standard reference, is complemented by bibl. 5. Book review by Henry R. Hope, *College Art Journal*, no. 4, pp. 435–37, 1950.

59. Delevoy, Robert L. *Léger: biographical and critical study*. Geneva, Skira, 1962.

 Translated from the French Taste of Our Time series. Bibliography. Also European editions.

60. Descargues, Pierre. *Fernand Léger*. Paris, Cercle d'Art, 1955.

 Prepared in close collaboration with the artist. Preface by

Léger: "C'est comme ça que cela commence" (pp. 5–6).—
"Charlot cubiste, scénario pour un dessin animé" (pp. 17–18).
Summaries by Léger precede each chapter. Quotations passim.

61. Düsseldorf. Städtische Kunsthalle. *Léger.* Dec. 16, 1969–Feb.
 8, 1970.

 26 pp., plates (col.). Eight contributions, documentation, 149
 exhibits, bibliography.

62. Elgar, Frank. *Léger: peintures 1911–1948.* Paris, Editions du
 Chêne, 1948.

 Brief introduction; 16 mounted col. pl. Also note bibl. 91, 109.

63. *Fernand Léger: la forme humaine dans l'espace.* Montréal,
 Editions de l'Arbre, 1945.

 Eight contributions include Léger's "À propos du corps humain
 considéré comme un objet" (translated bibl. 16, 18), M. A.
 Couturier, Maurice Gagnon, S. Giedion, François Hertel,
 S. M. Kootz, J. J. Sweeney.

64. Francia, Peter de. *On Léger's "The Great Parade."* London,
 Cassell, 1969.

 In the series edited by Carel Weight: Painters on Painting;
 32 pp., ill. (col.), notes.

65. Garaudy, Roger. *Pour un réalisme du XXᵉ siècle. Dialogue
 posthume avec Fernand Léger.* Paris, Grasset, 1968.

 "Un inédit de Fernand Léger" (pp. 225–44) is also titled:
 "De l'Acropole à la Tour Eiffel (conférence faite par Fernand
 Léger à la Sorbonne)." Chronology, notes.

66. George, Waldemar. *Fernand Léger.* Paris, Gallimard, 1929.

 The series Les Peintres nouveaux; 63 pp. incl. illus. Text of
 14 pp. translated bibl. 144.

67. Jardot, Maurice. *Léger.* Paris, Hazan, 1956.

 Also his *Léger Dessins.* Paris, Deux Mondes, 1953, 8 pp., 53
 illus.

68. Kuh, Katharine. *Léger.* Urbana, Ill., University of Illinois Press,
 1953.

 Classified bibliography by Hannah B. Muller complementing
 Cooper (bibl. 3). Does not mention concurrent catalogue with
 similar documentation: *Léger*, by Katharine Kuh, Chicago,
 Art Institute of Chicago, in collaboration with The Museum of

Modern Art, New York, and the San Francisco Museum of Art, 1953. 90 pp.

69. Nickels, Bradley J. *Fernand Léger: Paintings and Drawings, 1905 to 1930.* [Doctoral dissertation, Indiana University, Department of Fine Arts, June 1966]. Ann Arbor, Mich., University Microfilms, 1971.

Xerox edition of dissertation; 393 pp. including vita. Text contains quotations, bibliography of writings and statements by Léger (1913–60), and general bibliography. Important appendices A–G include selected texts and extracts by Léger. Translations of full or partial texts include: À propos du corps humain considéré comme un objet.—L'art abstrait.—L'art moderne devant le peuple.— Causerie sur l'art.—Citation (from Raynal, 1927).—Conférence sur l'esthétique de la machine.— Couleur dans le monde.—La couleur dans la vie.—L'esthétique de la machine, l'objet fabriqué, l'artisan et l'artiste.—Les origines de la peinture et sa valeur représentative.—Pensées.— Les réalisations picturales actuelles.—Réponse à une enquête sur le cubisme.

70. Paris. Musée des Arts Décoratifs. *Fernand Léger. 1881–1955.* Paris, June–Oct. 1955.

Prefatory texts by Léger, Jean Cassou, Georges Beauquier. Chronology by François Mathey includes quotations. Bibliography, based on Muller (bibl. 3, 5) enlarged in chronological order by Mathey to 1956. Catalogue and illustrations. Similar catalogue issued by Haus der Kunst, Munich, for Mar.–May 1957 show.

71. Paris. Musée National d'Art Moderne. *Fernand Léger.* Oct. 16, 1971–Jan. 10, 1972.

Major retrospective (195 pp. ill.) at the Grand Palais. Two hundred paintings, ceramics, tapestries. *La Grande Parade* (Guggenheim Museum) and *Les Constructeurs* (Léger Museum, Biot) are accompanied by all related studies. Texts by Jean Leymarie and Jean Cassou chronology, exhibitions, bibliography.

72. Raynal, Maurice. *Fernand Léger: vingt tableaux.* Paris, L'Effort Moderne, 1920.

Les Maîtres du cubisme; 18 pp., 20 mtd. pl. Texts also pub-

lished in *L'Esprit Nouveau*, Jan. 1921; *Bulletin de l'Effort Moderne*, Oct. and Nov. 1925.

73. Roy, Claude. *Fernand Léger: les constructeurs.* Paris, Falaize, 1951.

 Booklet (16 pp. plus ill.) published on the occasion of a Léger show at the Maison de la Pensée Française, Paris.

73a. San Lazzaro, Gualtieri di, ed. *Homage to Fernand Léger.* New York, Tudor, 1971.

 "Special issue of the XXe Siècle Review" based on 19 articles, 26 color plates, 150 reproductions. Also reprints 1952 Léger lithograph from *XXe Siècle.* Biographical chronology.

74. Sélection. *Fernand Léger.* Antwerp, Éditions Sélection, 1929.

 Cahier 5, Feb. 1929. Anthology of 10 contributions. Biographical and bibliographical note.

75. Solomon R. Guggenheim Museum. *Fernand Léger: Five Themes and Variations.* New York, Feb. 28–Apr. 29, 1962.

 Master Series Number 1. Text by Thomas M. Messer. 111 exhibits. Extensive chronological bibliography incorporates Muller (bibl. 3) and Mathey (bibl. 6), adding new selected references to 1961.

76. Tate Gallery. *Léger and Purist Paris.* London, Nov. 18, 1970–Jan. 24, 1971.

 Foreword by Sir Norman Reid; preface by John Golding. Major essays by Golding and Christopher Green. Includes translations from Léger (bibl. 31, 33, 46) by Charlotte Green. Catalogue, selected bibliography, bibliographical notes. For 1950 show see bibl. 184.

77. Tériade, E. *Fernand Léger.* Paris, Éditions Cahiers d'Art, 1928.

 800 copies; 27 pp. plus 93 plates.

78. Vallier, Dora. *Carnet inédit de Fernand Léger. Esquisses pour un Portrait.* Paris, Cahiers d'Art [1957?].

 Originally published in *Cahiers d'Art*, v. 31–32, pp. 95–175 incl. illus., 1956–57.

79. Verdet, André. *Fernand Léger: le dynamisme pictural.* Geneva, Cailler, 1955.

 In series Peintres et sculpteurs d'hiers et d'aujourd'hui. Chronology, bibliography, documentation. Also his *Fernand Léger.* Florence, Sansoni, 1969. (I Maestri del Novecento).

Chronology, bibliography. Translated in series 20th Century Masters, [Hamlyn Publishing Group, London, 1970].

80. Zervos, Christian. *Fernand Léger: oeuvres de 1905 à 1952.* Paris, Cahiers d'Art, 1952.

English translation, pp. 16–21. Bibliography.

81. Zurich. Kunsthaus. *Juan Gris—Fernand Léger.* Paris, Cahiers d'Art, 1933.

Major double anthology of 23 contributions edited by Christian Zervos for successive retrospectives: Apr. 2–26 (Gris), Apr. 30–May 25 (Léger). Drawn from *Cahiers d'Art* material but published separately with Kunsthaus cover.

General References

82. Apollinaire, Guillaume. *The Cubist Painters: Aesthetic Meditations 1913.* New York, Wittenborn, Schultz, 1949. pp. 43–45.

First edition 1944. Revised edition (1949) includes bibliography on Apollinaire and Cubism by Bernard Karpel. Preface by editor of Documents of Modern Art, Robert Motherwell, omitted from 1962 printing. Excellent annotated French edition by LeRoy C. Breunig and J.-Cl. Chevalier (Paris, Hermann, 1965).

83. *Art in Cinema.* A Symposium on the Avantgarde Film . . . edited by Frank Stauffacher. San Francisco, San Francisco Museum of Art. 1949. pp. 103–104 (index).

References to *Ballet Mécanique, Dreams That Money Can Buy,* Léger.

84. Banham, Reyner. *Theory and Design in the First Machine Age.* 2d ed. New York, Washington, Praeger, 1967.

Chap. 15: Architecture and the Cubist tradition. First edition: London, Architectural Press, 1960.

85. Barr, Alfred H., Jr. *Cubism and Abstract Art.* New York, Museum of Modern Art, 1936. pp. 82, 96, 214, 229, 232–33.

Synthetic cubism, pp. 77–98. Catalogue of exhibition; bibliography. Reprint edition: New York, Arno Press, 1966.

86. Barr, Alfred H., Jr. *Masters of Modern Art.* New York, Museum of Modern Art, 1954. p. 239 (index).

87. Biederman, Charles. *Art as the Evolution of Visual Knowledge.* Red Wing, Minn., The Author, 1948. pp. 683–84 (index).

88. Breunig, LeRoy C., ed. *Apollinaire on Art: Essays and Reviews: 1902–1918.* New York, Viking; London, Thames and Hudson, 1972. p. 540 (index).

 The Documents of 20th-Century Art Series. Translation, with added material, of his Gallimard edition: *Apollinaire: Chroniques d'Art*, 1960. Bibliography by Bernard Karpel.

89. Chipp, Herschel B. *Theories of Modern Art.* Berkeley and Los Angeles, University of California Press, 1968. pp. 197, 242–43, 277–80.

 Includes texts by Apollinaire and Léger.

90. Cooper, Douglas. *The Cubist Epoch.* London, Phaidon Press, 1971. p. 315 (index).

 "In association with the Los Angeles County Museum of Art and the Metropolitan Museum of Art" on the occasion of a major retrospective. Léger, nos. 175–88. Bibliography.

91. *Dictionary of Modern Sculpture.* Edited by Robert Maillard. New York, Tudor [1960?]; London, Methuen, 1962. pp. 165–69. Translation: *Dictionnaire de la sculpture moderne.* Paris, Hazan, 1960. Text by Frank Elgar. Also note bibl. 109.

92. *Dreams That Money Can Buy.* A film produced and directed by Hans Richter. 100 minutes, U.S., 1944–46.

 Also publicity booklet with text and illustrations. Film described as "7 dreams shaped after the visions of 7 contemporary artists," actually Calder, Duchamp, Ernst, Léger, Man Ray, Richter. Léger's sequence is the love story of two window mannequins, "a version of American folklore."

93. Egbert, Donald Drew. *Social Radicalism and the Arts—Western Europe.* New York, Knopf, 1970. p. xxviii (index).

 "A cultural history from the French Revolution to 1968."

94. *Encyclopedia of World Art*, New York, McGraw-Hill, 1959–68.

 Index, v. 15, p. 315; main Léger article, v. 9, p. 197. For additional material assembled by the supervisory editor, Dr. Bernard Myers, also see his *McGraw-Hill Dictionary of Art* (bibl. 116).

The Film Index see bibl. 123.

95. Fry, Edward. *Cubism*. New York, Toronto, McGraw-Hill, 1966. p. 199 (index).

 Includes "The origins of painting and its representational value," pp. 121–26.—"Contemporary achievements in painting," pp. 135–39.

96. Gallatin, Albert E., Collection. *Museum of Living Art: A. E. Gallatin Collection*. New York, New York University, 1940. pp. 12, 30.

 14 works by Léger. Essay by Jean Hélion; notes by G. L. K. Morris. Revised catalogue issued when collection was absorbed by the Philadelphia Museum of Art (1954).

97. Gleizes, Albert and Metzinger, Jean. *Cubism* (Translated). London, Leipsic, T. Fisher Unwin, 1913.

 First English edition of: *Du "Cubisme."* Paris, Figuière, 1912. Five Léger reproductions.

98. Golding, John. *Cubism, a History and Analysis, 1907–1914*. 2d ed. London, Faber and Faber, 1968. p. 205 (index).

 First edition: London and New York, 1959. Also note his essay "Léger and the heroism of modern life" in Tate catalogue (bibl. 76). General bibliography.

99. Habasque, Guy. *Cubism. Biographical and Critical Study*. Geneva, Skira, 1959.

 Translated from the French.

100. Haftmann, Werner. *Painting in the Twentieth Century*. New York, Praeger; London, Lund Humphries, 1960. v. 1, p. 422 (index); v. 2, p. 522 (index).

 First edition: Munich, Prestel Verlag, 1954, 2 v. Also second American popular edition, 1965.

101. Hamilton, George Heard. *Painting and Sculpture in Europe*. Baltimore, Penguin, 1967. p. 432 (index).

 Bibliography. Similar coverage in complementary text: *19th and 20th Century Art and Painting, Sculpture, Architecture*. New York, Abrams, 1970.

102. Heron, Patrick. *The Changing Forms of Art*. London, Routledge and Kegan Paul, 1955. pp. 148–51.

103. *History of Modern Painting [vol. 3]: From Picasso to Surrealism*. Geneva, Skira, 1950. p. 209 (index).

 Text by Maurice Raynal and others. Documentation by Hans Bolliger. Also European editions.

104. Jacobs, Lewis, ed. *Introduction to the Art of the Movies: an Anthology.* New York, Noonday Press (Farrar, Straus & Giroux), 1970 (copyright 1960).

Paperback edition. Includes bibl. 40, 176.

105. Janis, Sidney, Gallery. [*Léger Exhibition Catalogues*]. New York, 1948–60.

Illustrated catalogues issued for five Léger exhibitions: Sept. 21–Oct. 16, 1948.—Mar. 19–Apr. 7, 1951.—Sept. 15–Oct. 11, 1952.—Jan. 2–Feb. 2, 1957.—Dec. 5, 1960–Jan. 1961.

106. Kahnweiler, Daniel-Henry. *Juan Gris.* New York, Abrams, 1969. p. 344 (index).

Revised, enlarged version. Bibliography by Bernard Karpel. First edition: Paris, Gallimard, 1946. Translation: London, Lund Humphries; New York, Curt Valentin, 1947. Bibliography. Third edition: Stuttgart, Gerd Hatje, 1968. Bibliography. Translation, 1969.

107. Kahnweiler, Daniel-Henry. *The Rise of Cubism.* New York, Wittenborn, Schultz, 1949. pp. 17–19.

Documents of Modern Art series. Kahnweiler bibliography by Bernard Karpel. Translation: *Der Weg zum Kubismus.* Munich, Delphin, 1920. pp. 47–51.

108. Kootz, Samuel M. *Women.* New York, Samuel M. Kootz [Gallery], 1948. pp. 13–15.

Includes "The painter's conflict" by Clement Greenberg.

109. Lake, Carlton and Maillard, Robert. *Dictionary of Modern Painting.* 3d ed. New York, Tudor [1964?]. pp. 197–201.

Text by Frank Elgar, translated from the French. First French edition: Paris, Hazan [1954].

110. Liberman, Alexander. *The Artist in His Studio.* New York, Viking, 1960. pp. 49–52.

Text and photographs. In paperback edition (1968 and 1969), pp. 189–96.

111. Malevich, Kasimir Severinovich. *Essays on Art, 1915–1933.* Edited by Troels Andersen. New York, Wittenborn, 1971. p. 178 (index).

Documents of Modern Art, v. 16. Translated by Xenia Glowacki-Prus and Arnold McMillin. First edition (in 2 v.):

Copenhagen, Borgen, 1968. Main Léger comment, v. 2, pp. 62–69.

112. Manvell, Roger, ed. *Experiment in the Film.* London, Grey Walls, 1949. pp. 277–78 (index).

References to "Le Ballet mécanique" and "Dreams That Money Can Buy."

113. Markov, Vladimir. *Russian Futurism: a History.* Berkeley and Los Angeles, University of California Press, 1968. p. 640 (index).

114. Miller Company Collection. *Painting Toward Architecture.* Text by Henry-Russell Hitchcock. New York, Duell, Sloan and Pearce, 1948. pp. 27, 30, 50–51.

115. Mourlot, Fernand. *Art in Posters.* New York, Braziller, 1959. pp. 31–37.

116. Myers, Bernard, ed. *Encyclopedia of Painting.* 3d rev. ed. New York, Crown, 1970. p. 299.

Coverage enlarged in his *McGraw-Hill Dictionary of Art.* New York, McGraw-Hill, 1969. v. 3, p. 401–402 (article by John C. Galloway). Additional: v. 1, p. 330 ("Biot, Fernand Léger Museum"). Dr. Myers also was supervisory editor for bibl. 94.

117. Raynal, Maurice. *Modern French Painters.* New York, Brentano's, 1928; London, Duckworth, 1929. pp. 111–16, 230–32.

Translation: *Anthologie de la peinture en France.* Paris, Montaigne, 1927.

118. Rischbieter, Henning, ed. *Art and the Stage in the 20th Century.* Greenwich, Conn., New York Graphic Society [1969] p. 305 (index).

"Painters and sculptors work for the theatre." Chapter on Léger, pp. 92–99; bibliographical references. Translated from the German edition: *Bühne und Bildende Kunst im XX. Jahrhundert.* (1968). Documentation by Wolfgang Storch.

119. Rosenblum, Robert. *Cubism and Twentieth-Century Art.* New York, Abrams; London, Thames and Hudson, 1961. p. 327 (index).

120. Schmeller, Alfred. *Cubism.* New York, Crown, n.d.; London, Methuen, 1956.

"Movements in Modern Art" series translated from the Ger-

man. Brief introduction and comments on plates 2, 8, 18, 23.

121. *The Selective Eye.* Paris, Lausanne, L'Oeil; New York, Random House, 1955. pp. 114–17, col. pl. pp. 118–19.

Translation of Douglas Cooper: "The Big Parade" from *L'Oeil* (Paris) no. 1, 1955.

122. Uhde, Wilhelm. *Picasso and the French Tradition.* New York, E. Weyhe, 1929. p. 68.

Translated from the French, 1928, pp. 69–70.

123. U.S. Works Project Administration. Writers Project. *The Film Index, a Bibliography, Vol. 1: The Film as Art.* Editor: Harold Leonard. New York, Museum of Modern Art Film Library and H. W. Wilson, 1941. p. 685 (index).

Reprint edition: New York, Arno Press, 1966.

124. Wadley, Nicholas. *Cubism.* London, etc., Hamlyn, 1970. pp. 95–100, 185 (index).

124a. Wilenski, Reginald. *Modern French Painters.* New York, Harcourt, Brace, 1963, p. 401 (index).

First edition: London, 1940; several revisions.

125. Yale University. Art Gallery. *Collection of the Société Anonyme: Museum of Modern Art.* New Haven, Conn., Associates in Fine Arts, 1950. pp. 153–54.

Comment by Marcel Duchamp, biography, brief quotes, bibliography, list of works.

Articles and Catalogues on Léger

126. Ashton, Dore. Exhibitions at the Janis Gallery and the Museum of Modern Art. *Arts & Architecture* (Los Angeles), Feb. 1961, pp. 5, 30.

127. Barry, Iris. Ballet Mécanique. *In* The Film in Germany and in France. Series III, Program 5. New York, Museum of Modern Art Film Library [1939?].

Undated program notes. Probably first major American presentation. Repeated in: Film Notes. *Bulletin of the Museum of Modern Art,* v. 16, no. 2–3, p. 47, 1949.

128. Bond, Kirk. Léger, Dreyer and montage. *Creative Art* (New York), Oct. 1932, pp. 135–38.

129. Canaday, John. Léger alive and well. *New York Times*, Nov. 24, 1968, p. D27.

Reviews exhibition; evaluates Léger.

130. Carré, Louis, Gallery. *Léger: constructivist and bard.* New York, Mar. 28–Apr. 21, 1951.

With portions of Léger texts; notes by M. A. Couturier and Jerome Mellquist. Review: *Art News* (New York), Apr. 1951, p. 23.

131. Cassou, Jean. Fernand Léger. *Art News* (New York), Nov. 1949, pp. 27, 58–59.

Comments on the Léger exhibition, Musée d'Art Moderne, Paris.

132. Chicago, Art Institute. *Léger* by Katharine Kuh. 1953.

See bibl. 68.

133. Cincinnati Modern Art Society. *Exhibition of Painting by Fernand Léger.* Cincinnati, Art Museum, Nov. 14–Dec. 17, 1944.

Includes Léger: "The question of truth" (from *Architectural Forum's Plus*, Feb. 1939).—S. Giedion: "Léger and America."

134. Cooper, Douglas. *Fernand Léger.* London, Tate Gallery, 1950.

See bibl. 184. Also note essay, bibl. 121.

135. Couturier, M. A. A modern church adorned by the great artists of our time. *Harper's Bazaar* (New York), Dec. 1947, p. 121–23.

Mentions Léger's mosaic decoration.

136. Davis, Richard. Institute acquires painting by Léger . . . "Table and Fruit." *Minneapolis Institute Bulletin*, v. 37, pp. 3–7, Jan. 3, 1948.

137. Denvir, Bernard. Painter of modern industrial forms. *Studio* (London), Dec. 1950, pp. 170–73.

On the occasion of the Tate show (bibl. 184).

138. Denvir, Bernard. Poussin of Pigalle: Léger. *Art and Artists* (London), Jan. 1971, pp. 16–19.

Dreams That Money Can Buy. See bibl. 92.

139. Ely, C. B. Monsieur Léger. *Sewanee Review* (Sewanee, Tenn.), Jan. 19, 1919, pp. 43–47.

139a. Elderfield, John. Epic cubism and the manufactured object: notes on a Léger retrospective. *Artforum* (New York), Apr. 1972, pp. 54–63.
 On the occasion of the Tate show (bibl. 76).

140. Fernand Léger exhibition. *Museum of Modern Art Bulletin* (New York), v. 3, no. 1, p. [1–8], Oct. 1935.
 With catalogue of 43 works, 3 ill. Largely text by Morris (bibl. 163). Exhibition number. Reviews: *Art News* (New York), Oct. 5, 1935, p. 5.—Oct. 12, 1935, pp. 3, 6.—*Art Digest* (New York), Oct. 1, 1935, p. 12.—*Art Digest* (New York), Dec. 15, 1935, p. 12.—*New Yorker*, Oct. 19, 1935, p. 58.—*Newsweek* (New York), Oct. 12, 1935, p. 7. Also bibl. 151 (Greene).

141. Fitzsimmons, James. Notes on Léger's works. *Arts & Architecture* (Los Angeles), Dec. 1953, pp. 6–7.

142. Geldzahler, Henry. Late Léger: parade of variations. *Art News* (New York), Mar. 1962, pp. 32–34.

143. George, Waldemar. Fernand Léger. *The Arts* (New York), May 1929, pp. 303–13.
 Translates text of Léger booklet (bibl. 66).

144. George, Waldemar. Fernand Léger—triumphs and miseries of a victory. *Formes* (Paris), no. 7, pp. 4–5; 7 ill., July 1930.

145. Giedion, Siegfried. Léger in America. *Magazine of Art* (Washington, D.C.), Dec. 1945, pp. 295–99.
 On paintings completed at Rouses Point. Also note bibl. 133.

146. Goldin, Amy. Léger now. *Art News* (New York), Dec. 1968, pp. 24–27.

147. Golding, John. [Review of exhibit at Waddington Galleries, London]. *Studio International* (London), May 1970, pp. 226–27.

148. Goodrich, Lloyd. [Léger]. *The Arts* (New York), Nov. 1930, pp. 117–19.
 On retrospective at Reinhardt Gallery.

149. Green, Christopher. Léger, Purism and the Paris machines. *Art News* (New York), Dec. 1970, pp. 54–56, 67.
 See bibl. 76.

150. Greenberg, Clement. Master Léger. *Partisan Review* (New York), Jan. 1954, pp. 90–97.

151. Greene, Balcomb. The function of Léger. *Art Front* (New York), Jan. 1936, pp. 8–9.

　　Initiated by the Museum of Modern Art show (bibl. 140).

152. Gregory, Bruce. Léger's United Nations murals. *Art Journal* (New York), no. 1, pp. 35–36, Fall 1963.

　　Also: Léger's atelier. no. 1, pp. 40ff., Fall 1962.

153. Howe, Russell W. Chalk and cheese: Puy and Léger. *Apollo* (London), Aug. 1949, pp. 31–33.

　　Studio interview with Léger.

154. International Galleries. *Fernand Léger, 1881–1955: Retrospective Exhibition.* Chicago, Nov.–Dec. 1966.

　　Includes brief extracts (unsourced). Catalogue of 61 works (1909–55); exhibitions list (1949–67). Chronology, bibliography.

155. Janis, Sidney. School of Paris comes to U.S. *Decision* (New York), Nov.–Dec. 1941, pp. 85–95.

　　On Léger in America, pp. 85–87, 89.

Janis, Sidney, Gallery. [*Léger Exhibitions*]. See bibl. 105.

156. Kahnweiler, Daniel-Henry. Fernand Léger. *Burlington Magazine* (London), Mar. 1950, pp. 63–69.

　　Includes Léger letter, Dec. 11, 1919. (Also in Nickels, bibl. 69.)

157. Kormendi, A. Fernand Léger. *Creative Art* (New York), Sept. 1931, pp. 218–22.

157a. Krauss, Rosalind. Léger, Le Corbusier, and Purism. *Artforum* (New York), Apr. 1972, pp. 50–53.

　　On the occasion of the Tate exhibition (bibl. 76).

158. Léger. *Current Biography* (New York) v. [4], pp. 436–38, 1943.

159. Lozowick, Louis. Fernand Léger. *Nation* (New York), Dec. 16, 1925, p. 712.

160. Martiennsen, R. Fernand Léger in Paris—1938. *South African Architectural Record* (Johannesburg), Aug. 1942, pp. 237–39.

　　Also: Architecture in modern painting. Mar. 1939, pp. 83–86, 91.

161. Mauny, Jacques. Paris letter. *The Arts* (New York), June 1927, pp. 320, 321, 323.

Léger at the Salon des Tuileries.

162. McBride, Henry. Léger. *Art News* (New York), Mar. 1951. pp. 23, 54, 56, 57.

163. Morris, George L. K. Fernand Léger versus cubism. *Museum of Modern Art Bulletin* (New York), v. 3, no. 1, pp. [2–3, 5–7], Oct. 1935.

164. Morris, George L. K. On Fernand Léger and others. *The Miscellany* (New York), no. 6, pp. 1–16, Mar. 1931.

165. "Pity Us! Interview" [with Léger]. *Art Digest* (New York), Oct. 1935, p. 26.
 Reprinted from the *New York Herald Tribune*.

166. Pleynet, Marcelin. Léger legacy. *Art News* (New York), Feb. 1967, pp. 42–43.

167. Raynal, Maurice. Léger. *Vogue* (New York), Oct. 1, 1953, pp. 144–45.

168. Rexroth, Kenneth. Fernand Léger: master mechanic. *Art News* (New York), Oct. 1953, pp. 20–23.
 On Museum of Modern Art retrospective (bibl. 140).

169. Richter, Hans. In memory of two friends. *College Art Journal* (New York), v. 15, no. 4, pp. 340–43, 1956.

169a. Robinson, Duncan. Fernand Léger and the International Style. *Form* (Cambridge, Eng.), no. 1, pp. 16–18, Summer 1966.

170. Rothschild, Herbert and Nanette, Collection. *Herbert and Nanette Rothschild Collection.* (An Exhibition in Celebration of the Founding of Pembroke College). Providence, Rhode Island School of Design, 1966.
 Léger, no. 87–91, with text. Exhibited at the Museum of Art and Brown University, Oct. 7–Nov. 6, 1966.

171. Sacks, Lois. Fernand Léger and the Ballet suedois. *Apollo* (London), v. 91, pp. 463–68, June 1970.
 Bibliography.

172. Solomon R. Guggenheim Museum. *A Handbook to the Solomon R. Guggenheim Museum Collection.* New York, 1959.
 Léger, pp. 102–109, 248–49. Also *Selected Sculpture and Works on Paper.* 1969. pp. 52–55.

172a. Sutton, Denys. Léger at the Tate. *Art News and Review* (London), v. 2, no. 2, p. 3, 1950.

173. Sweeney, James Johnson. Eleven Europeans in America. *Museum of Modern Art Bulletin* (New York), v. 13, no. 4–5, pp. 13–15, 38, Sept. 1946.
 List of exhibitions (1941–45), brief bibliography.

174. Sweeney, James Johnson. Fernand Léger: simple and solid. *Art News* (New York), Oct. 1955, v. 5, no. 6, pp. 29–31.

175. Sweeney, James Johnson. Léger and cinesthetic. *Creative Art* (New York), v. 10, pp. 440–45, June 1932.
 Includes quotes from the artist. Reprinted in Jacobs (bibl. 104).

176. Sweeney, James Johnson. Léger and the cult of the close-up. *The Arts* (New York), v. 17, pp. 561–68, May 1931.
 Incorporates translation of Léger lecture (Berlin, 1928).

177. Sweeney, James Johnson. Léger and the search for order. *View* (New York), v. 4, no. 3, pp. 84–87, Oct. 1944.

178. Sweeney, James Johnson. Léger's art is the man. *New York Times Magazine* (New York), Oct. 18, 1953, pp. 28–29, 42, 44, 46.

179. Sweeney, James Johnson. [A picture by Léger: "Contraste de Formes"]. *Creative Art* (New York), July 1931, pp. 63–64.

180. Sweeney, James Johnson. Today's Léger-demain. *Art News* (New York), Oct. 15, 1942, pp. 18–19, 30.
 "Famous French abstractionist's work in his two year American exile."

181. Sylvester, David, ed. Fernand Léger. In his *Modern Art from Fauvism to Abstract Expressionism*. London, Rainbird; New York, Watts, 1965, pp. 79–80.

182. Sylvester, David. Portrait of the artist: Fernand Léger. *Art News and Review* (London), v. 2, no. 2, pp. 1, 7, Feb. 25, 1950.

183. Sylvester, David. The realism of Léger. *Art* (London), no. 1, p. 4, Nov. 1954.

184. Tate Gallery. *Fernand Léger*. An Exhibition of Paintings, Drawings, Lithographs and Book Illustrations. London, Arts Council, Feb. 17–Mar. 19, 1950.
 12 pp.; checklist (76 exhibits); introduction by Douglas Cooper. Reviewed by Denvir (bibl. 137), Sutton (bibl. 172a). Also *Architectural Review* (London), Apr. 1950, p. 94; *Art*

News (New York), Apr. 1950, p. 51; *Art News and Review* (London), Feb. 25, 1950, p. 3. For 1971 show see bibl. 76.

185. Tillim, Sidney. Five themes and variations at the Guggenheim Museum. *Arts* (New York), v. 36, p. 84, May 1962.
 Review of bibl. 75.

186. Wadley, Nicholas. Léger and Purist Paris at the Tate Gallery. *Burlington Magazine* (London), v. 113, pp. 55–56, Jan. 1971.
 About the 1971 show (bibl. 76).

187. Warnod, André. "America isn't a country—it's a world." [Interview with F. Léger summarized]. *Architectural Forum* (New York), Apr. 1946, pp. 50, 54, 58, 62.
 Translation from *Arts* (Paris), no. 49, Jan. 1946.

188. Whitney Museum of American Art. *European Artists in America.* New York. Mar. 13–Apr. 11, 1945.
 No. 63–69 by Léger.

189. Wraight, Robert. The Musée Fernand Léger. *Studio* (London), Dec. 1961, pp. 206–209.

Index

Numbers in italics refer to illustrations.